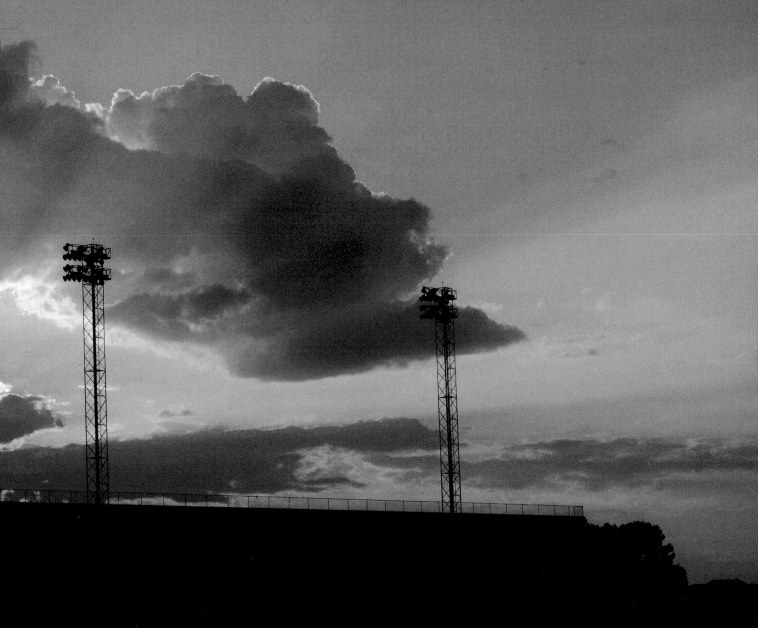

FRIDAY NIGHT LIVES

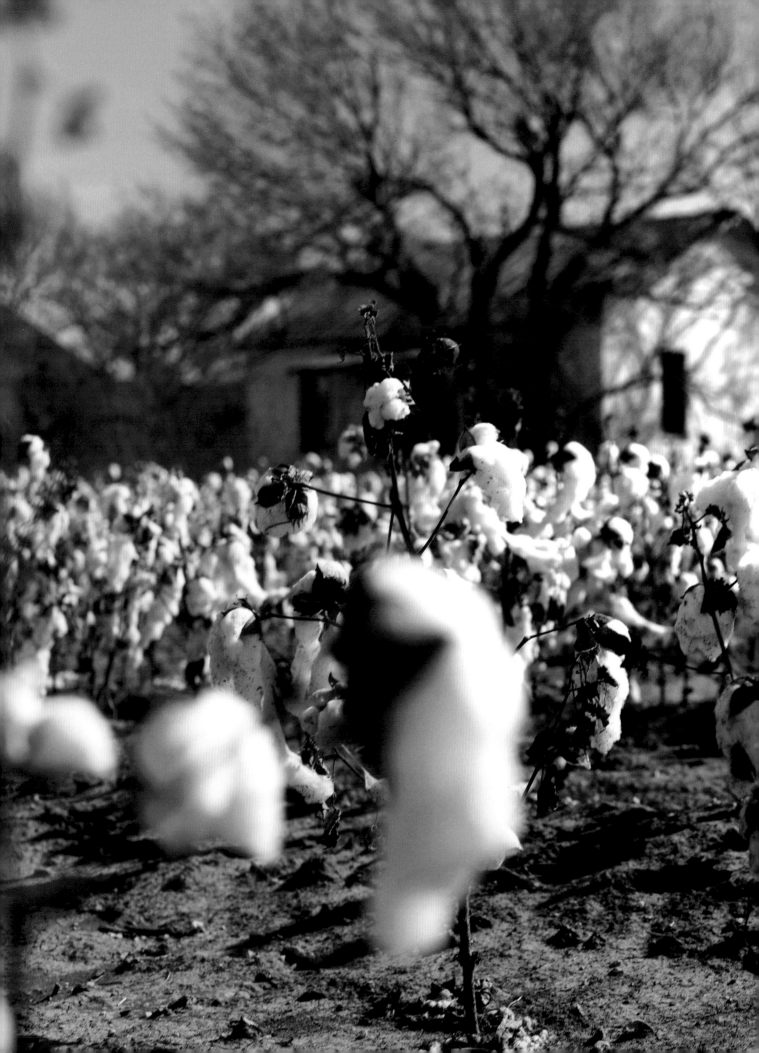

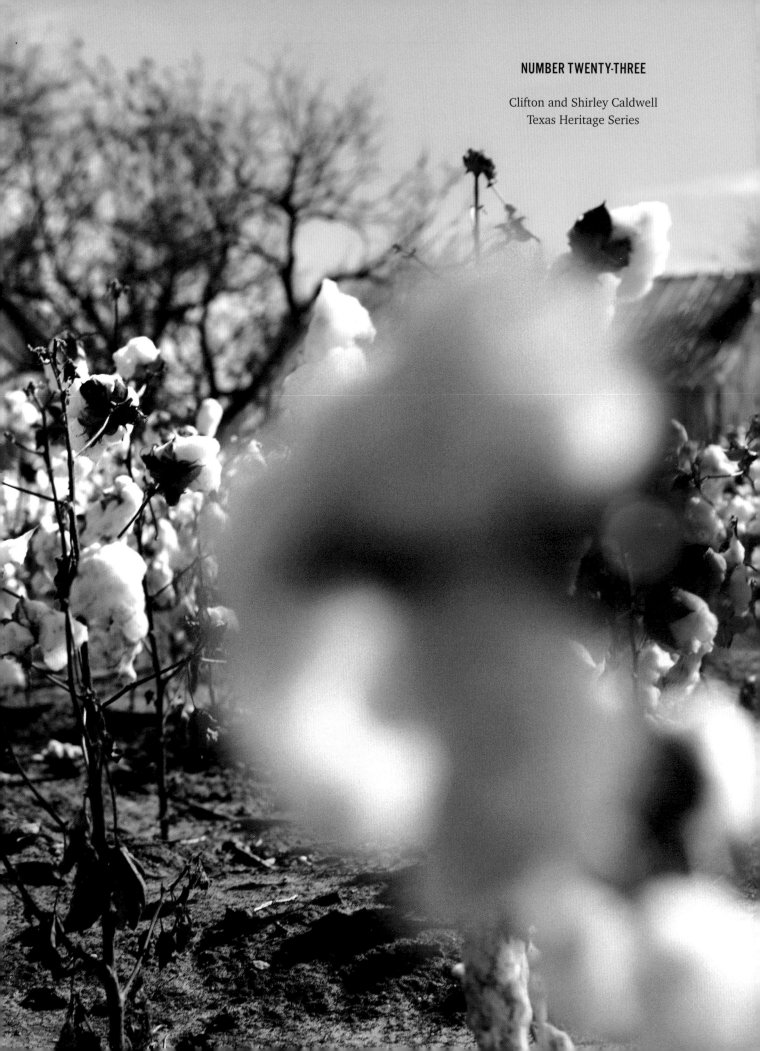

NUMBER TWENTY-THREE

Clifton and Shirley Caldwell
Texas Heritage Series

FRIDAY
NIGHT LIV

PHOTOS FROM THE TOWN, THE TEAM, AND AFTER

ROBERT CLARK
FOREWORD BY HANIF ABDURRAQIB

UNIVERSITY OF TEXAS PRESS, AUSTIN

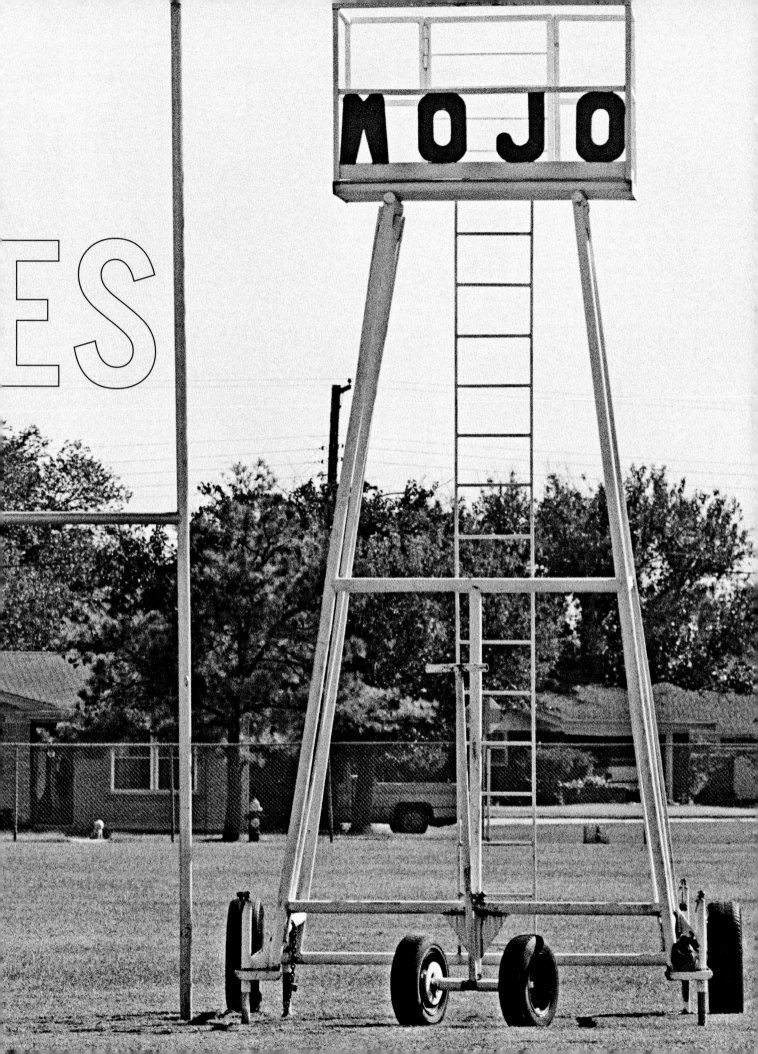

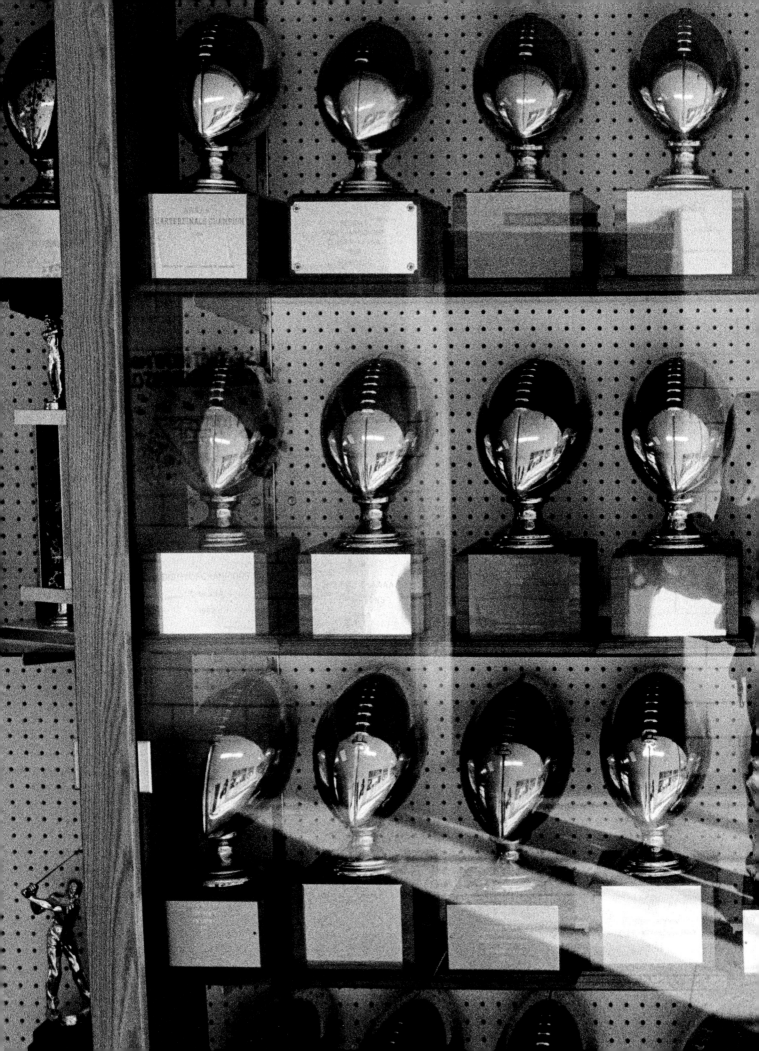

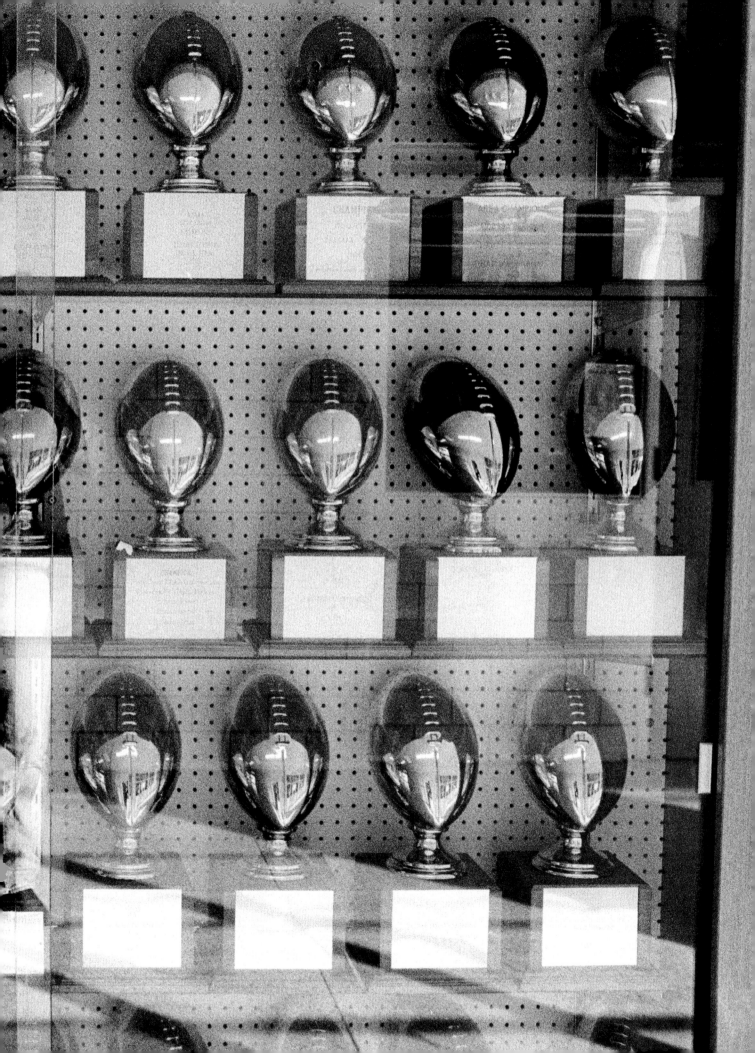

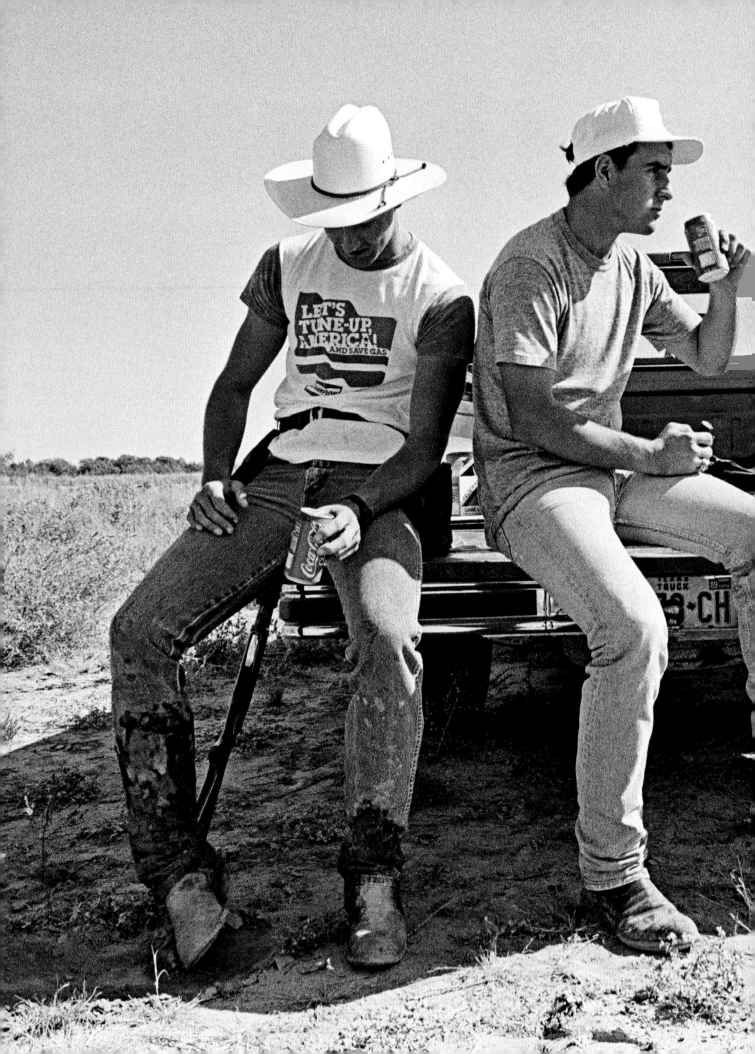

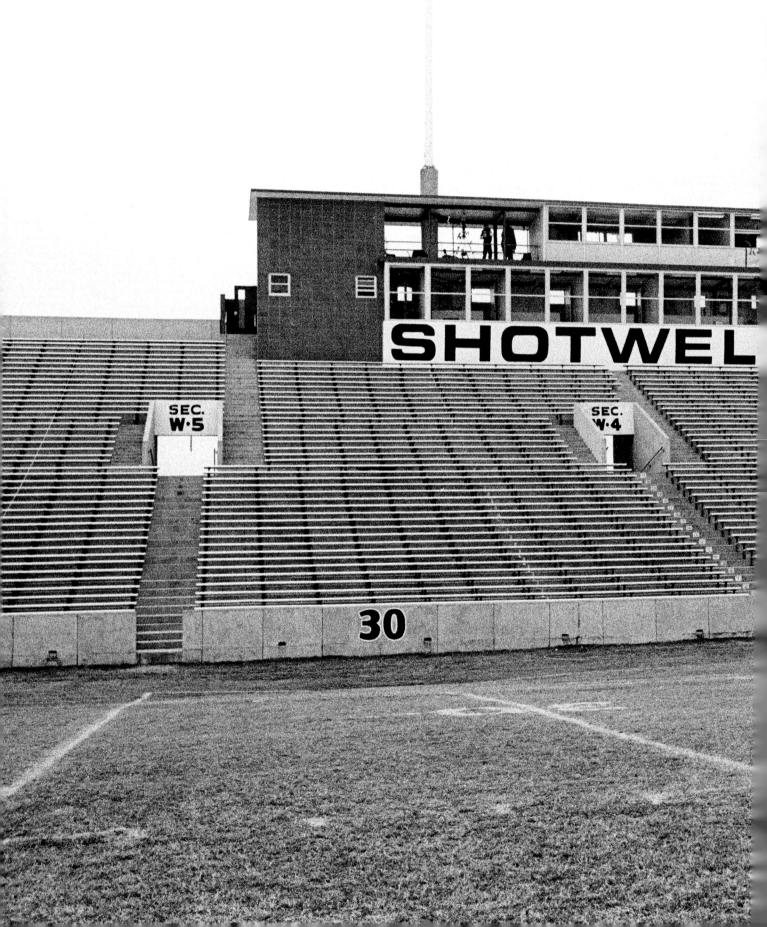

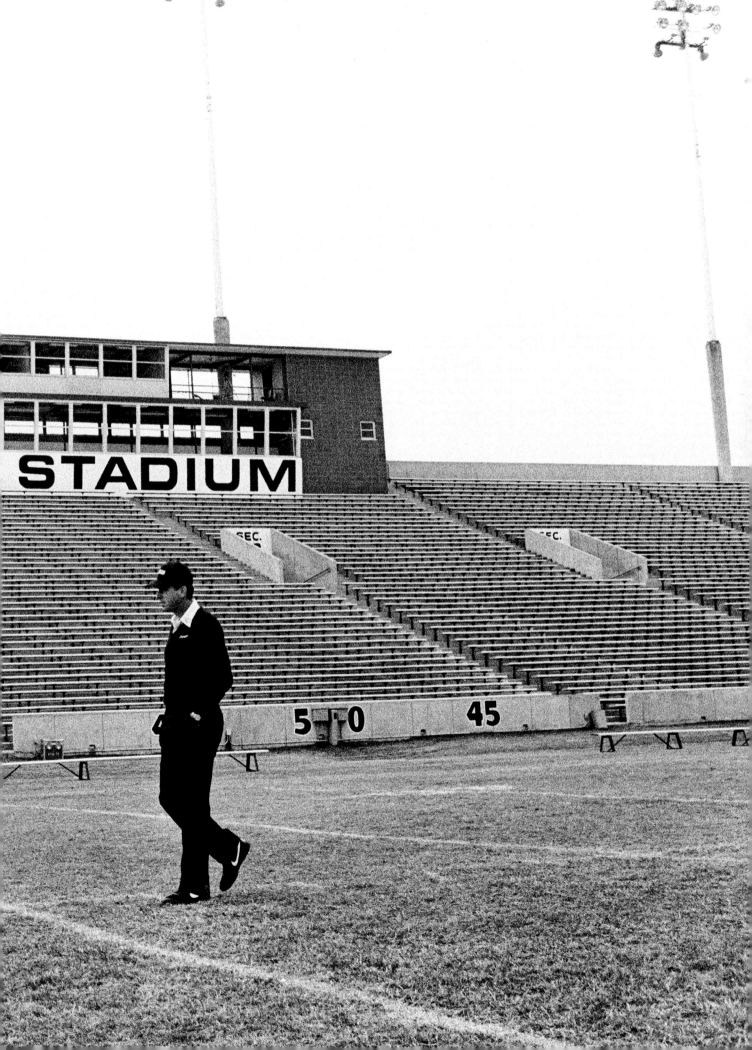

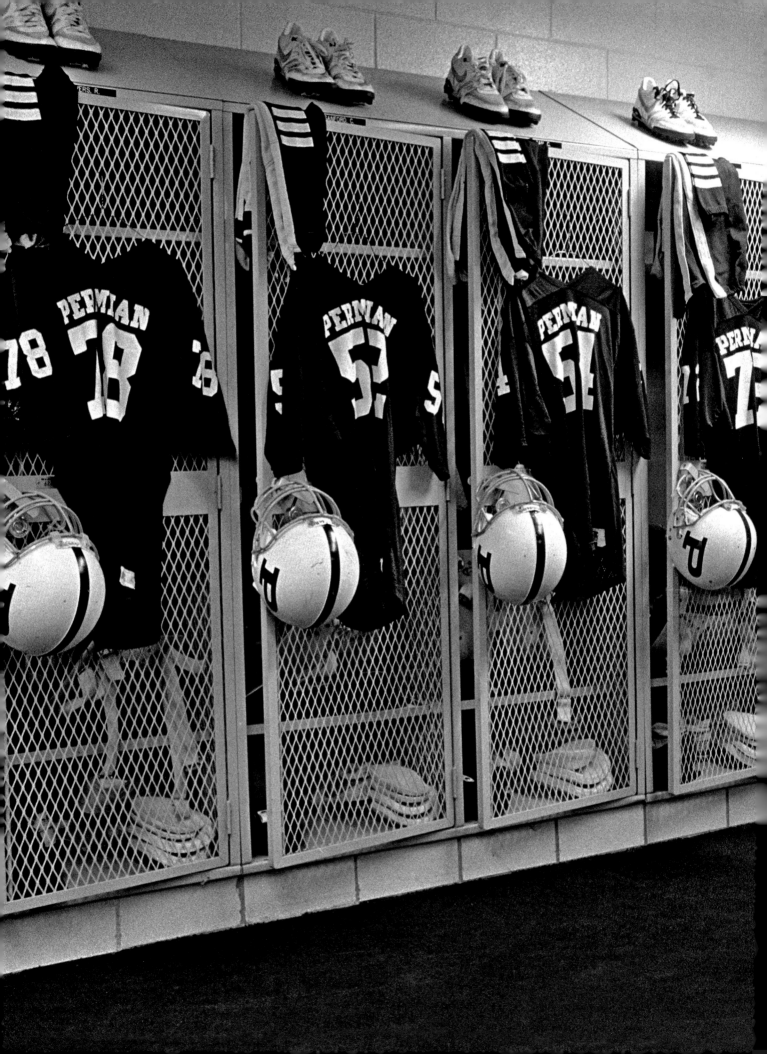

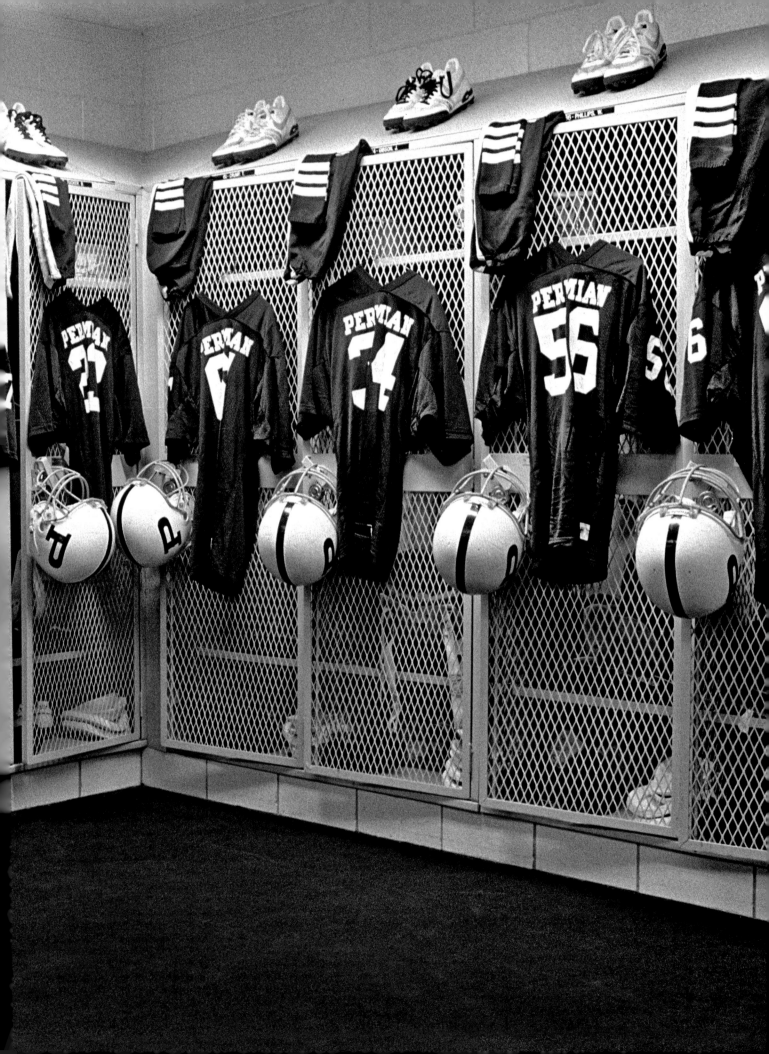

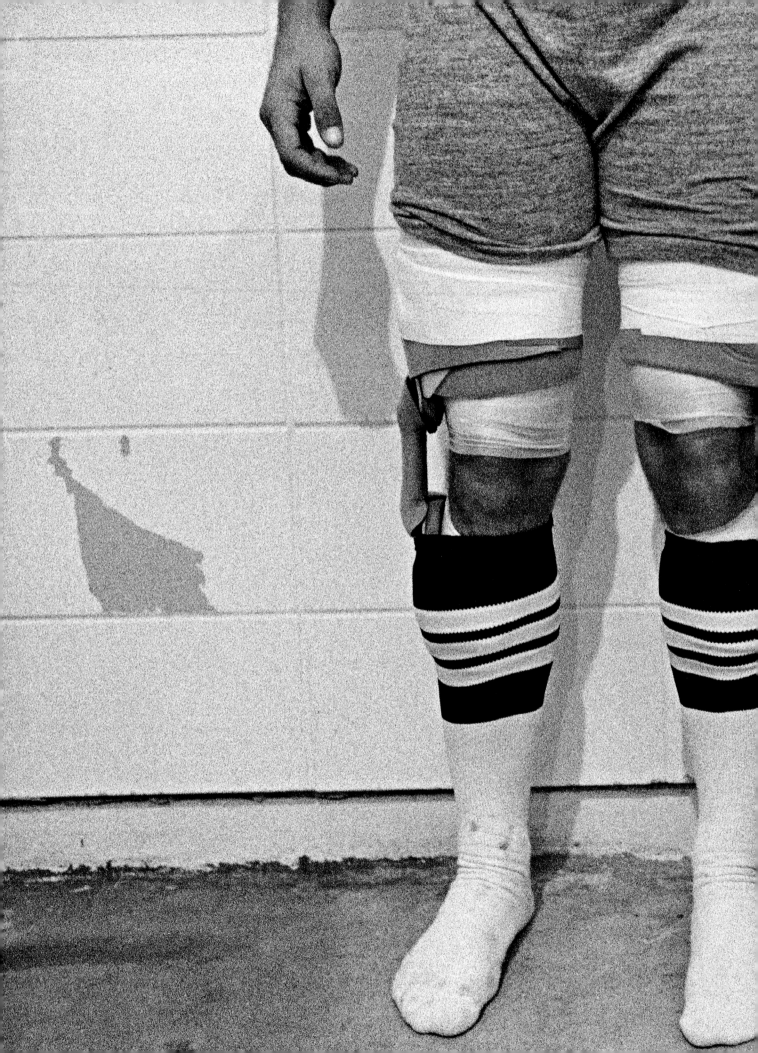

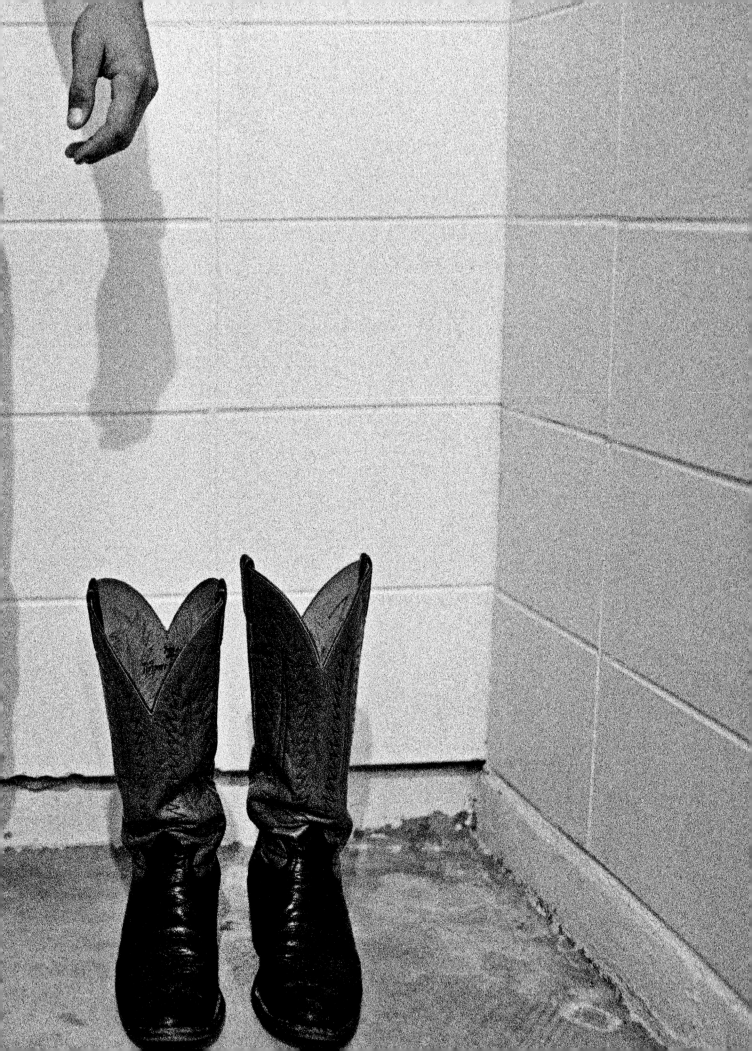

Publication of this work was made possible in part by support from Clifton and Shirley Caldwell
and a challenge grant from the National Endowment for the Humanities.

Requests for permission to reproduce material from this work should be sent to:
Permissions
University of Texas Press
P.O. Box 7819
Austin, TX 78713-7819
utpress.utexas.edu/rp-form

♾ The paper used in this book meets the minimum requirements
of ANSI/NISO Z39.48-1992 (R1997) (Permanence of Paper).

Library of Congress Cataloging-in-Publication Data

Names: Clark, Robert, 1961- author, photographer. | Abdurraqib, Hanif, 1983- writer of foreword.
Title: Friday night lives : photos from the town, the team, and after / Robert Clark ; foreword by Hanif Abdurraqib.
Description: First edition. | Austin : University of Texas Press, 2020.
Identifiers: LCCN 2020018385 | ISBN 978-1-4773-2119-5 (hardcover)
Subjects: LCSH: Bissinger, Buzz, 1954- Friday night lights. | Permian High School (Odessa, Tex.)—Football—
Pictorial works. | Football—Social aspects—Texas—Odessa—Pictorial works. | LCGFT: Photobooks.
Classification: LCC GV958.P47 C53 2020 | DDC 796.3309764/862—dc23
LC record available at https://lccn.loc.gov/2020018385

ISBN 978-1-4773-2119-5 (hardcover)

JACKET AND BOOK DESIGN: EmDash, Austin

ENDSHEETS:
The sun sets over Ratliff Stadium in Odessa, Texas. It opened in 1982, was built at a
cost of $5.6 million dollars, and has a capacity of 19,302 people. The facility has been
described as the epicenter of Texas high school football.

CONTENTS

FOREWORD

HANIF ABDURRAQIB

MY INTRODUCTION TO TEXAS came well before I ever set foot in the state itself. I found H. G. Bissinger's book *Friday Night Lights* at a used bookstore when I was a teenager in the early 2000s, drifting in the dog days of summer between my junior and senior years of high school. I had just gotten my first car, a brown Nissan Maxima with a faulty alarm and inconsistent shades of window tint. Despite the ways that an engine and four wheels can expand a geographical radius, there are only so many places you can go when you are sixteen years old. And so I spent many of my days simply driving around Columbus, Ohio, popping into stores I couldn't afford until I worked my way down to the stores I could afford.

On the cover of that edition of *Friday Night Lights* was the now iconic black-and-white photo taken by Robert Clark: Odessa Permian football players Brian Chavez, Mike Winchell, and Ivory Christian linking hands together and walking along the sideline of a football field. I was drawn to the book because of this image first. I was a high school athlete, preparing to become a college athlete. I was still young and eager enough to buy into all of the mythologies about brotherhood and family that sports sold me. The captains on my own soccer team would walk out to the middle of the pitch before the game in this same manner: hands clasped together, forming a single chain of movement.

Being from Ohio, I know there are similar ways to understand the enthusiasm that can set upon an entire community as the days tick toward the weekend. In Massillon, Ohio, Paul Brown Tiger stadium looms large within the town's landscape. Boys born in the town are given tiny footballs in the hospital. The Massillon Tigers are among the winningest high school programs in the nation, and their rivalry with nearby Canton McKinley is one of the fiercest rivalries in all of high school sports. Even if you didn't live near Massillon, you might make the trip up on a Friday night, just to see what all the noise was about. In this way, entering the world of Odessa through the pages of *Friday Night Lights* felt at least somewhat familiar, even though I was entering a different era of high school football and high school football players. And even though the physical space and concerns of the local population were all different, there was a comfort in the idea that even before I knew what football was, there was a town that revolved around a few hours on a Friday night inside of a stadium. With summer's spiral into autumn, there was the promise of some escape waiting at the end of the week. If your job was shit or if things at home weren't great or if you had played once and had some glory slip through your fingers, the game could become a portal to some newer, or better, dreams.

The issue with this, of course, is that the people acting as vehicles toward those dreams are teenagers, some with dreams of their own—teenagers who are flawed, complex, and fighting through the many pressures of being alive and young while also being

I'M REMINDED ONCE AGAIN THAT SPORTS ARE THE BACKDROP OF THE STORY, AS THEY OFTEN ARE. THE STORY HAS ALWAYS BEEN ABOUT HUMANITY, ANXIETY, LOSS, FEAR, AND THE PROMISE OF A PLACE AND THE PEOPLE IN IT.

uniquely responsible for the contentment of their friends, family, and the other people they share a town with. Bissinger does a great job of capturing this in *Friday Night Lights*, even when he doesn't paint the town of Odessa in the most generous light. There is, of course, the tragic story of James "Boobie" Miles, who succumbed to a domino effect of tragedies after blowing out his knee during the dying moments of a preseason game before his senior year—an injury that caused his pile of scholarship offers to vanish. Among a great many other things, the book turns a sharp eye to issues of race, as well as perceived usefulness once someone becomes less than a hero. There's Mike Winchell, the starting quarterback who defied the stereotypes of starting quarterbacks on great teams as being confident, boastful, and easygoing. In the book, Winchell is portrayed as anxious, caring, deeply thoughtful, and prone to surgical self-reflection. There's also Don Billingsley, the troubled troublemaker with a tumultuous home life, and Ivory Christian, who played middle linebacker with a singular violence, but who, off the field, was reserved and often ambivalent.

It was the generosity of Bissinger's time and language that worked to afford these students all of their many dimensions and addressed the town as its full self, even if the people inside the town were uncomfortable with that fullness coming to light. When the film version of *Friday Night Lights* came out in 2004, one drawback to its success—and the subsequent revisit to the book it inspired—was that the real-life players and people from that 1988 Odessa Permian team began being referred to as "characters," as if they were crafted specifically for this story to play itself out and were not actual people with real lives that extended beyond the ways they were immortalized in the text (a text that was made infinitely more interesting by fate: Bissinger arrived in Odessa surely not expecting a star player to have a devastating injury that would shape the narrative of the story and the narrative of the town so immensely).

A corrective to this, for me, always rested in the photos of Robert Clark. It was his photo of the captains

walking hand-in-hand that led me to the book, after all. In this collection of photos, you are confronted with the aesthetics of a high school football–obsessed town at the end of a decade mired in economic stagnation and decline, as an oil bust drained Odessa of one of its primary sources of work and income. The promise of the 1988 Permian Panthers and the hope placed on them show up in the town's surroundings. In these photos, you see "STATE! '88" painted haphazardly on a white fence. On the bumper of a Ford pickup, there are bumper stickers declaring its owner a MOJO Booster on one side, and on the other side, another bumper sticker that reads "ENDANGERED SPECIES: OILFIELD HAND."

And, of course, beyond capturing the anxieties of a town looking for excitement and emotional renewal through its high school football team, Clark's photos also do the vital work of reminding us that the central participants in this whirlwind of a story were, at the time, young people: teenagers, who were more than just cogs in the machinery of a place and its history and its obsession. The photos taken at practices are stunning, of course. It is a gift to be able to capture the strain and exhaustion that a morning practice can inflict on a body, and how the body pushes through, no matter what. There are photos of players lifting weights reflected in a mirror, and photos of players sprawled out on the gym floor, waiting for their chance at whatever drill they are called to next. The photos of an afternoon practice translate the weight of expectation, with boosters watching from lawn chairs while players run drills with the sun sketching its heat along their faces. Some get to seek a brief reprieve from it by basking in sprays of water.

Clark's most important work, however, is what he captures beyond the pads and helmets and watching eyes of elders: the mischief, the disappointment, the desire for players to cling to each other in moments outside of the game. On the bus to Abilene High, student managers hover around each other while a card game unfolds. I love this photo for how it allows us to see the fullness of these young people, who deserve their own escape from the pressures they were taking on simply

by being adjacent to the Permian Football Behemoth. In a locker room before a game, a player stands in his uniform socks and two knee braces next to his now-empty cowboy boots. It's a portrait of being, and becoming. After a loss at Midland Lee, Jerrod McDougal cries against the wall in a locker room, while outside, Don Billingsley receives a hug from a woman with tall, blonde hair, and his melancholy turns into a wide smile.

There are two photos of Boobie that stand out, one, before the Abilene game. He sits in front of his locker, his face resting inside of his hands, parted into a gentle V shape. His already wide shoulders look even more broad with the added bulk of his pads, contrasted with the narrow shape of his locker. A "Terminator X" towel dangles from his waist. This was the game where Boobie returned and attempted to play on his damaged knee, receiving only a handful of carries. In this shot before the game, he already looks defeated, as if he knows the attempts at recapturing his hopes for a limitless future are futile. It makes his arc even more heartbreaking—that he clung so desperately to football as a pathway, he couldn't see anything else.

The second photo is from after Boobie left the team, frustrated after a game at Midland Lee. Free from the grasp of football, which consumed him for an entire lifetime, Boobie and his beloved uncle L.V. lean into each other and laugh on a porch. It is a photo that situates Boobie as someone beyond the game he played or the injury that altered his life. He's a kid, spending time with a person who means the world to him. The photos need each other to work. One serves as a reminder of what seemed to be a monumental loss; the other, a reminder of the entire world outside of that perceived loss.

I came to the story of *Friday Night Lights* late, years after it actually took place. At the time it arrived for me, I thought high school sports was the only thing I had to define myself. I had yet to fall back in love with reading, and so I had yet to fall in love with writing. Winning and losing games was what I knew: getting up earlier than everyone else and running on a track during long, hot summer mornings; joking around

in a weight room and occasionally lifting a thing or two. It was such a massive part of my identity that I refused to see beyond it. Despite being drawn to the book by its cover, I didn't see the photos then like I see them now, years removed from whatever small slivers of athletic glory I got to accumulate. It is funny what distance can afford. When I first read the book, I saw myself as someone entangled with these players solely through our athletic desires and the people pushing us toward them. Now, through the lens of Robert Clark, I'm reminded once again that sports are the backdrop of the story, as they often are. The story has always been about humanity, anxiety, loss, fear, and the promise of a place and the people in it.

Propelled by *Friday Night Lights* and the photos in it, I drove to Odessa in 2004, in my early twenties. I drove from Ohio, with no real purpose other than a feeling that I needed to see the school. I needed to see the stadium. All of its mythology felt so larger than life, and I needed to be reminded that it was real, and touchable. It was a foolish trip, one buoyed by what I felt were the dying moments of my reckless youth. I stood outside Ratliff Stadium and I looked at the banners celebrating the titles of the Permian Panthers football team. This was in the month after the film was released. It was late fall, and football season had wound down disappointingly. The team had a 4–6 record, but there were still banners adorning the fences outside of the stadium, cheering the team on. I didn't stay long, and I didn't linger much in the town itself. It was just good to know that there was something worth seeing beyond the story that became a national phenomenon—that there were people still living with all it had given them, whether they wanted it or not. I am thankful for these photos. I am thankful for the fact that they do that same work, pouring some of the humanity back into the narrative. I hope someone younger than I am now finds *Friday Night Lights* in a used bookstore far from Odessa some day. And when they get the urge to want to make the trip to see that world for themselves, they'll look up this book instead.

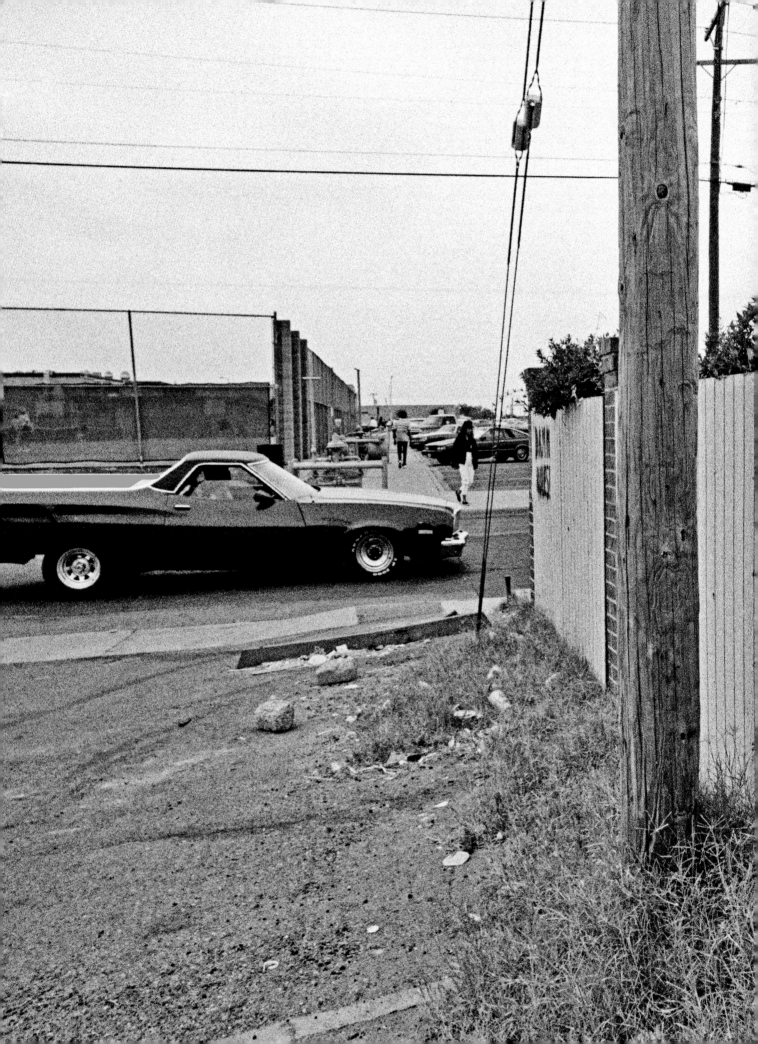

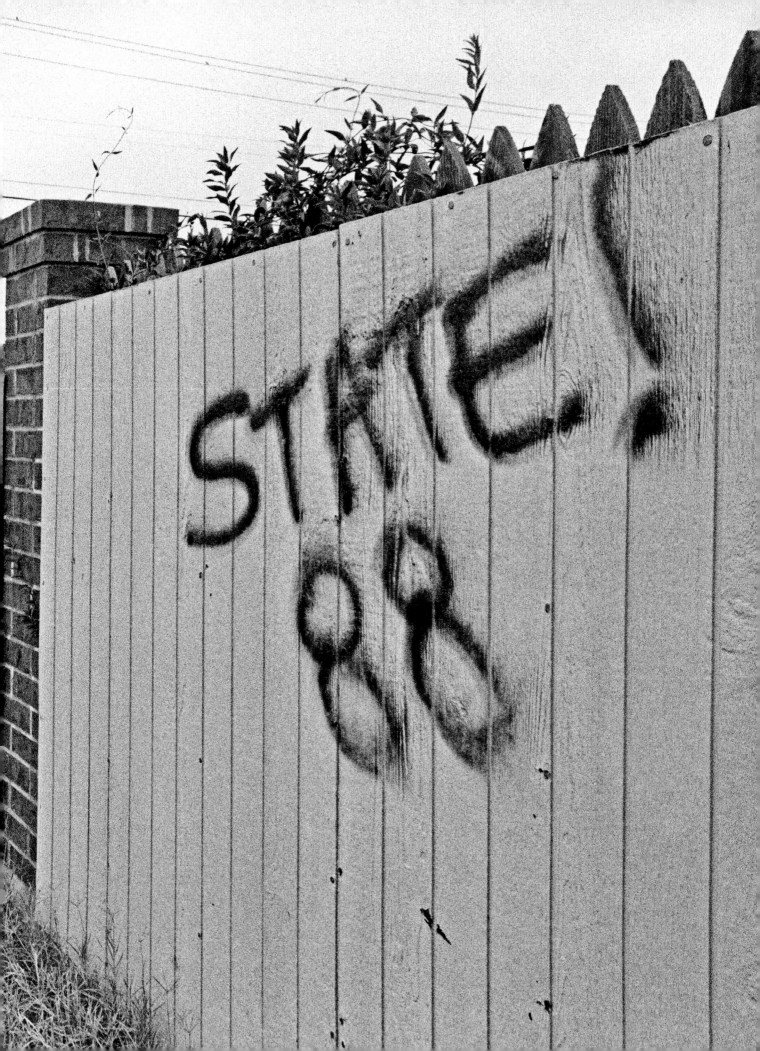

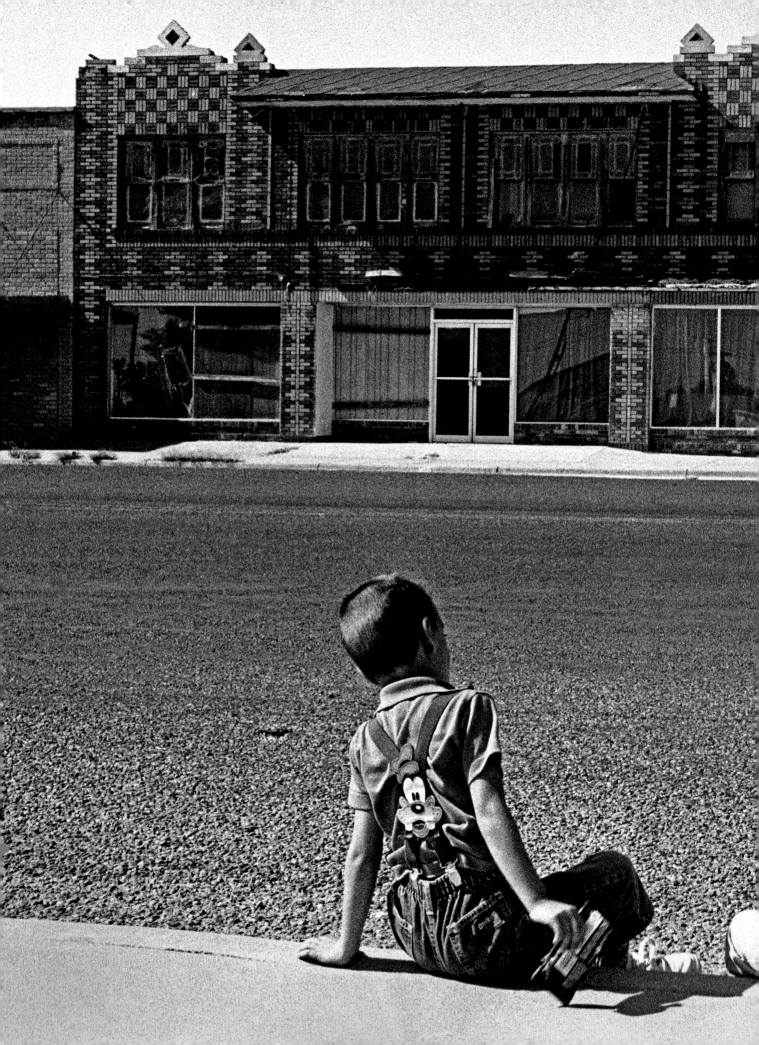

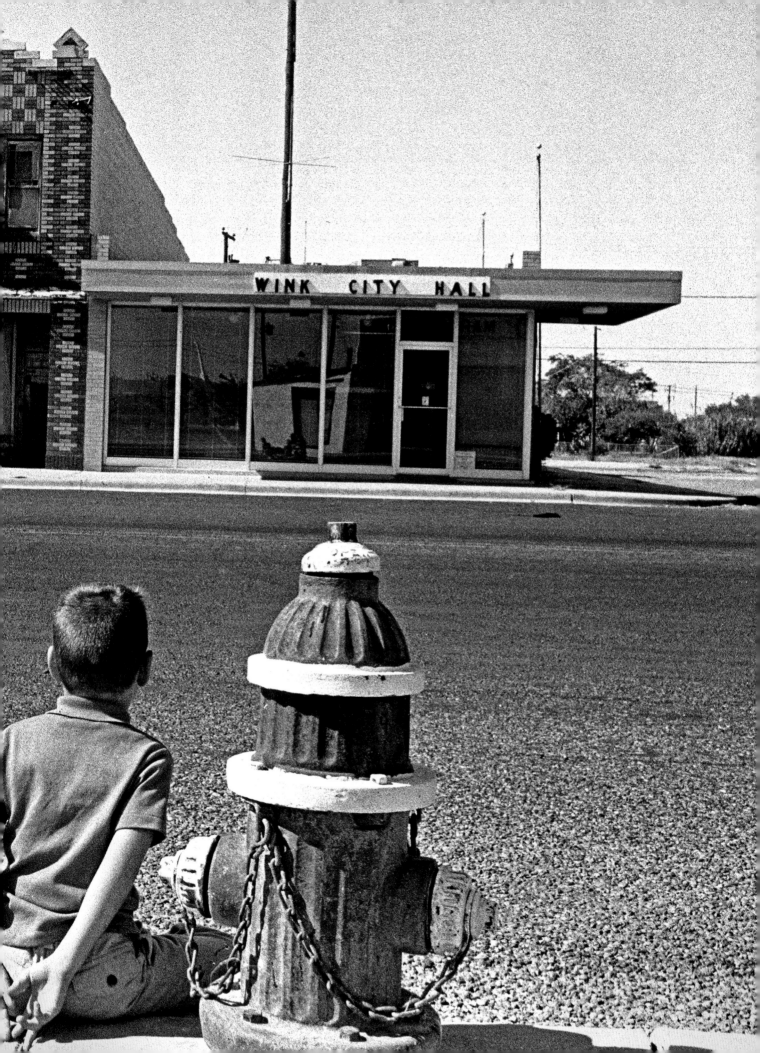

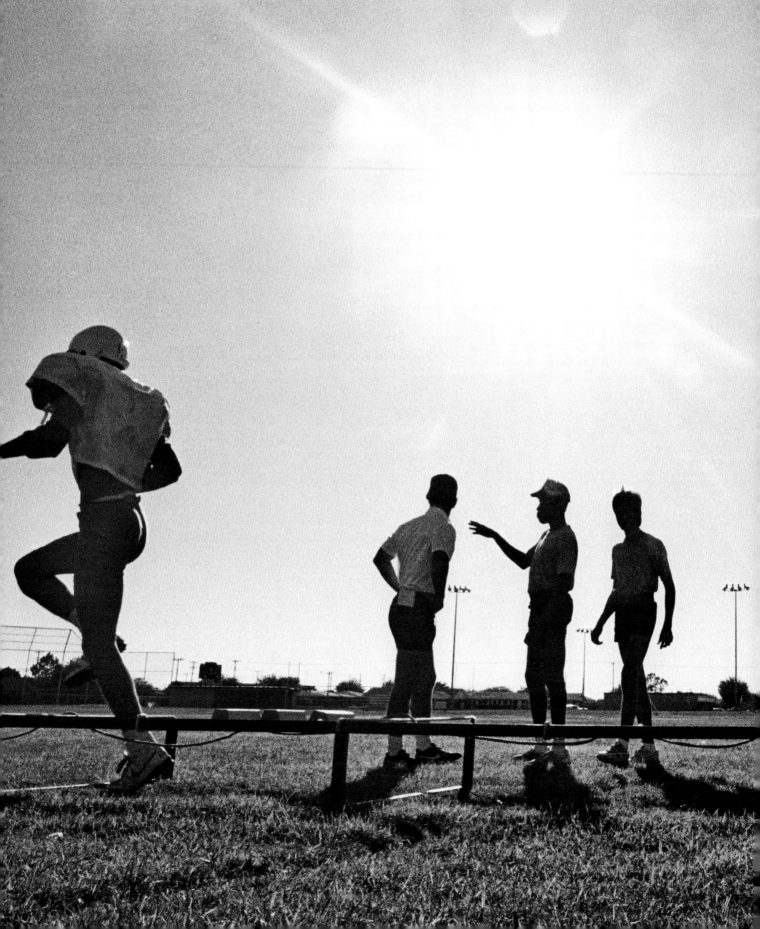

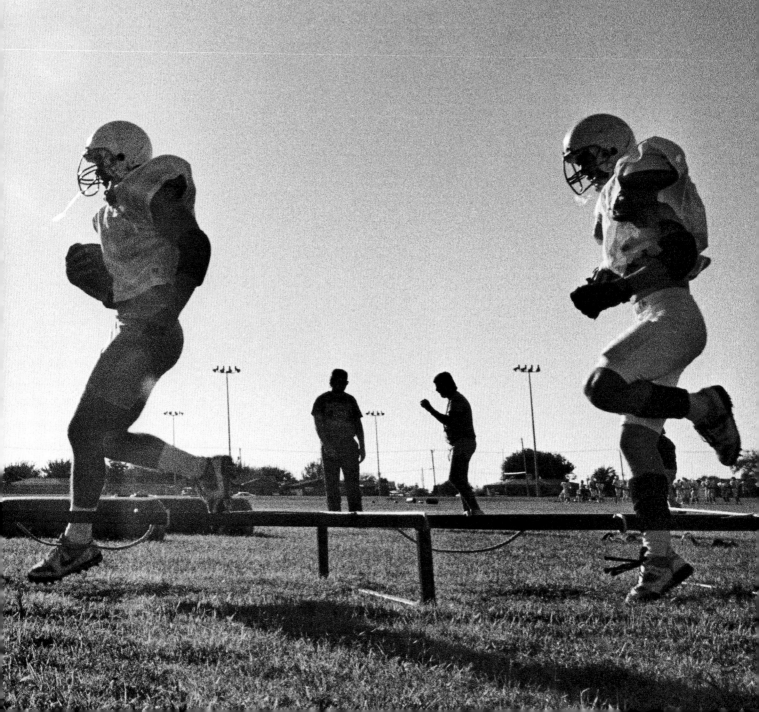

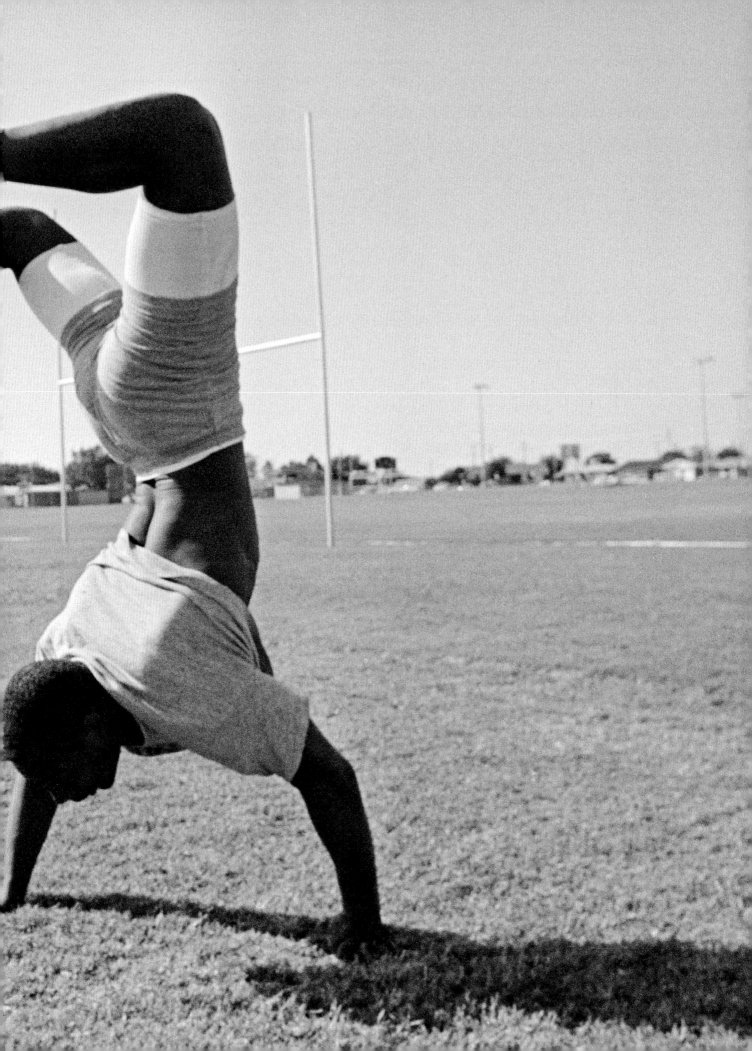

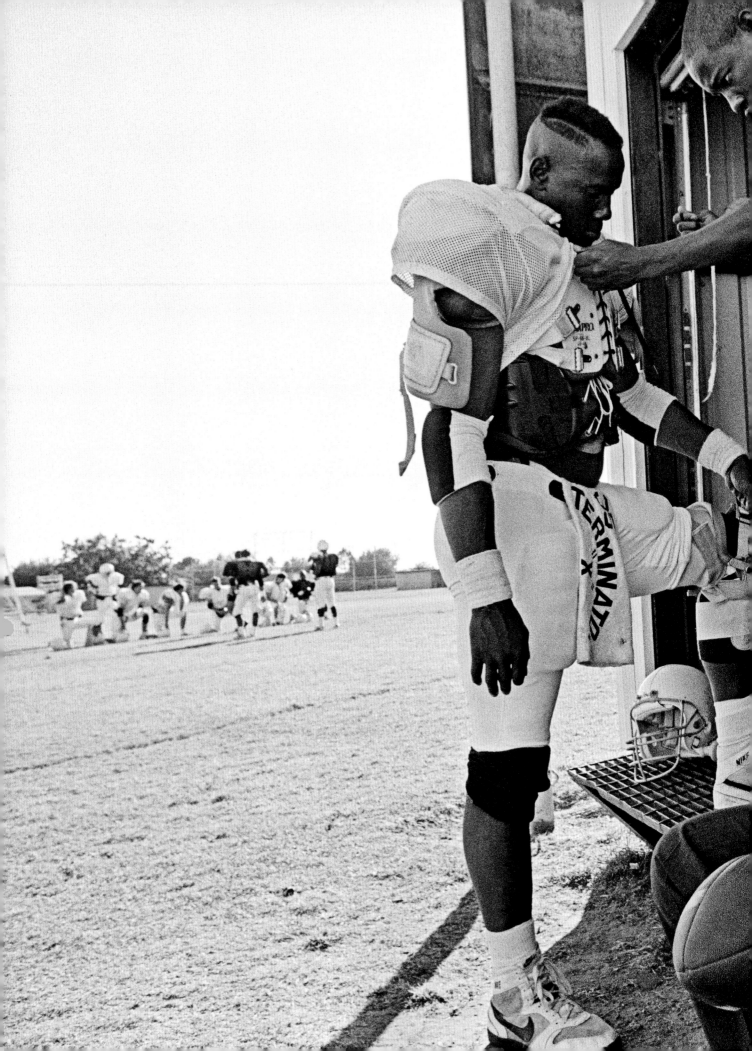

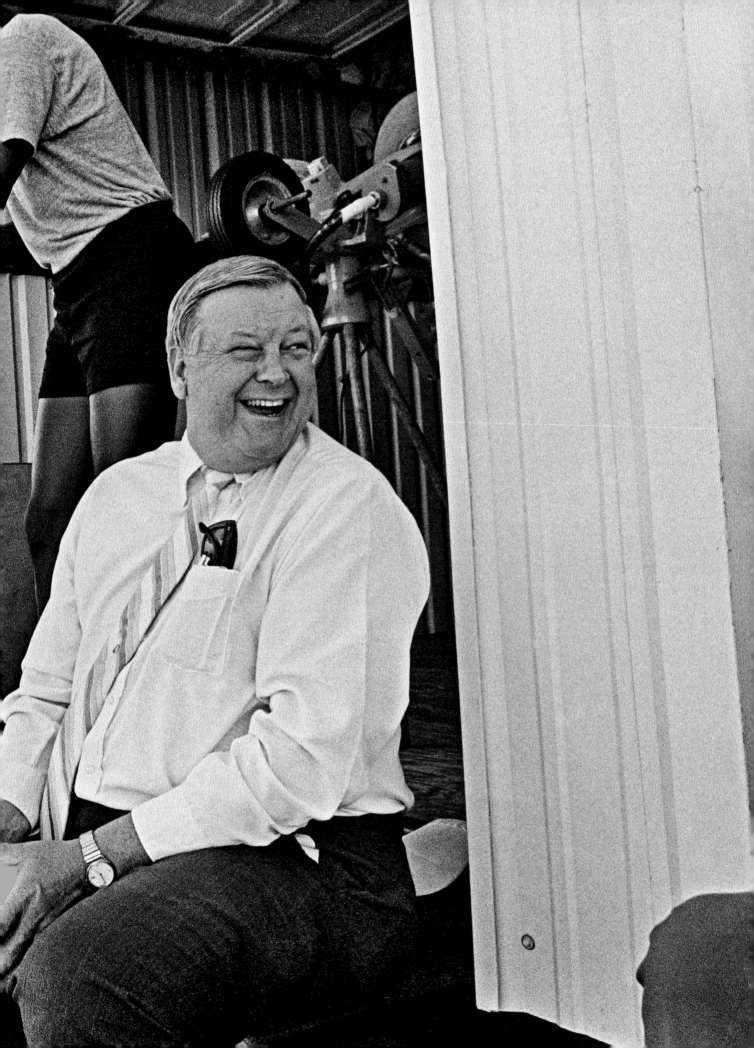

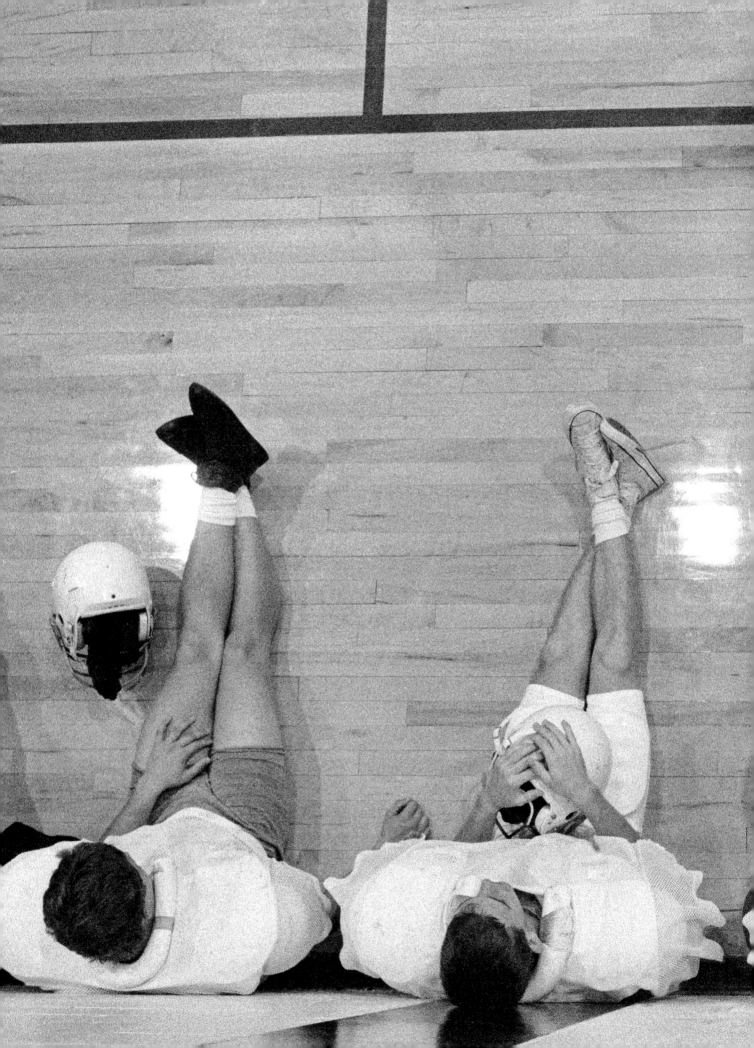

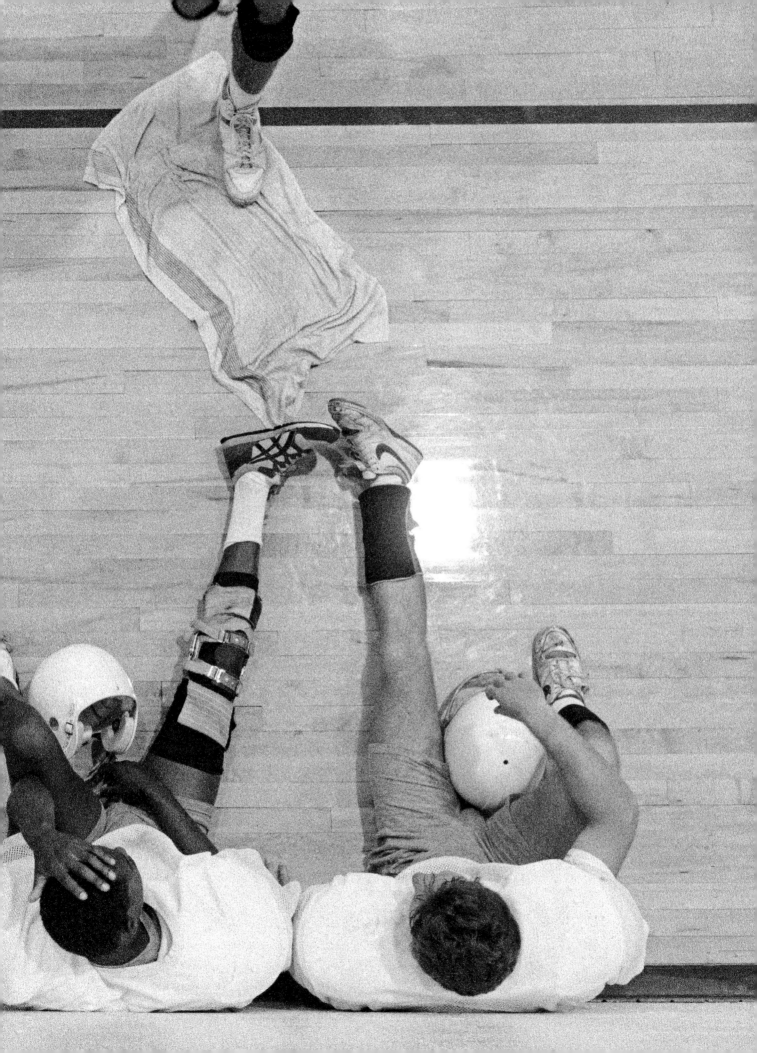

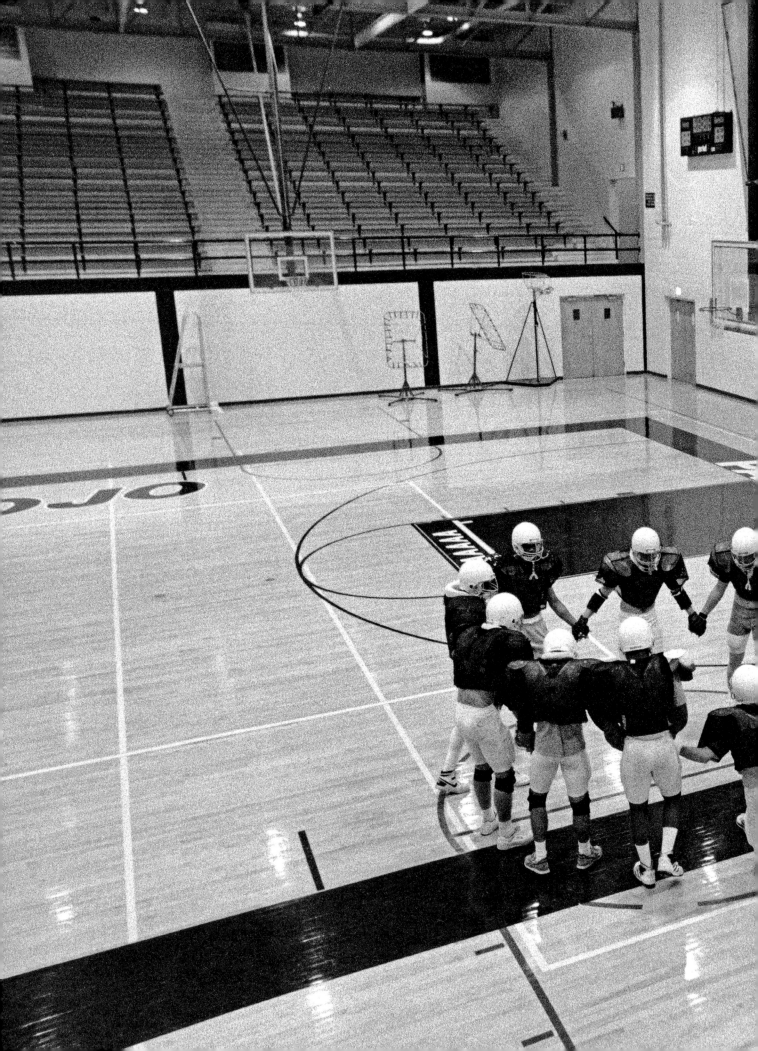

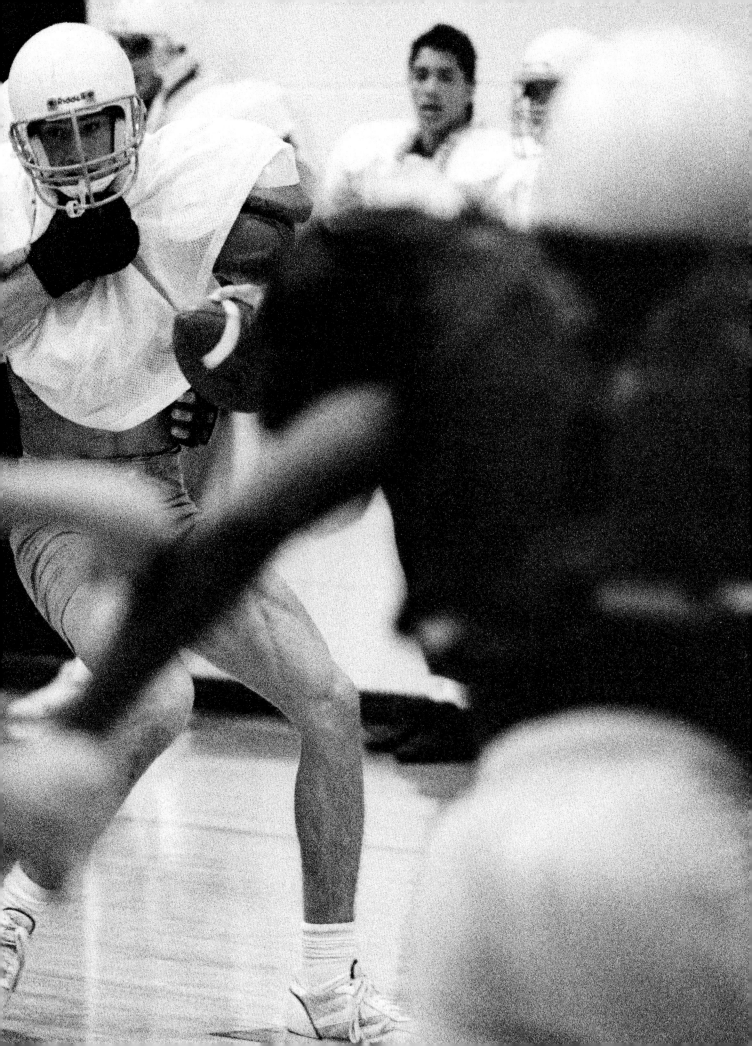

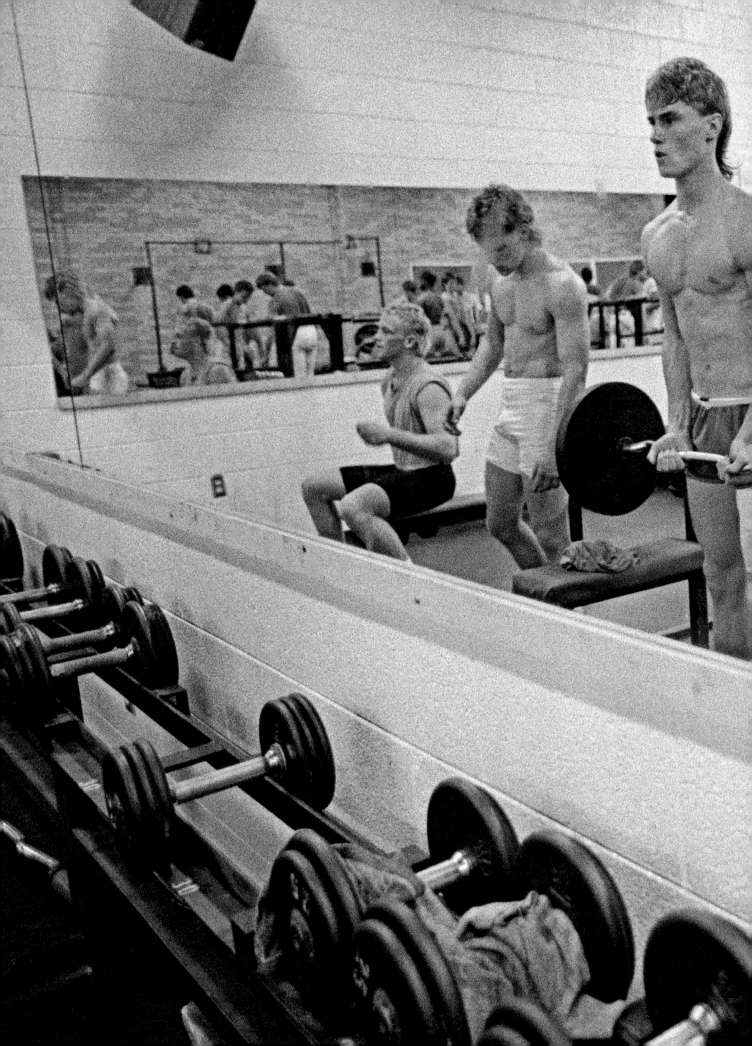

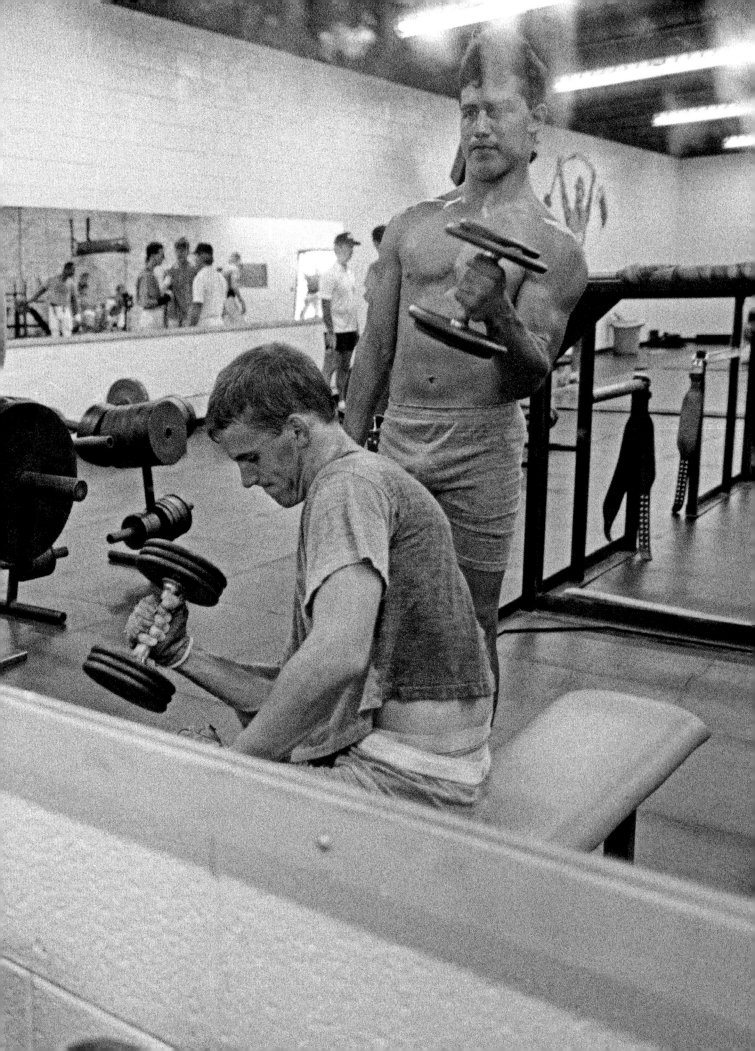

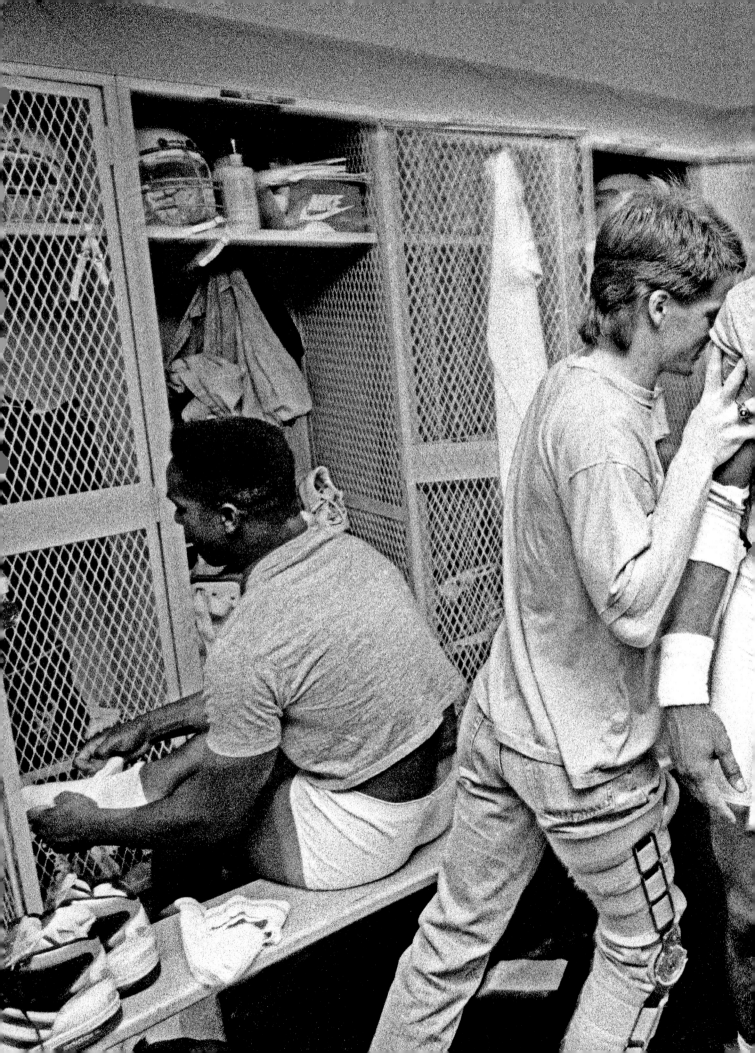

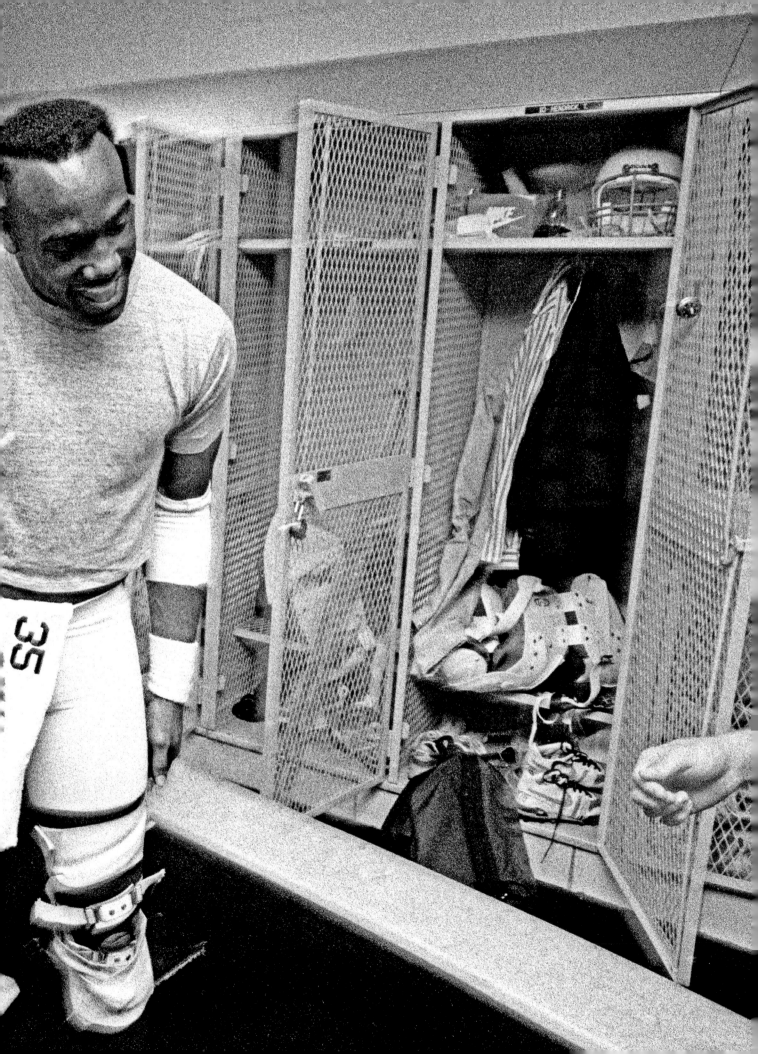

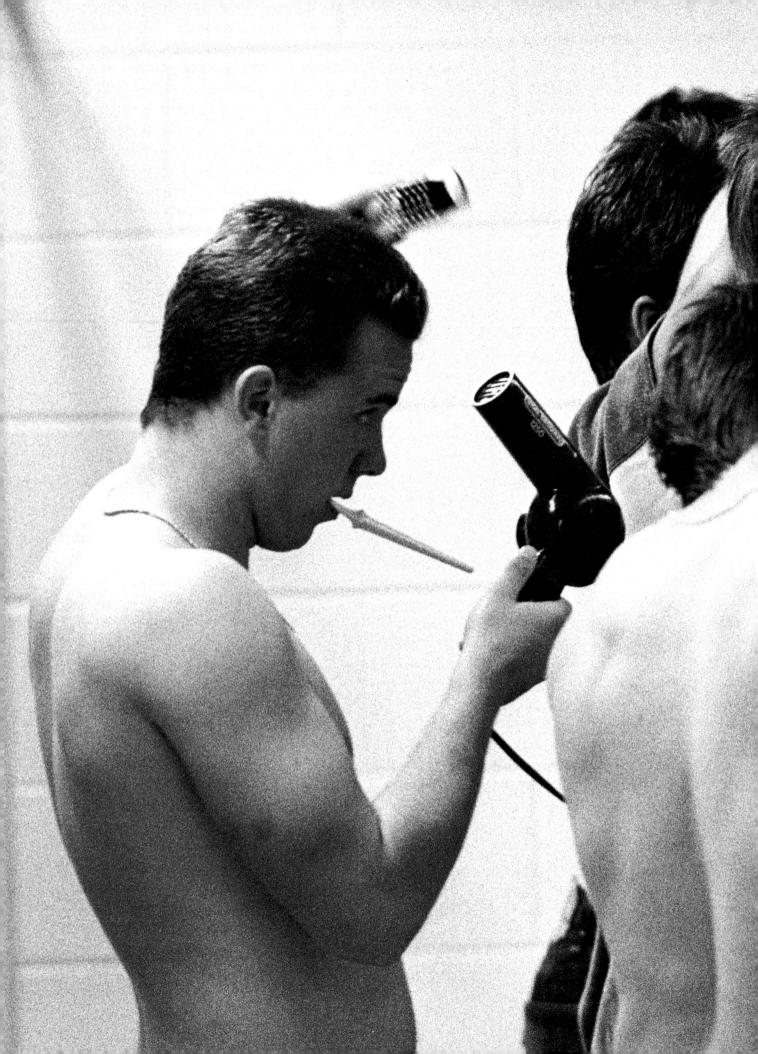

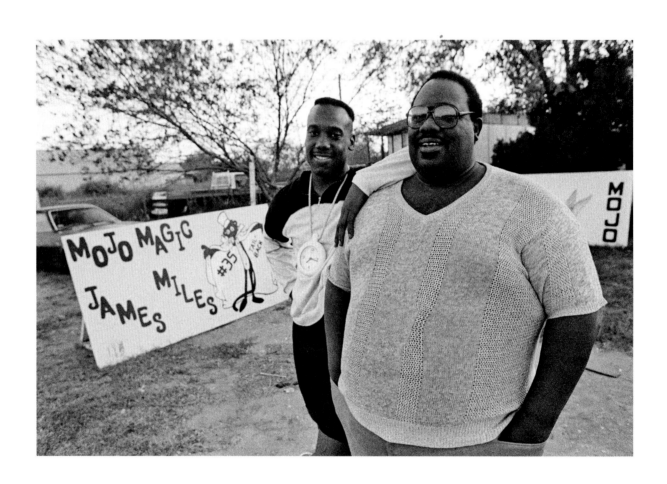

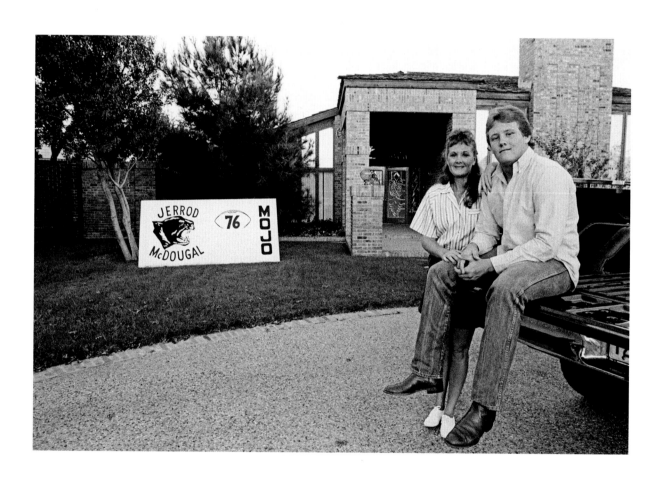

FRIDAY NIGHT LIVES **45**

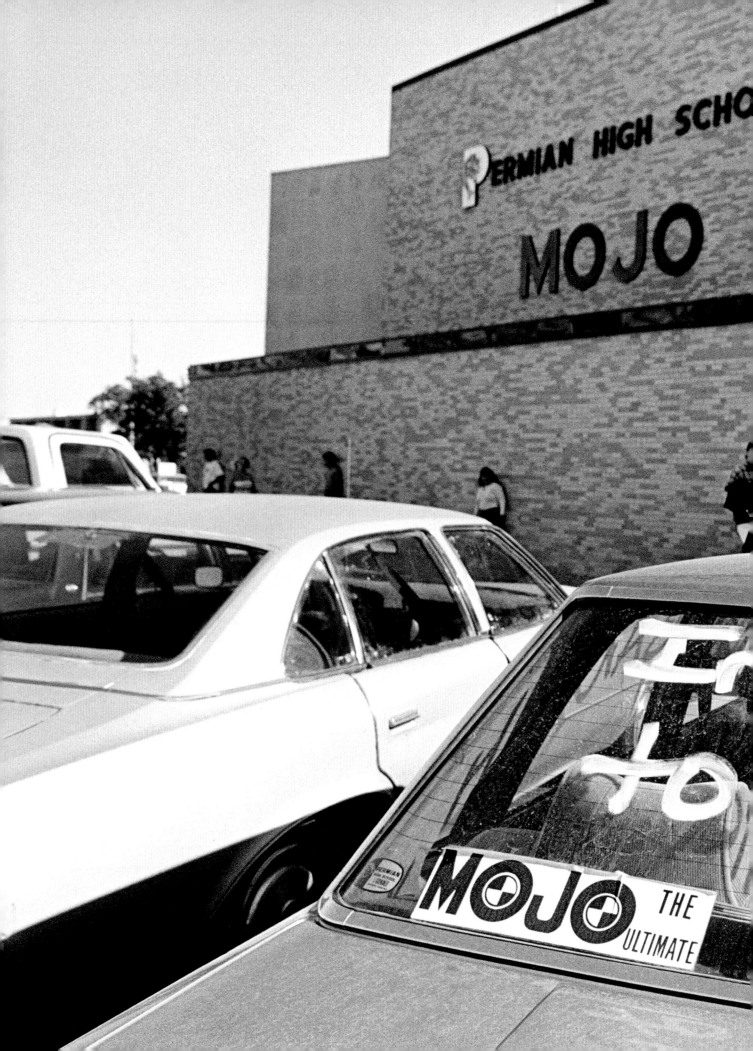

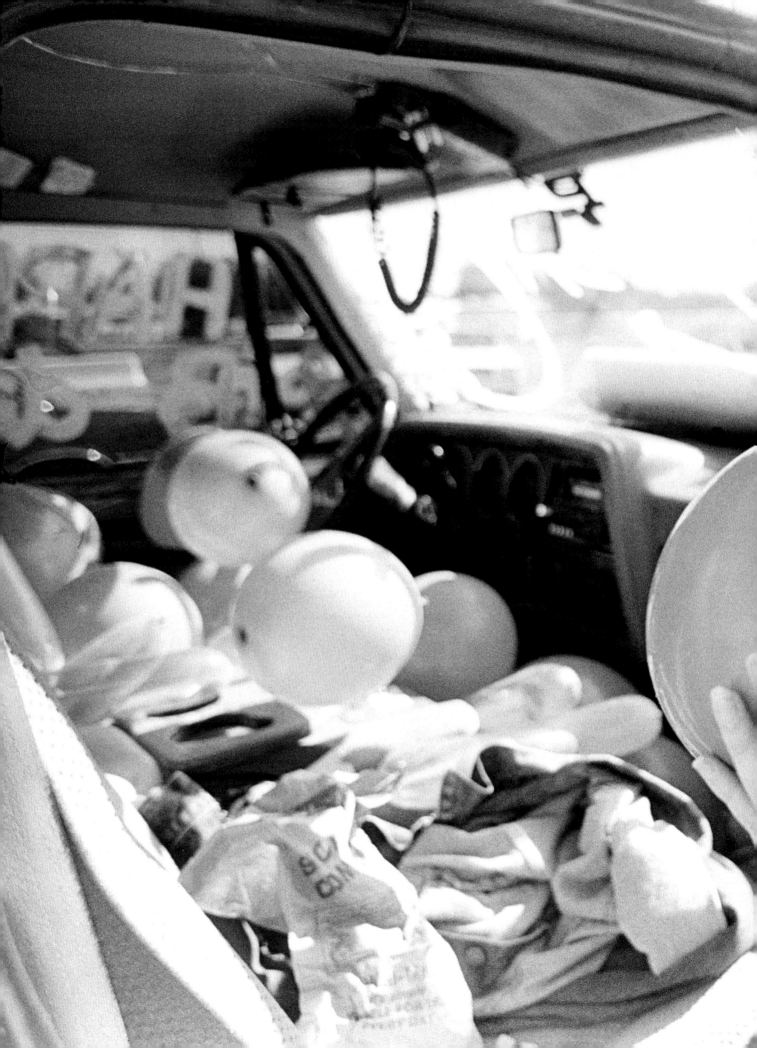

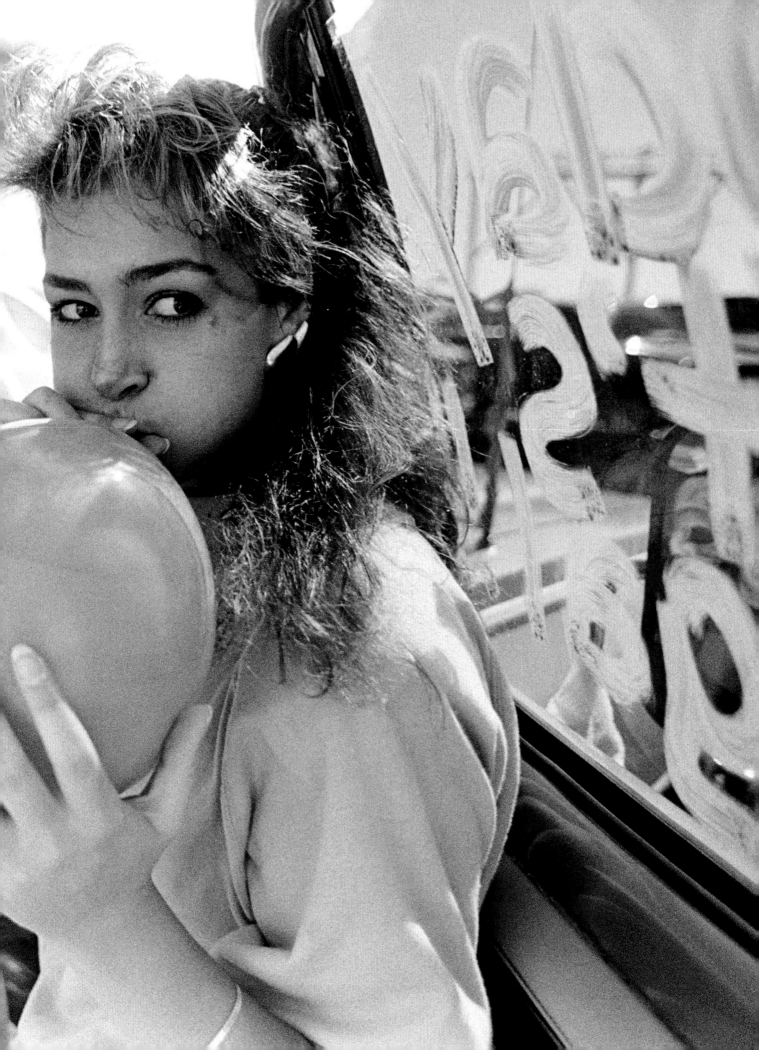

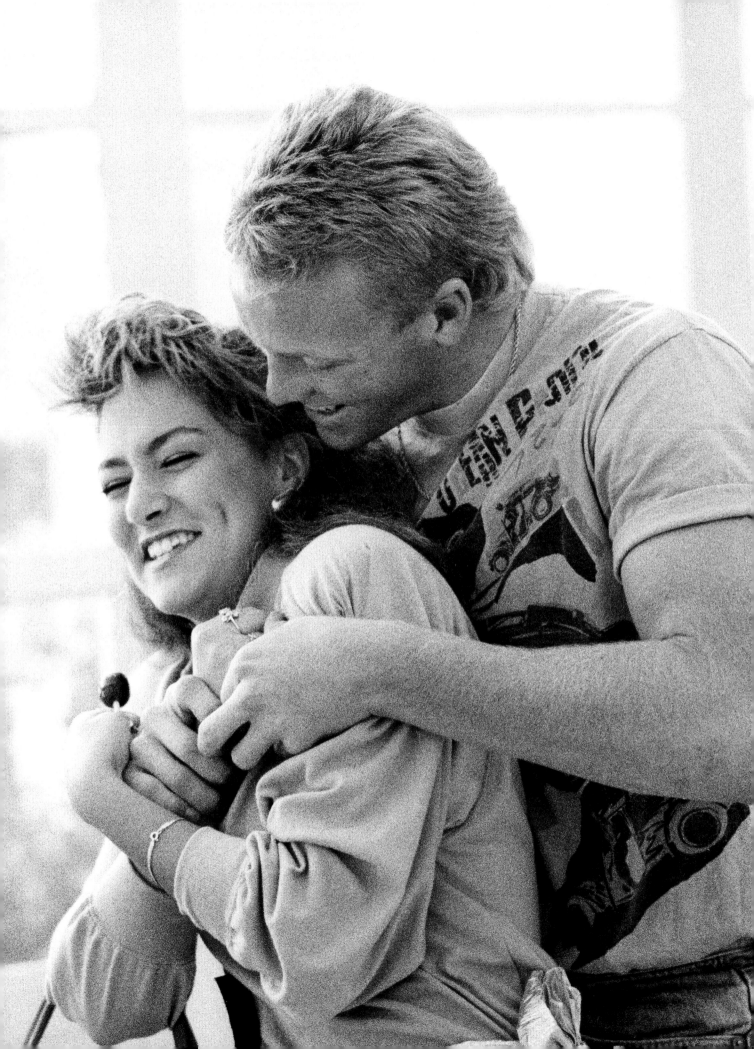

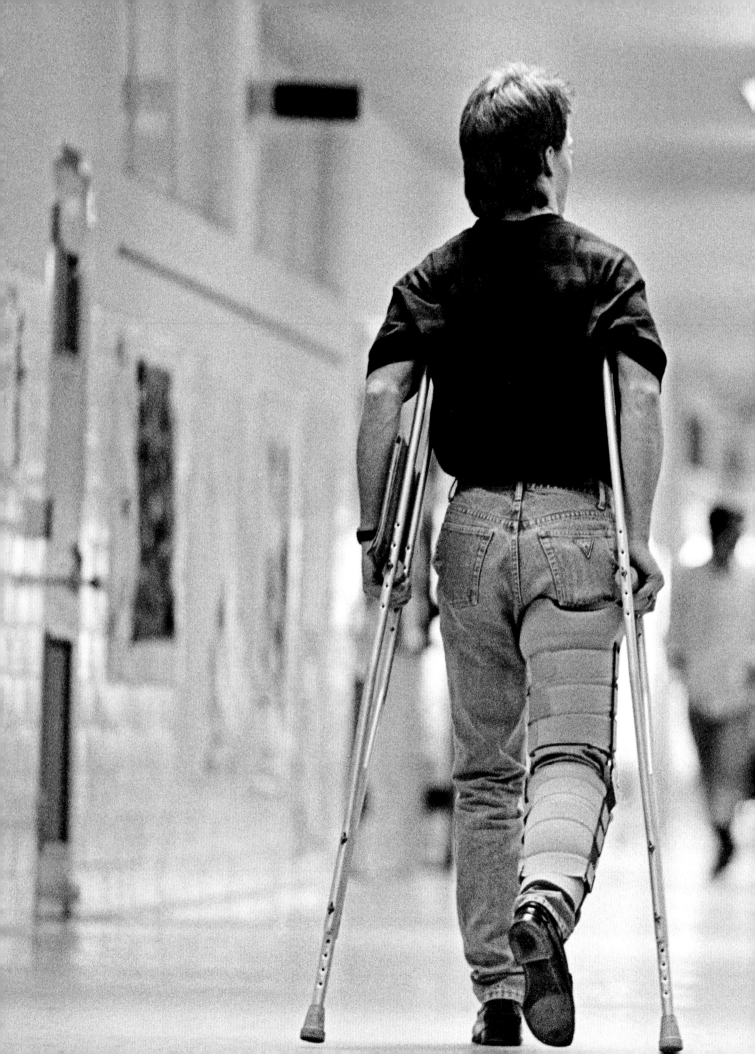

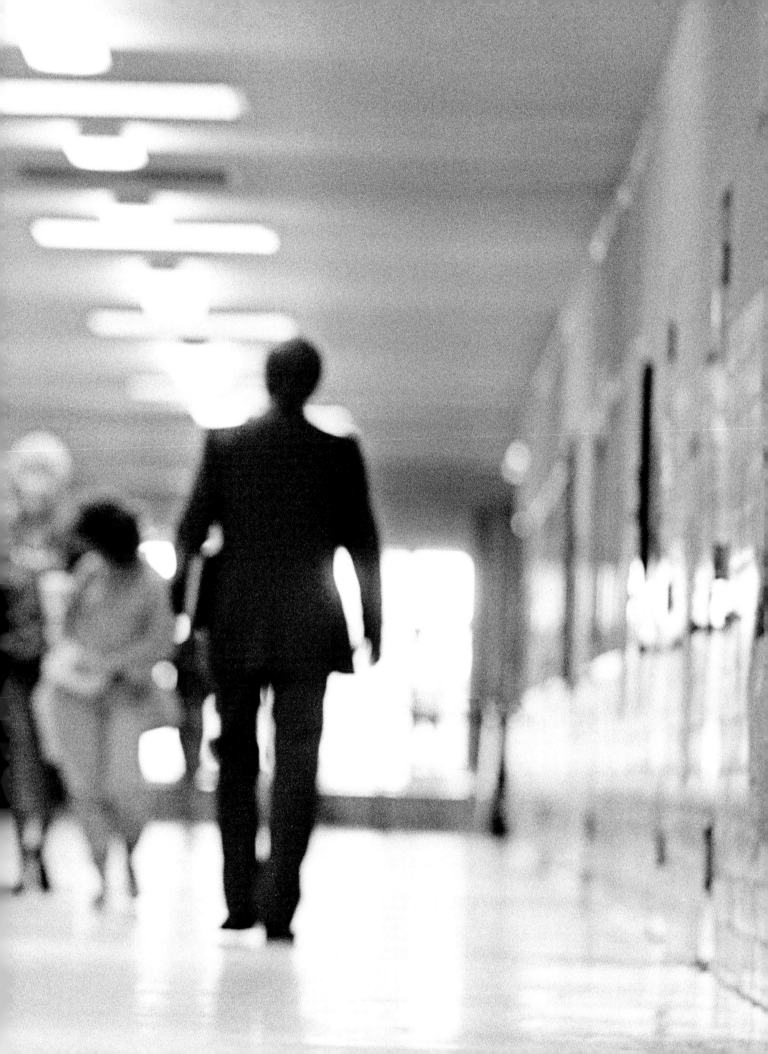

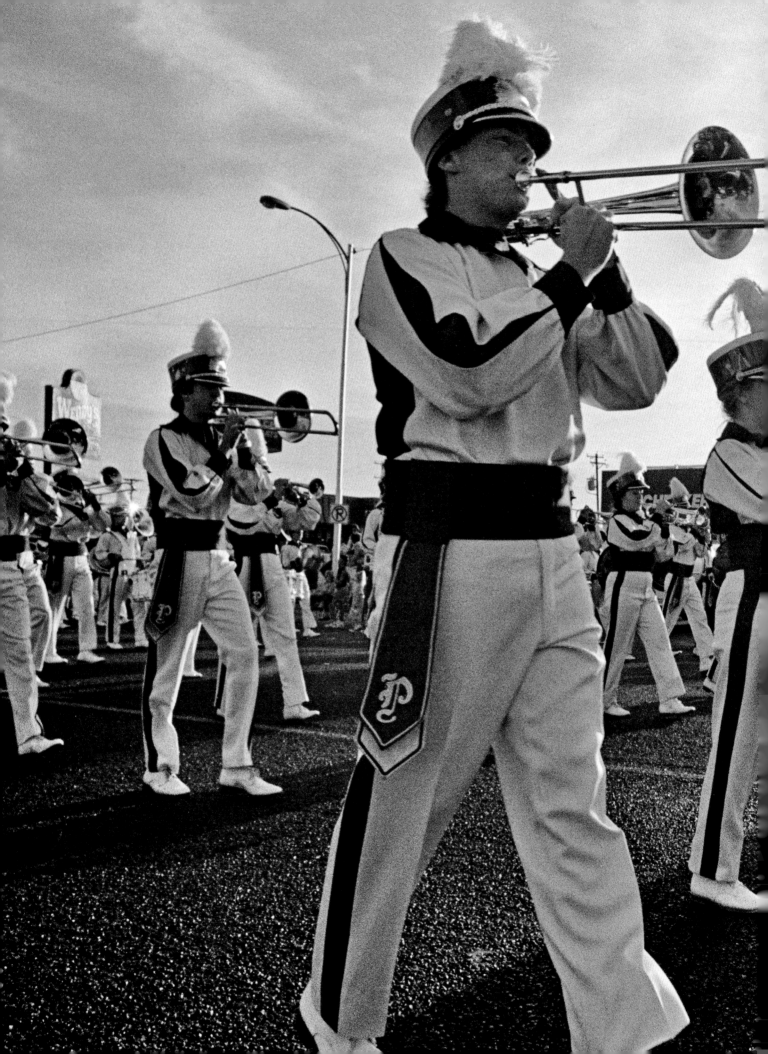

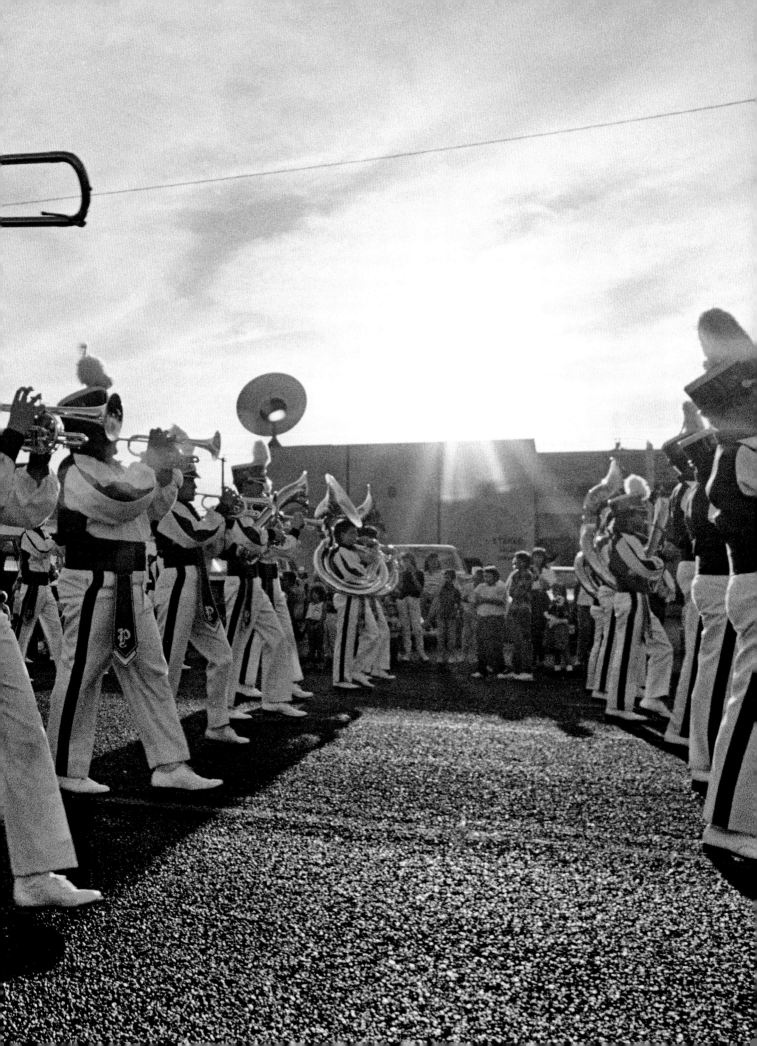

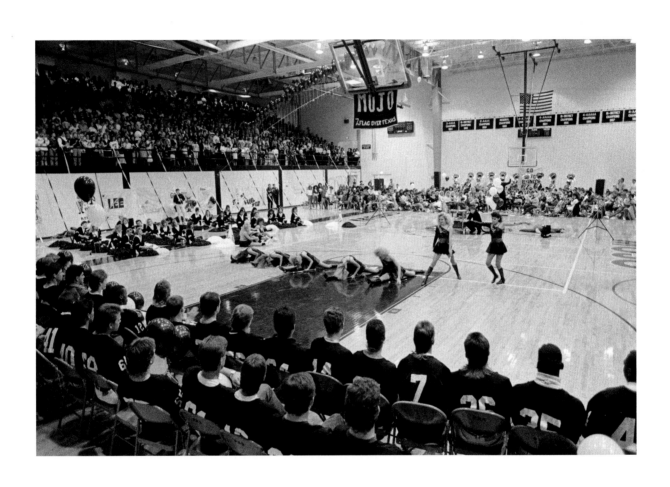

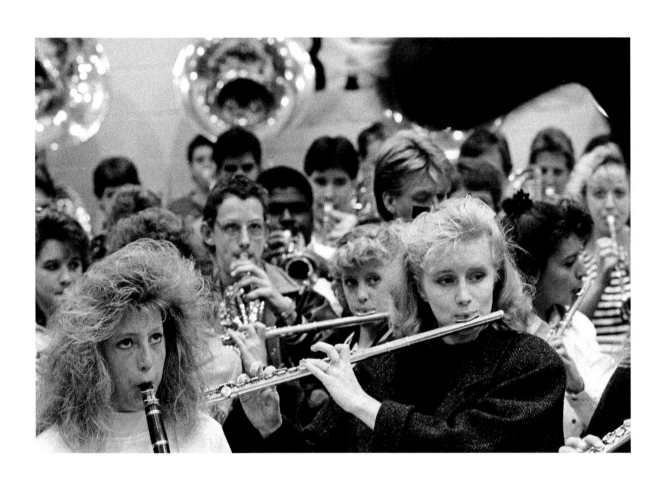

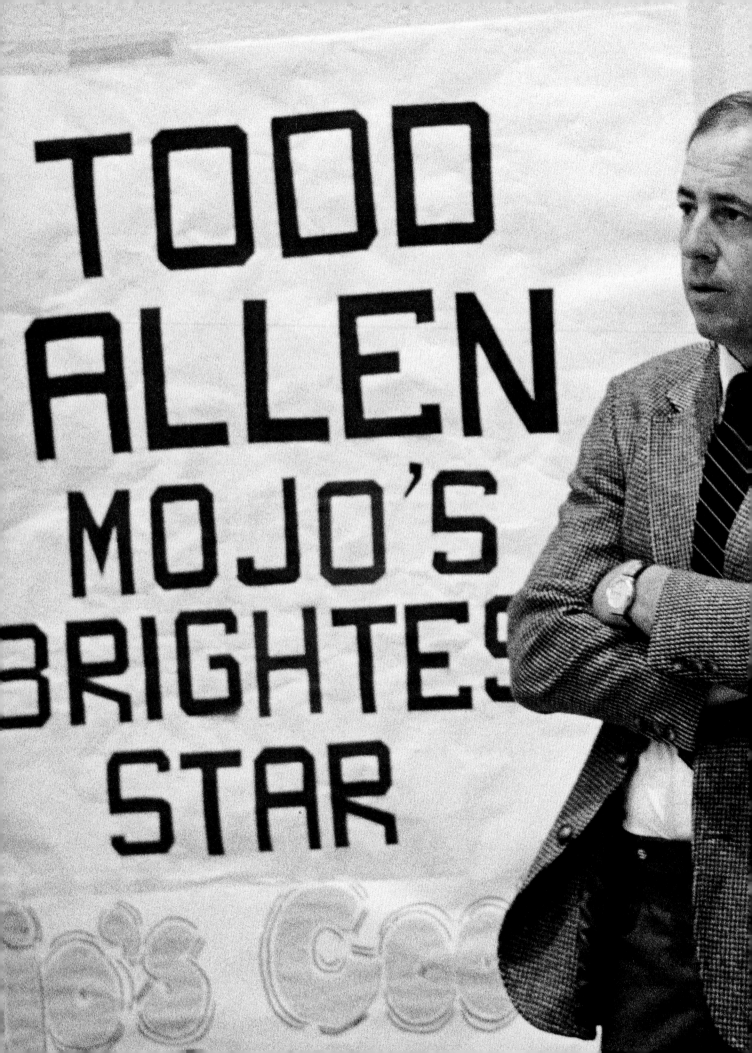

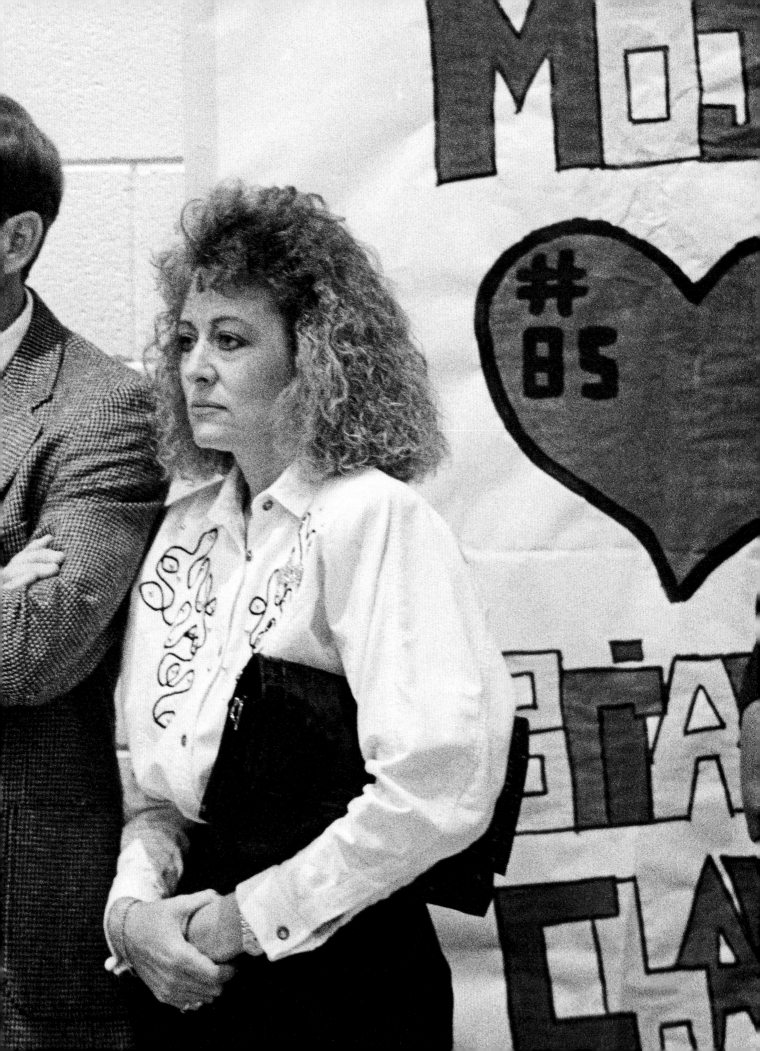

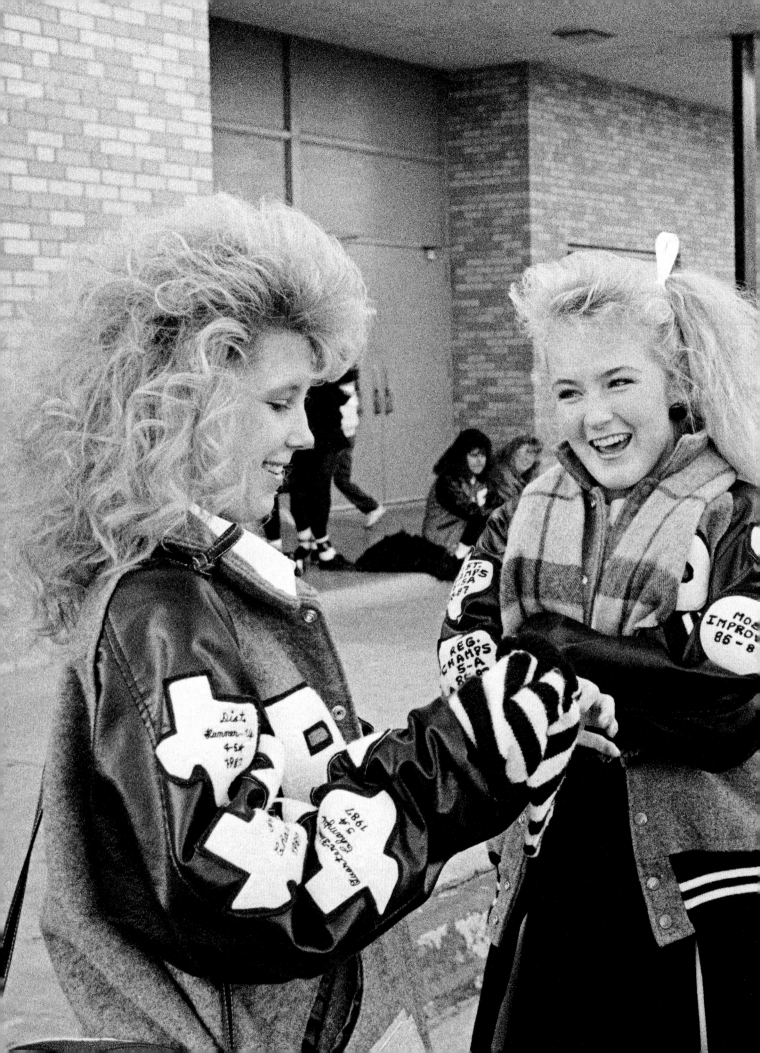

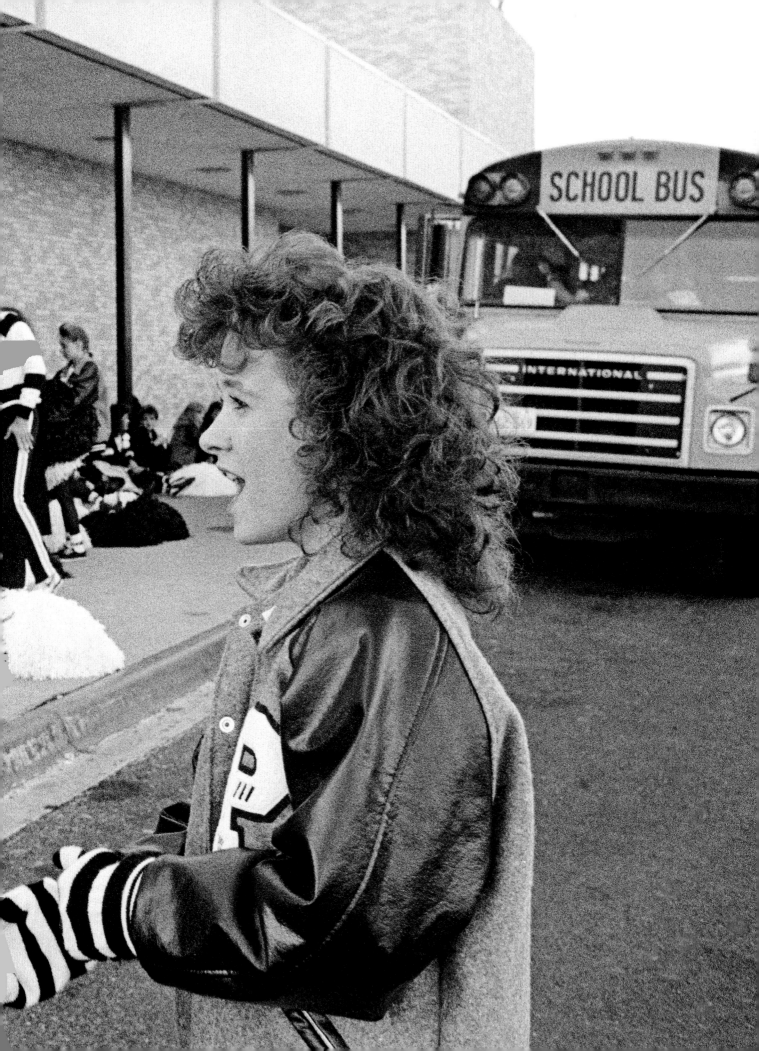

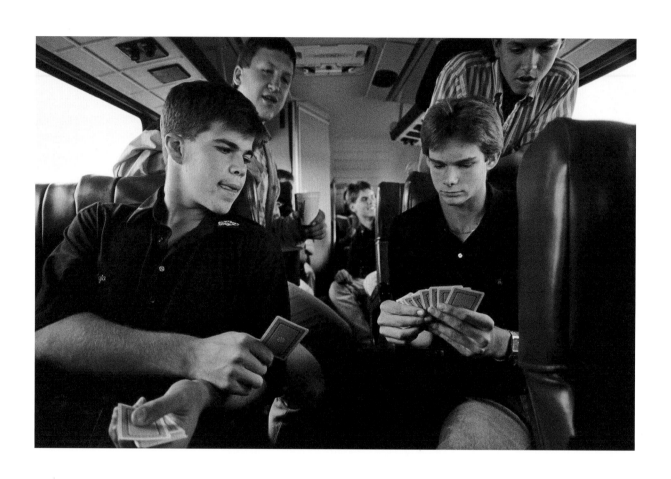

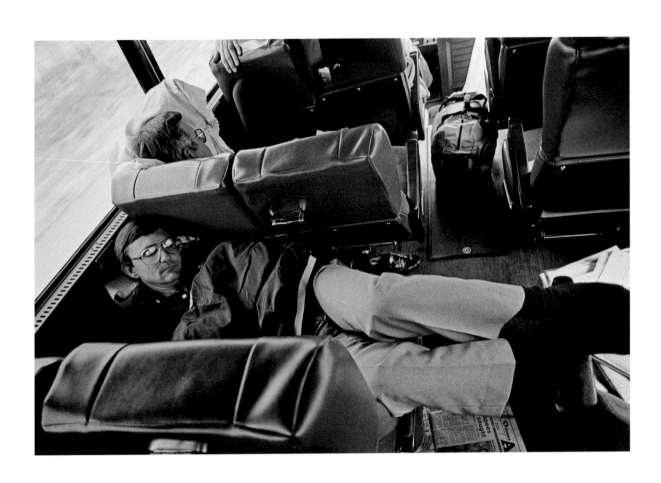

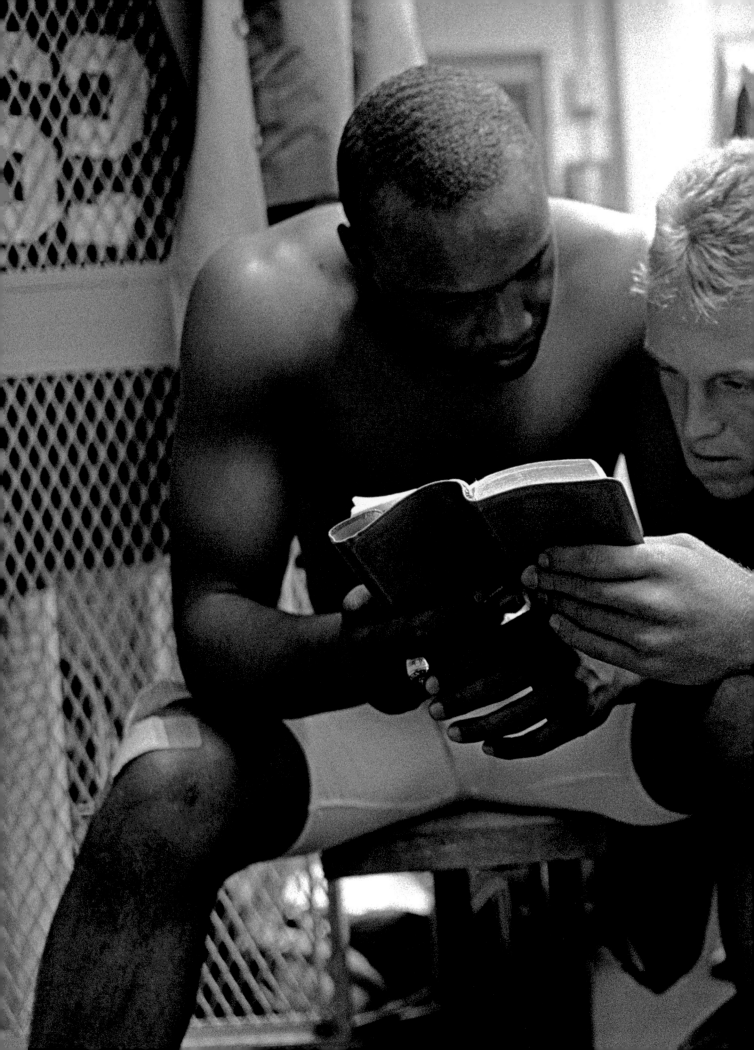

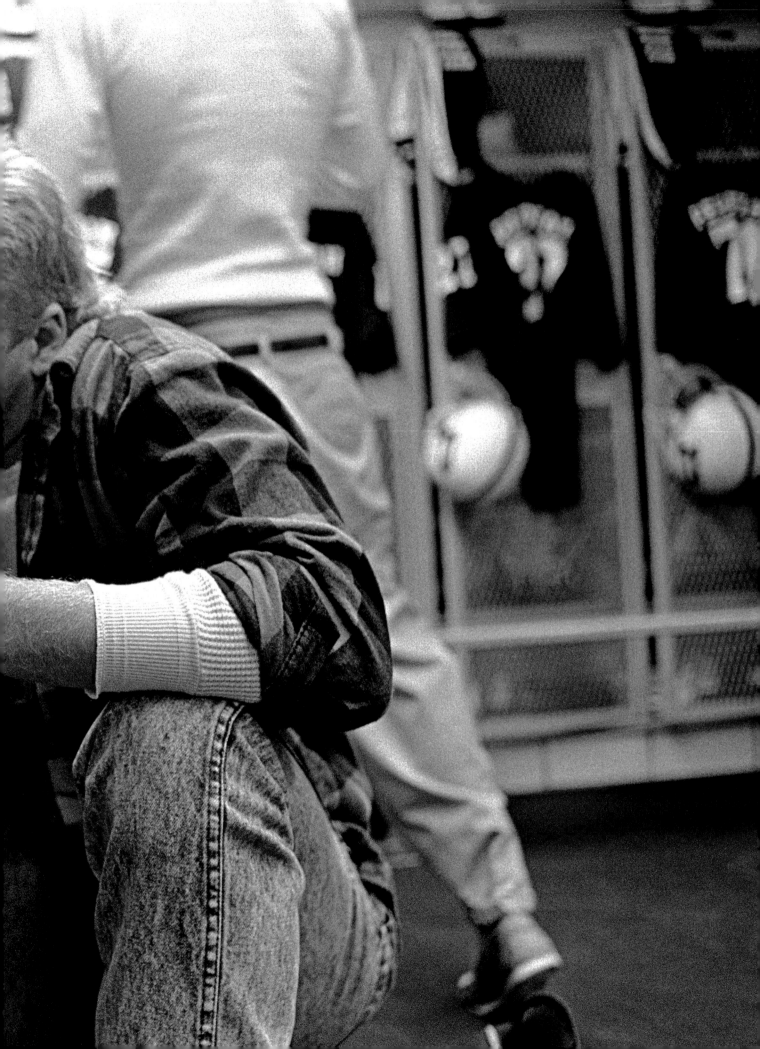

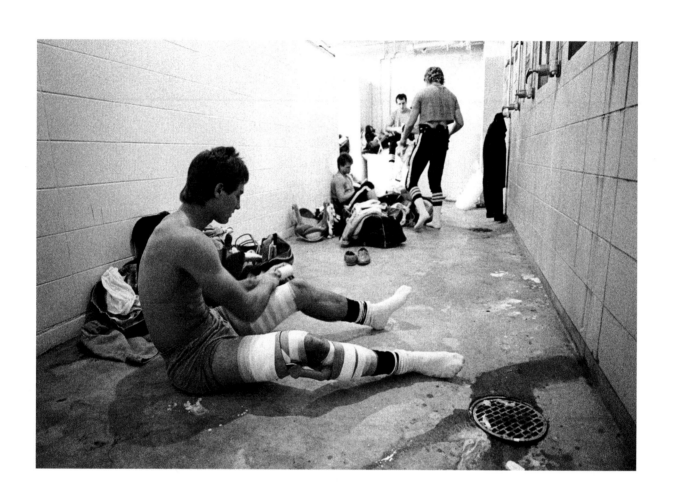

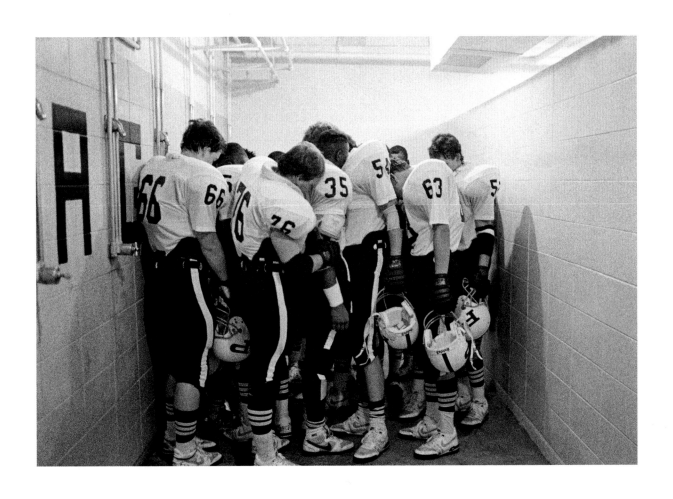

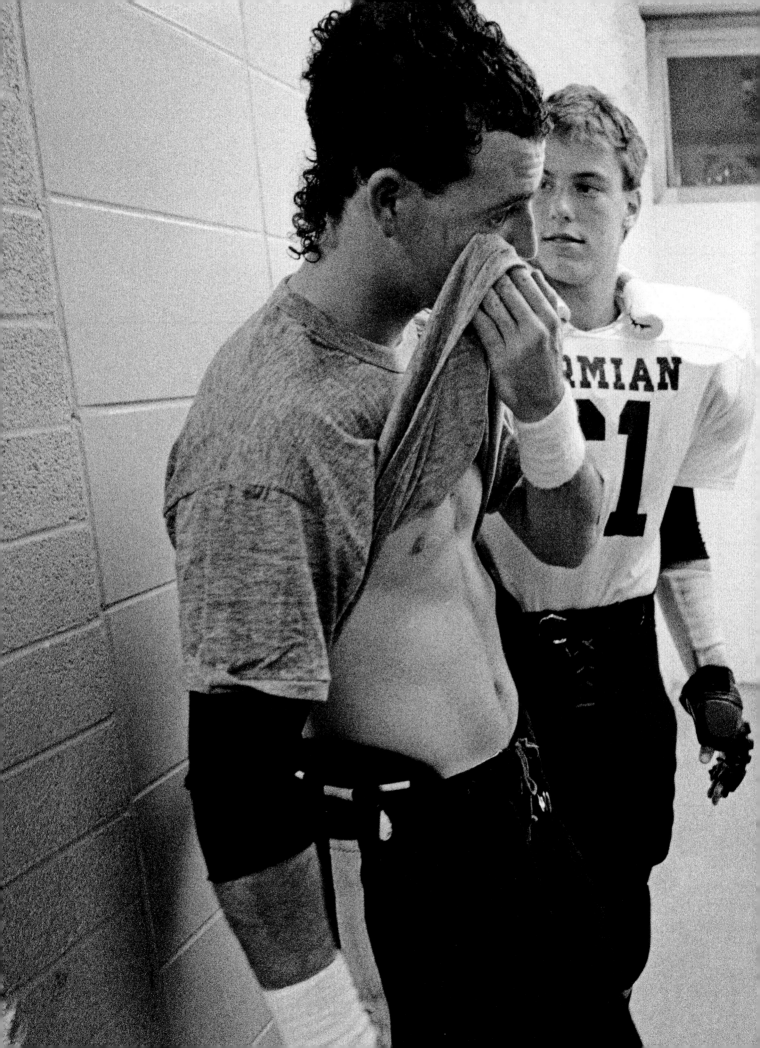

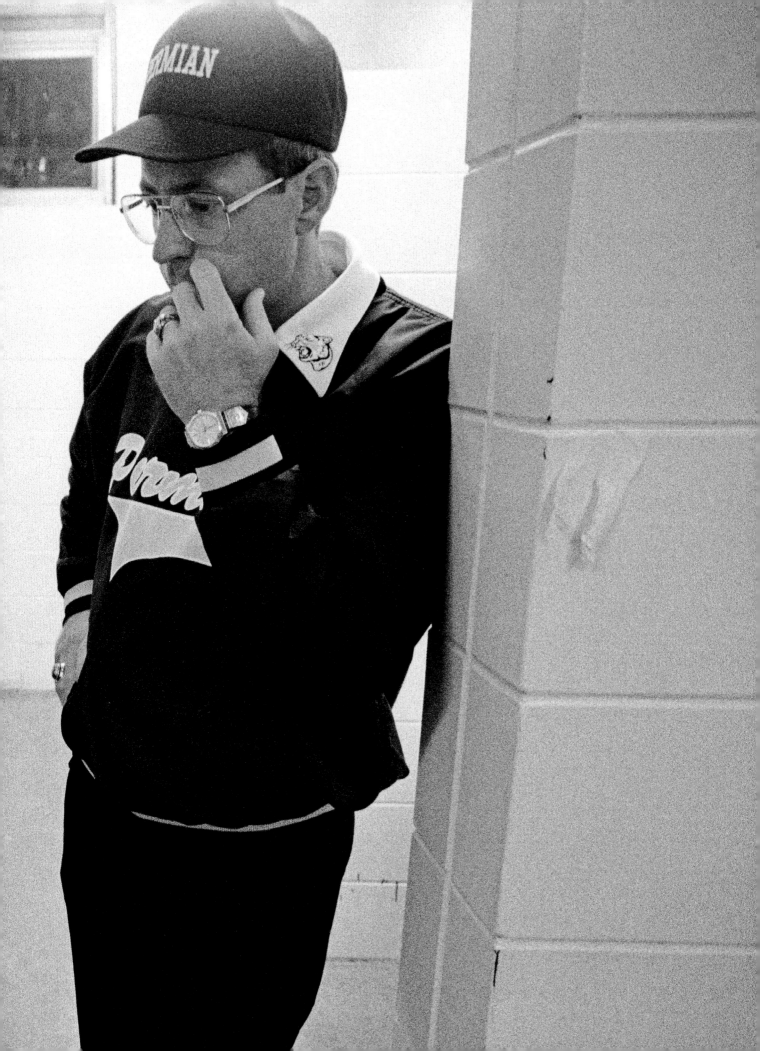

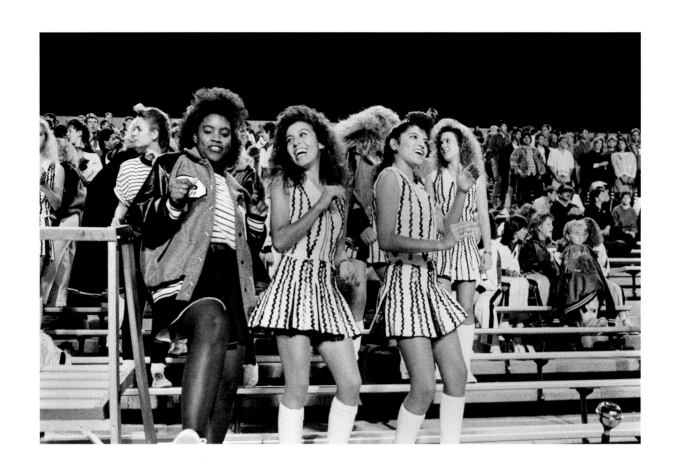

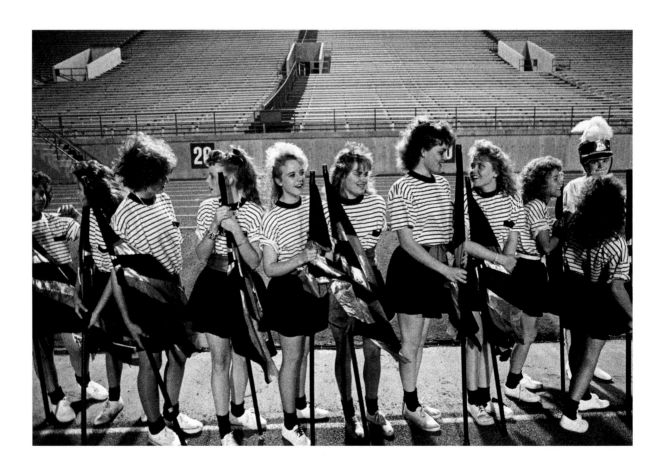

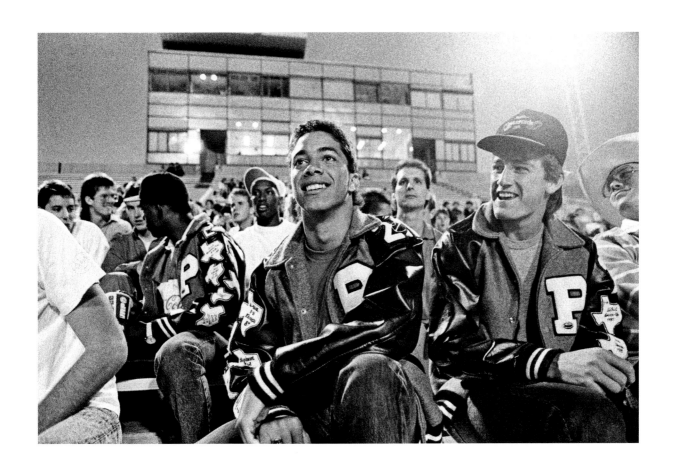

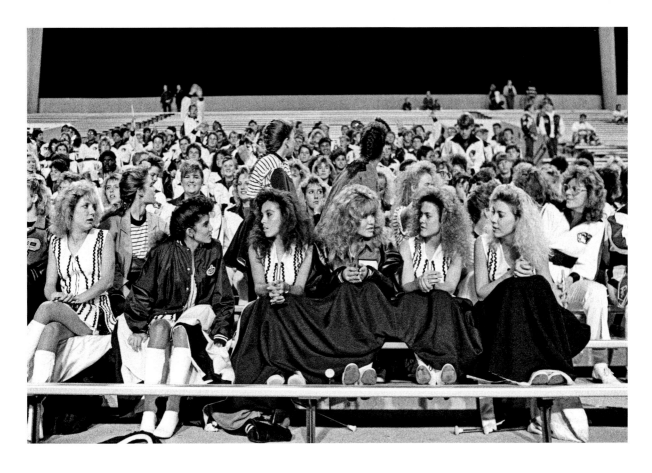

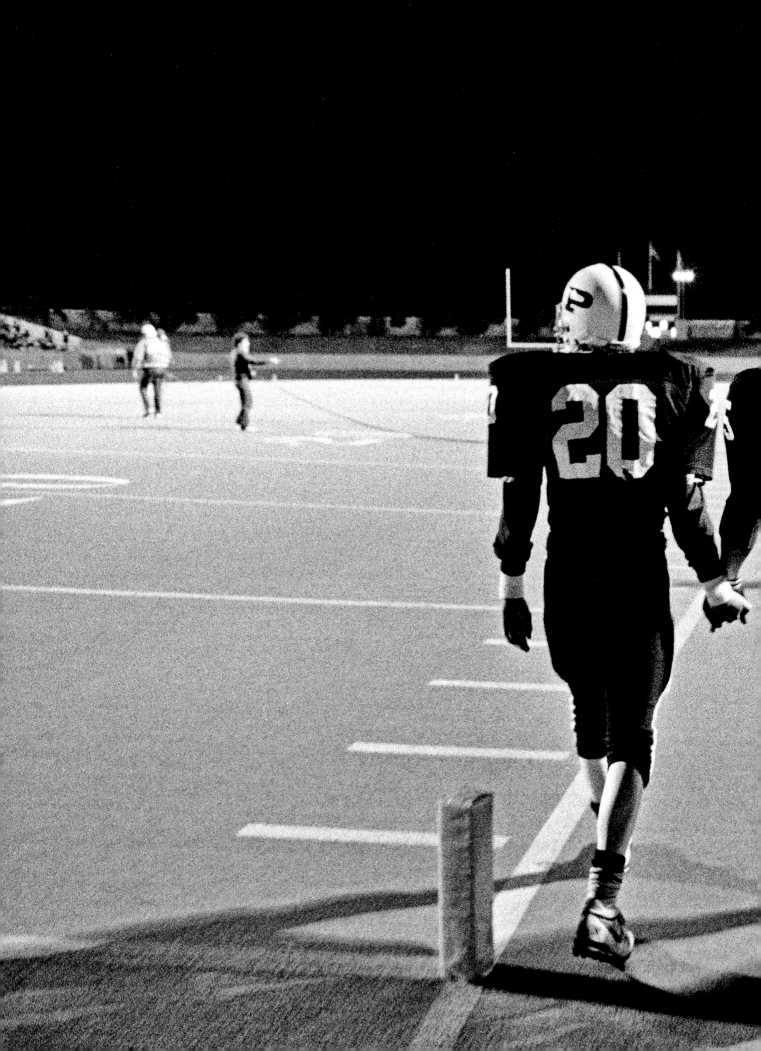

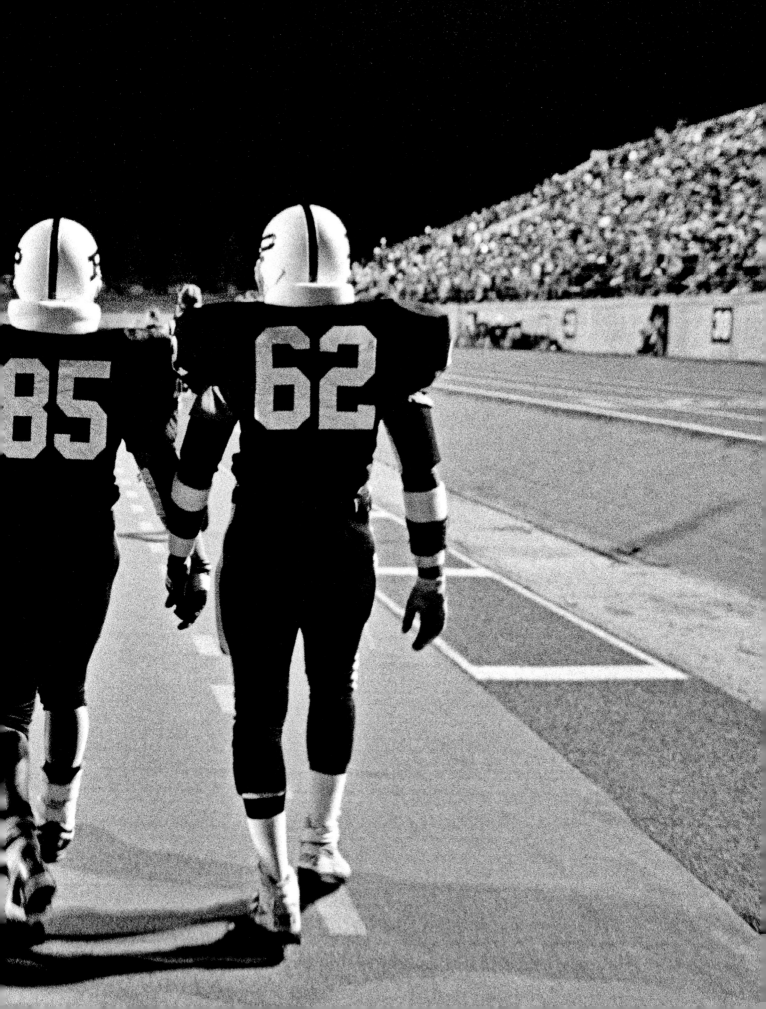

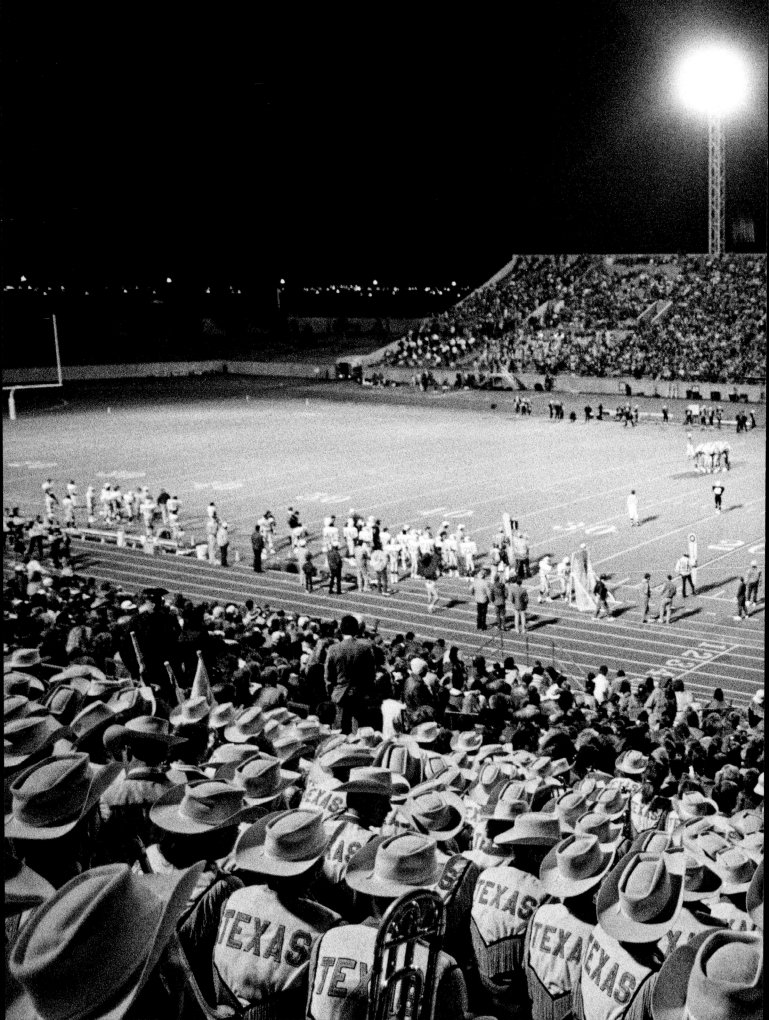

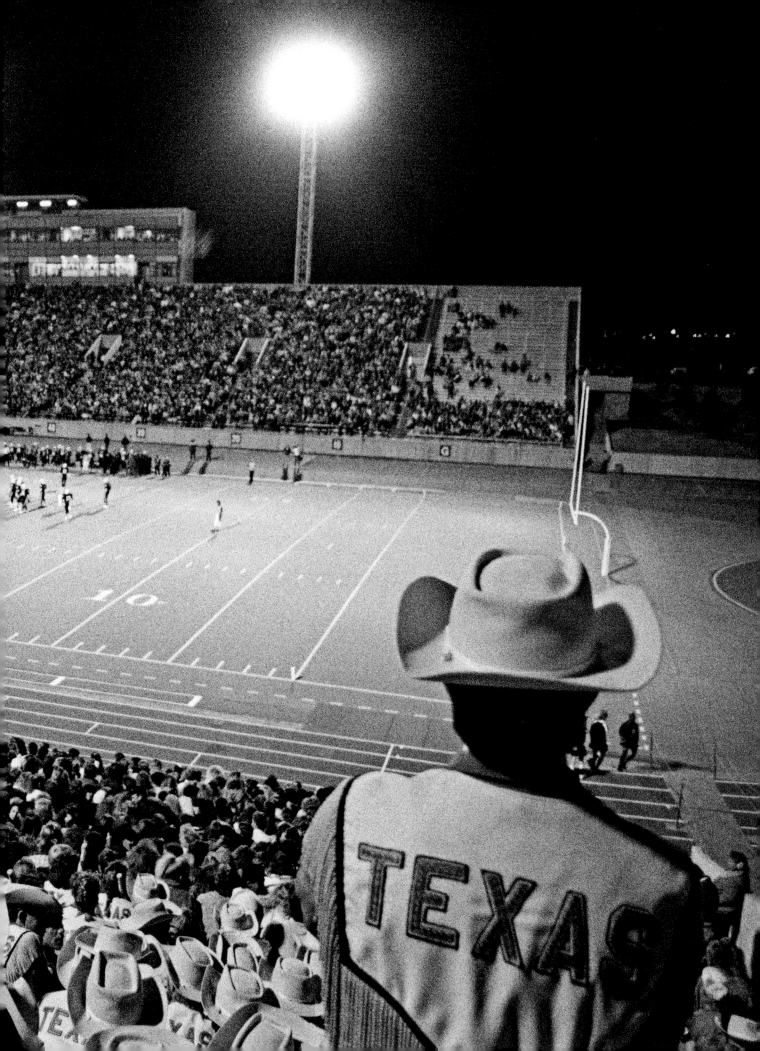

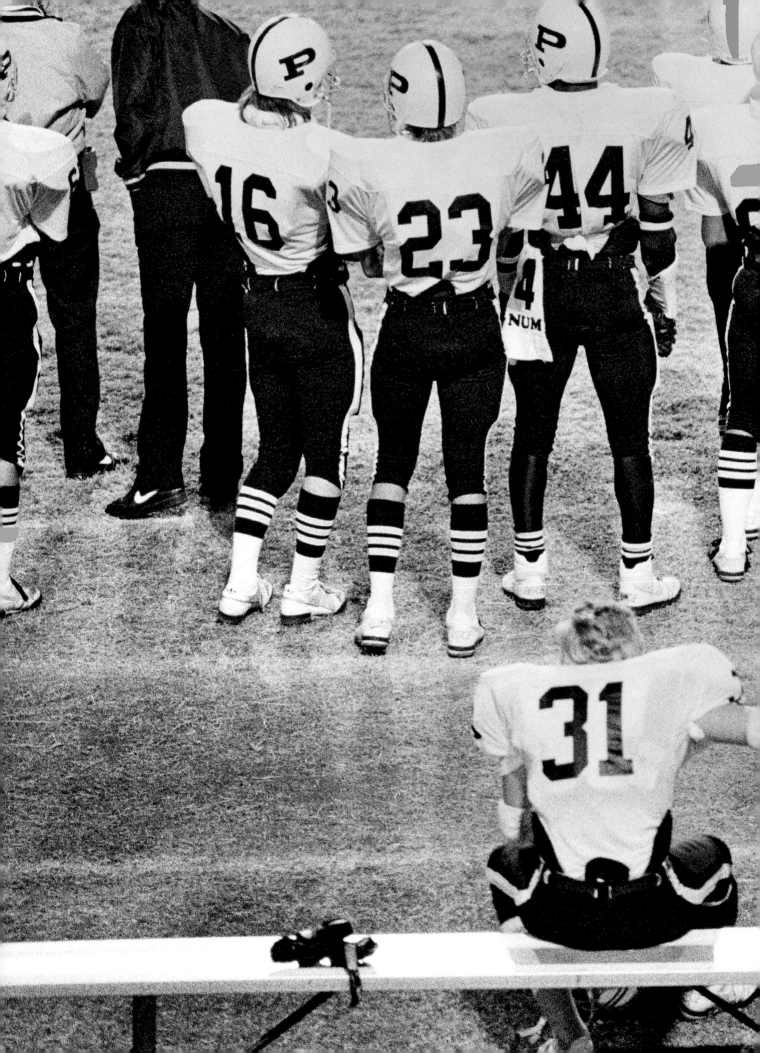

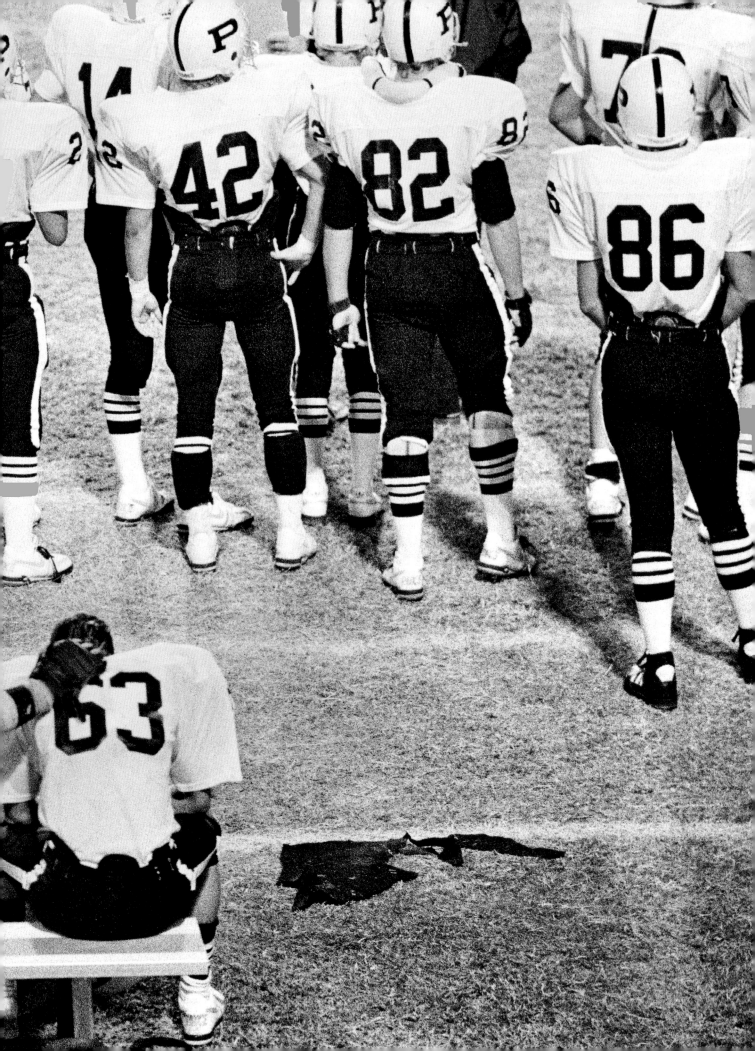

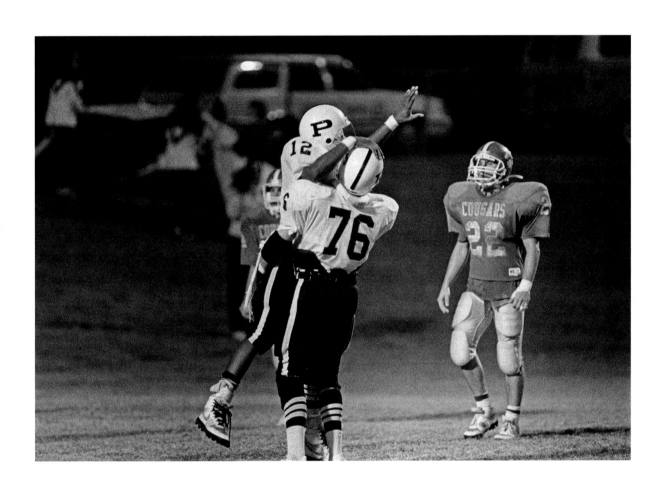

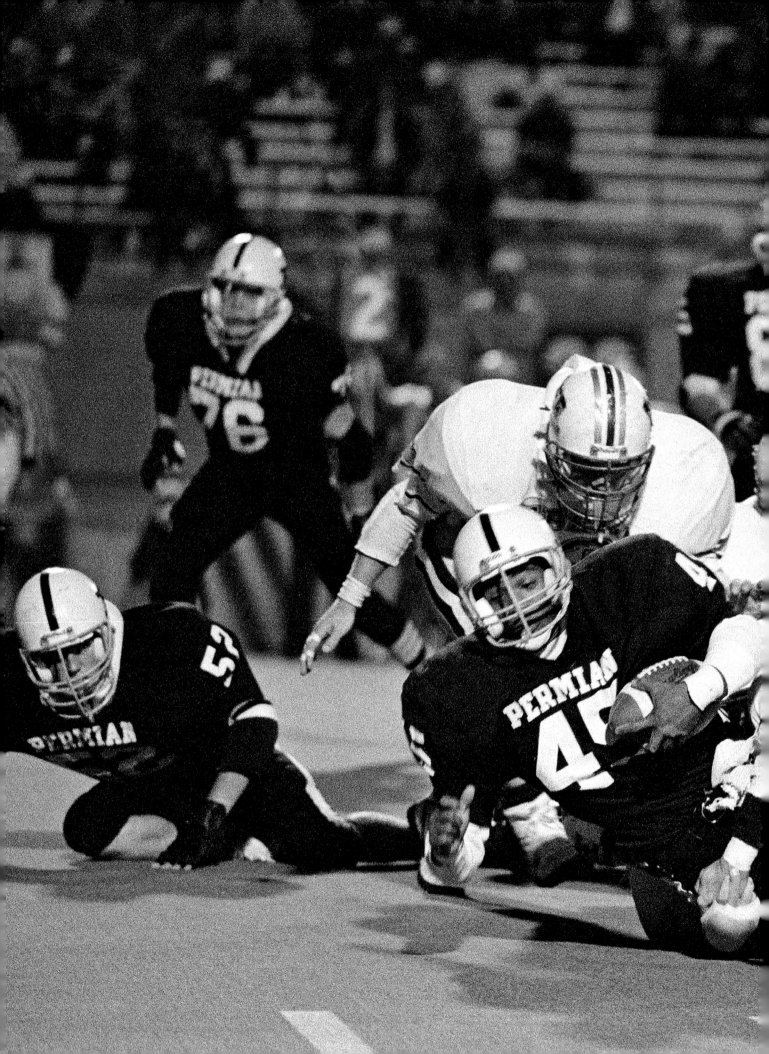

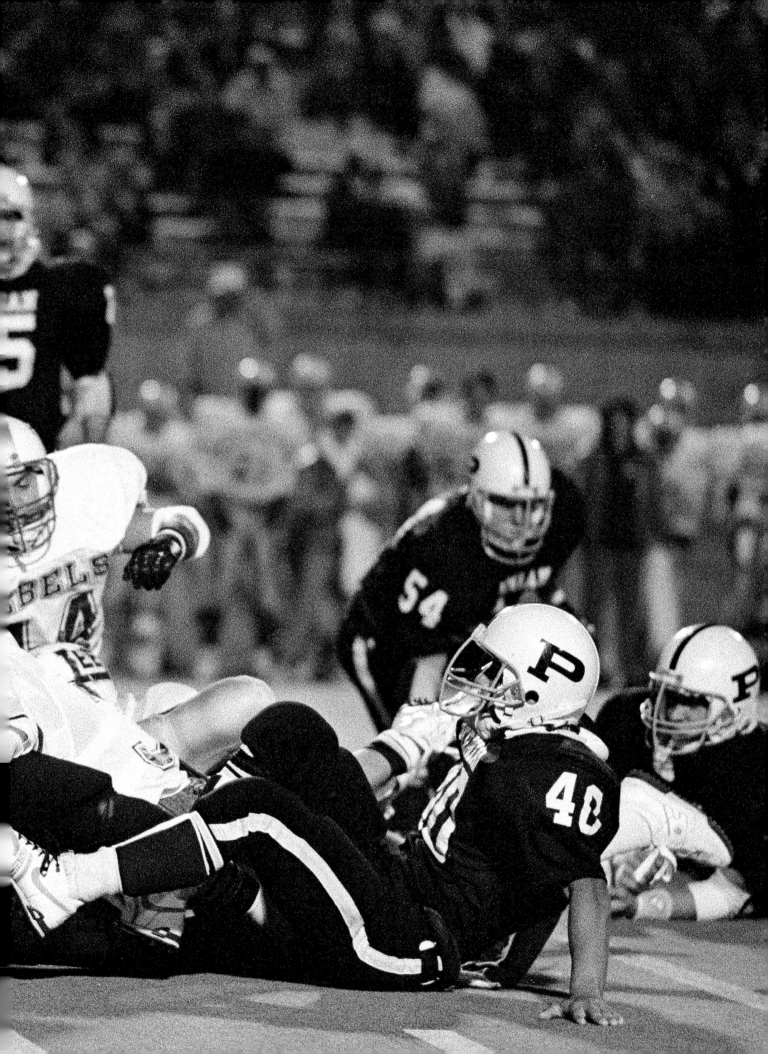

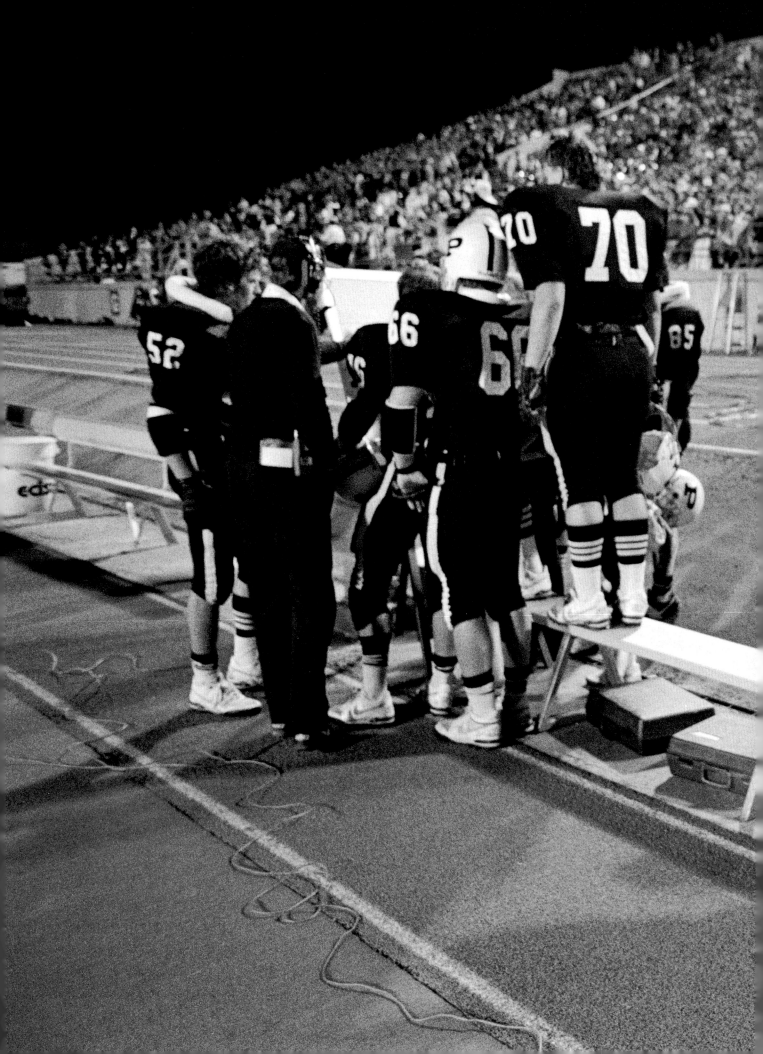

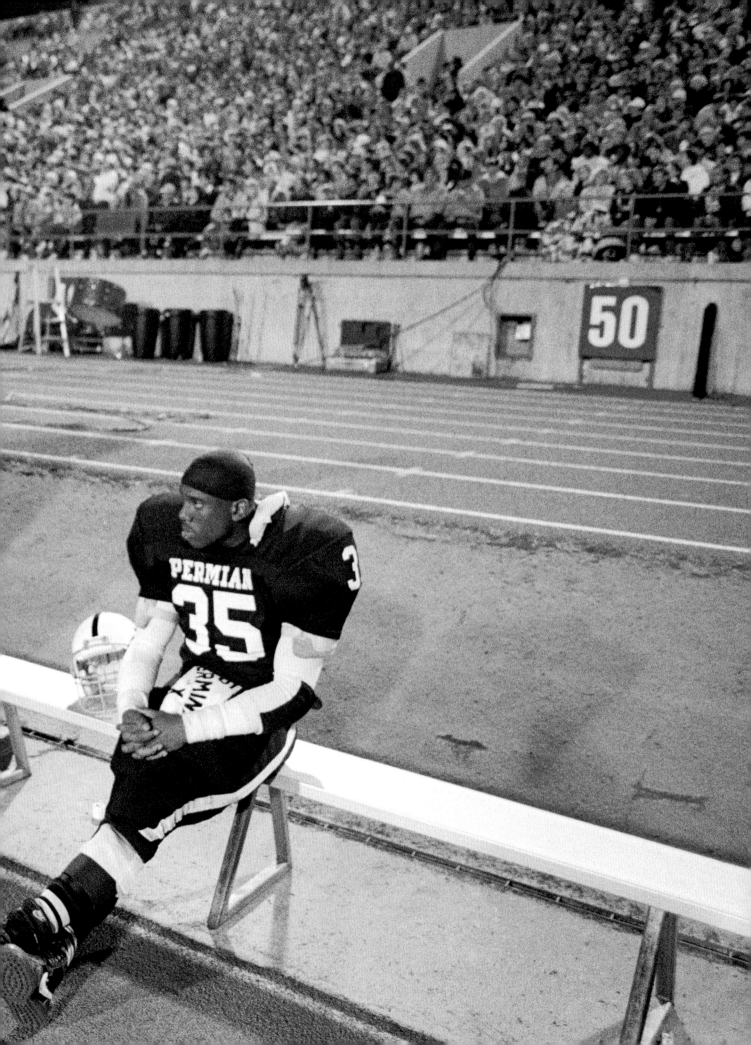

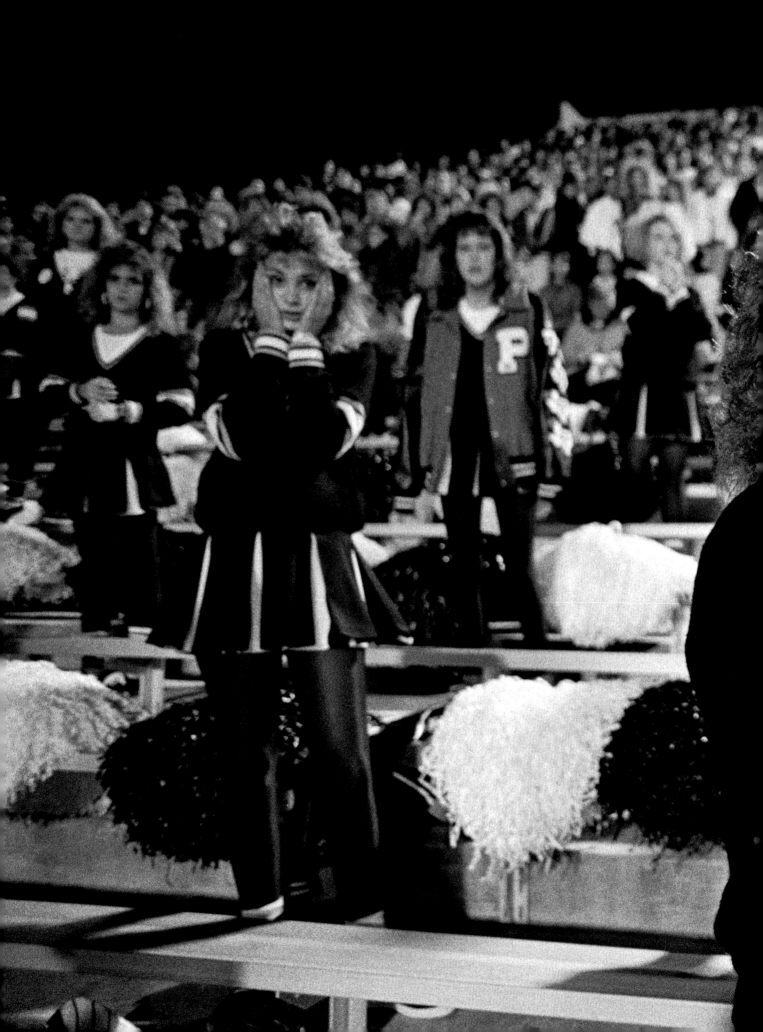

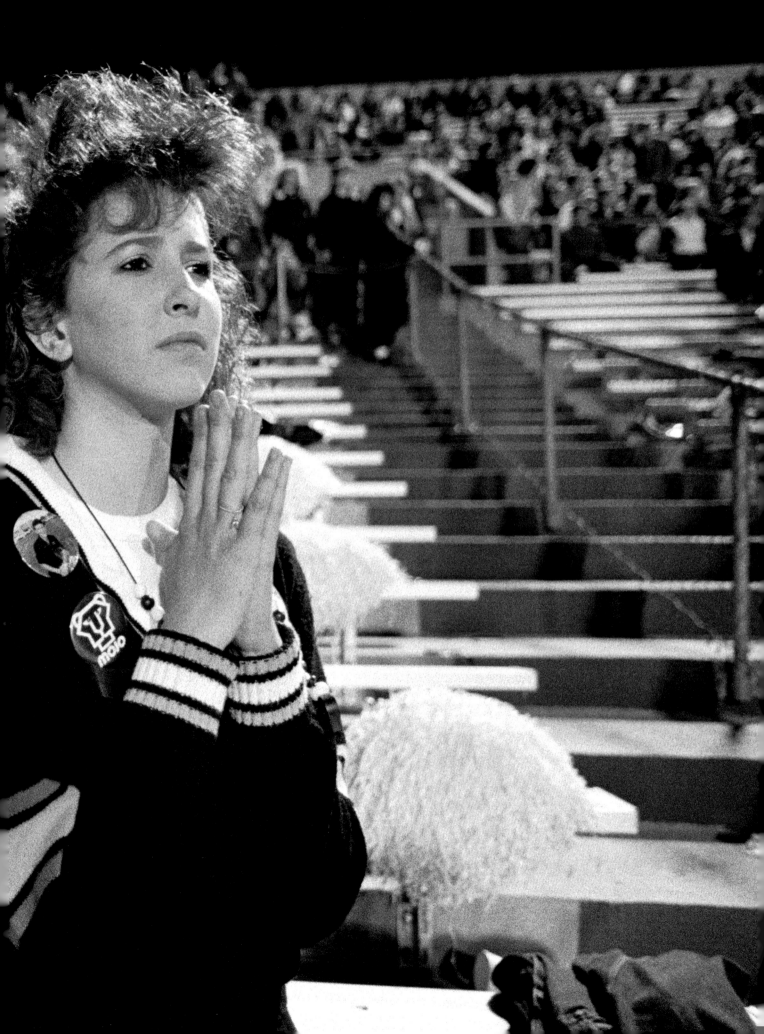

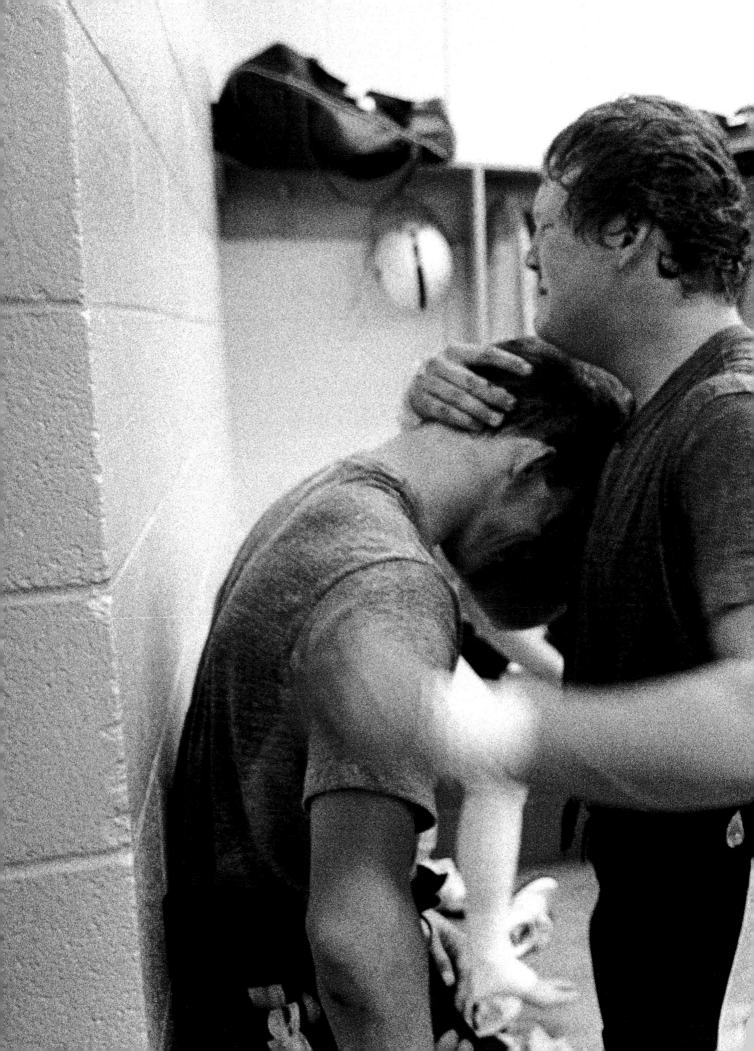

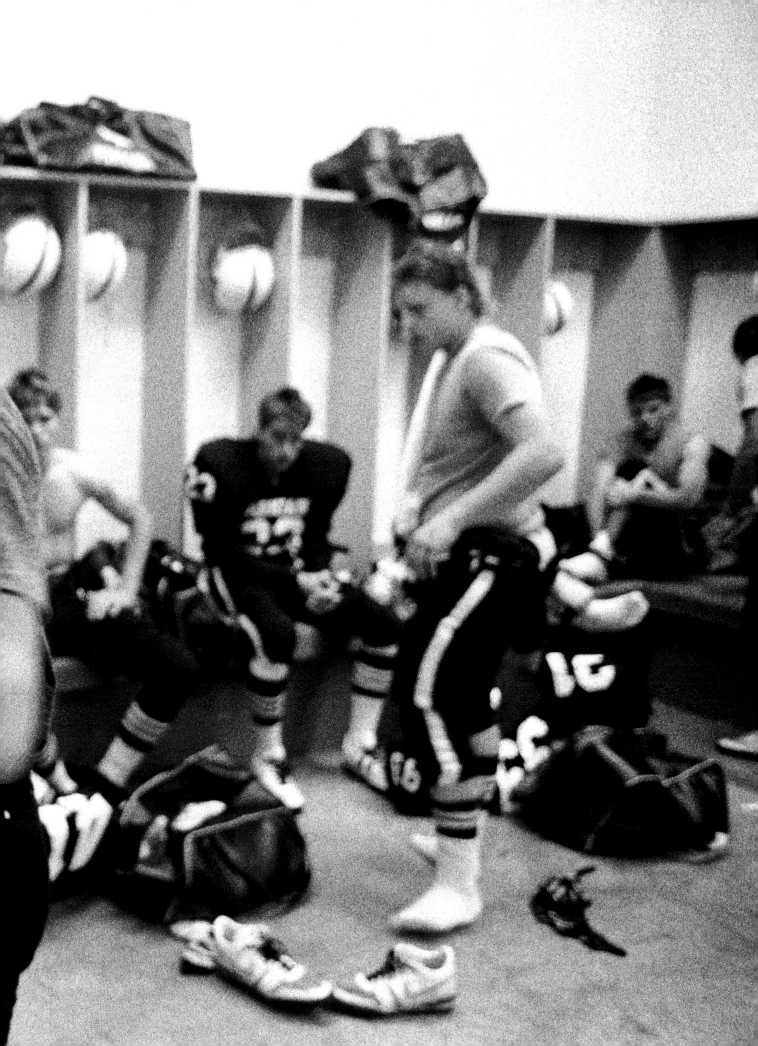

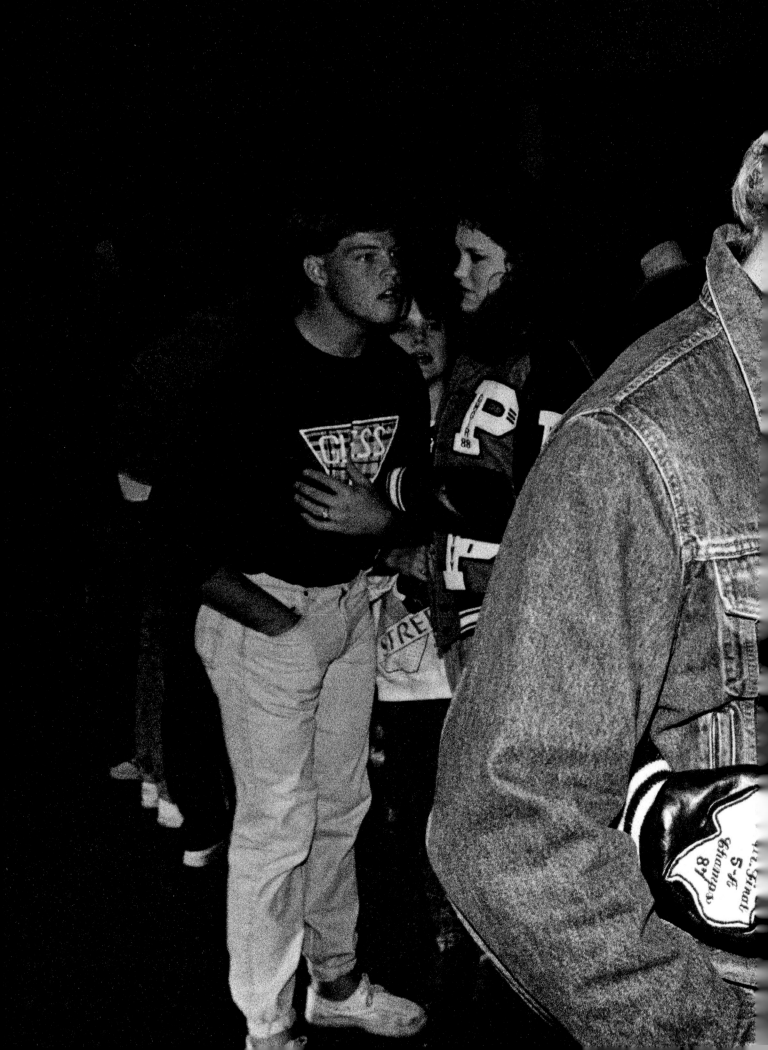

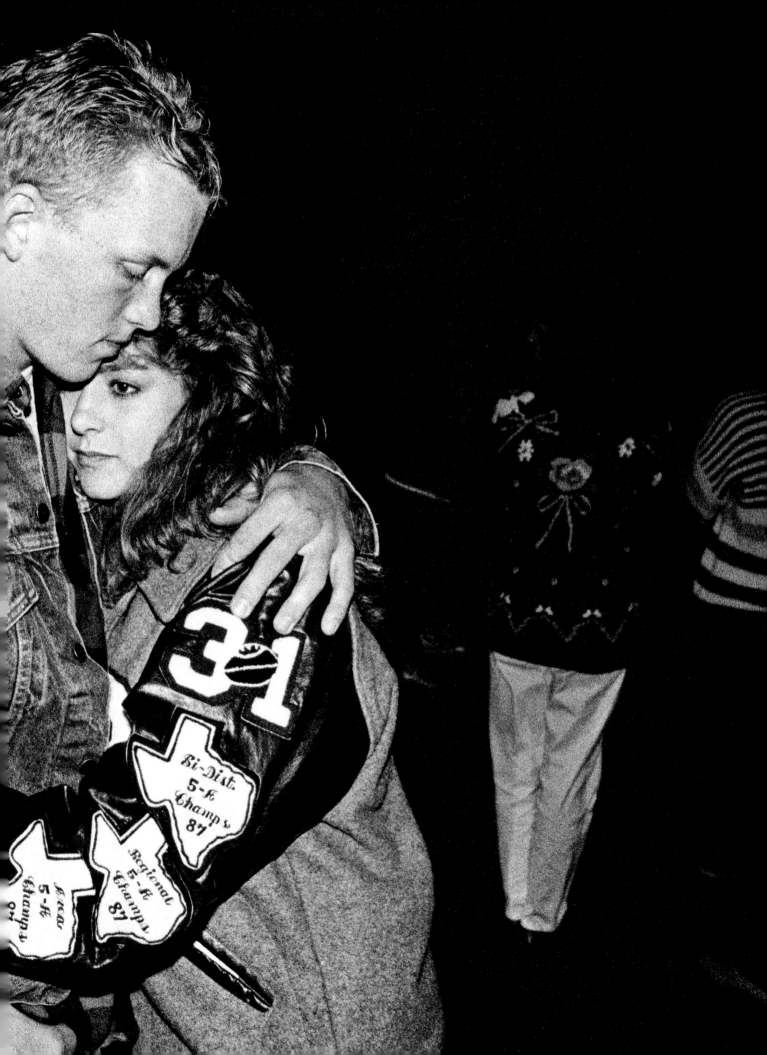

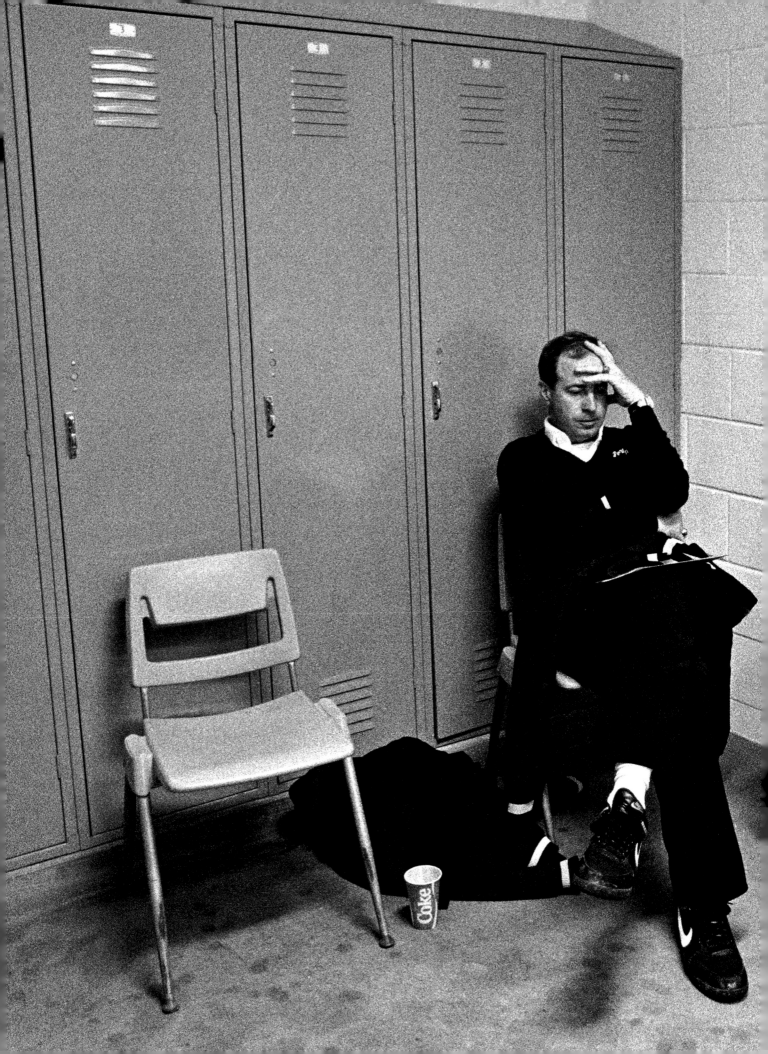

MIKE WINCHELL

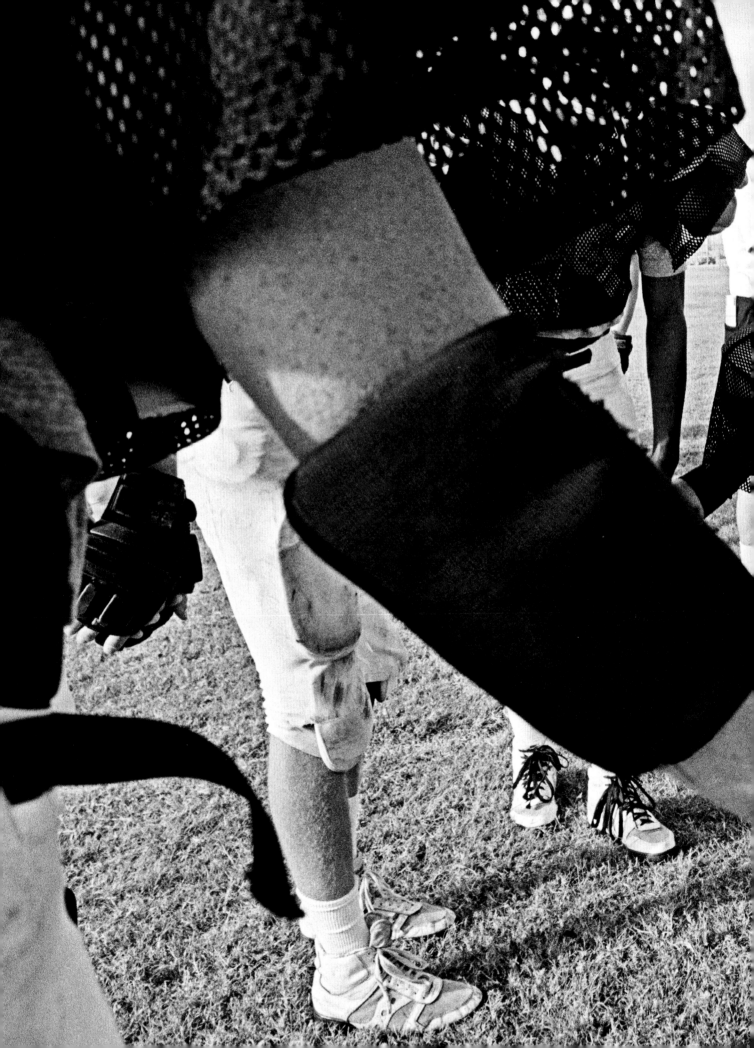

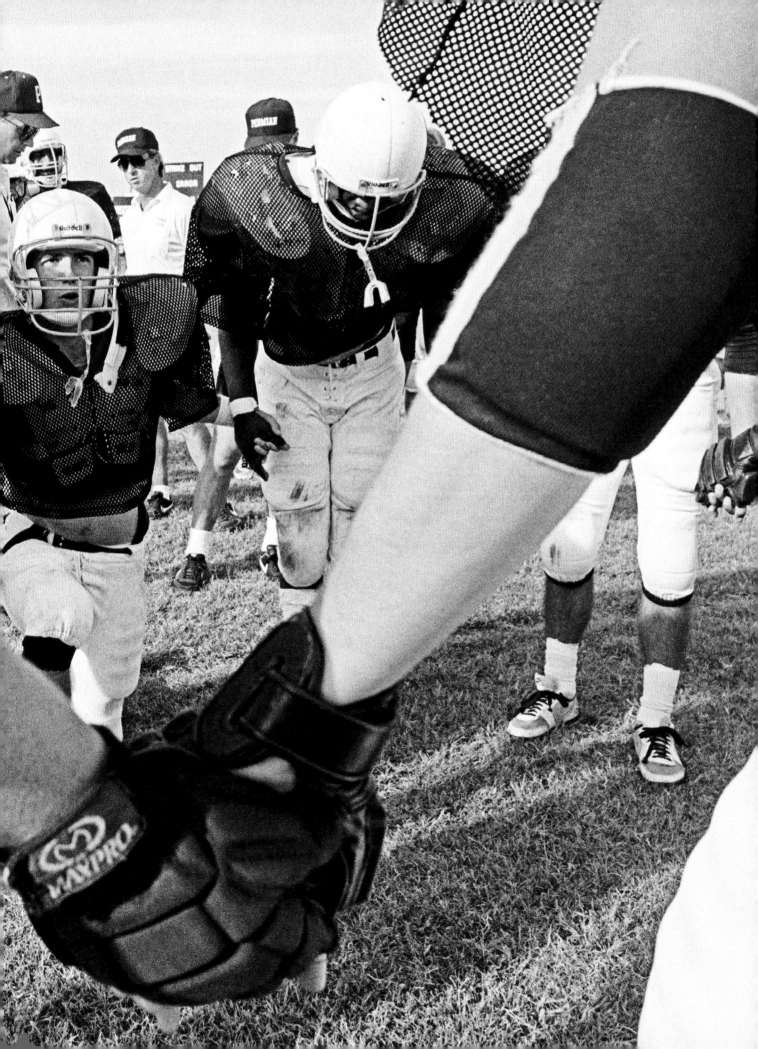

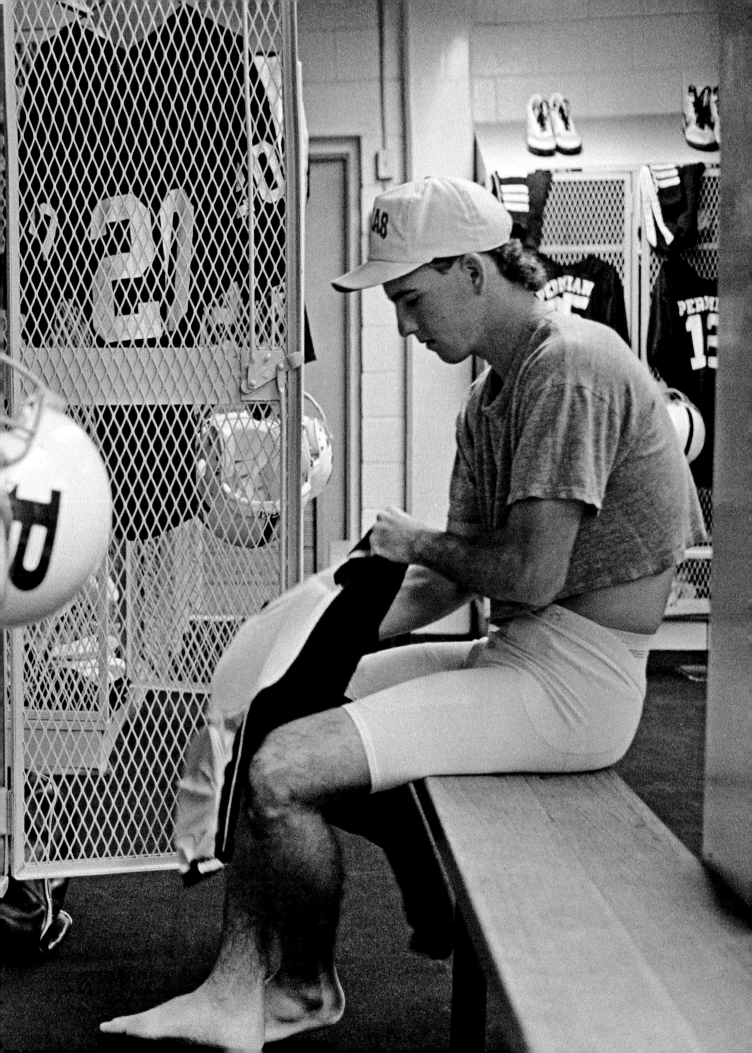

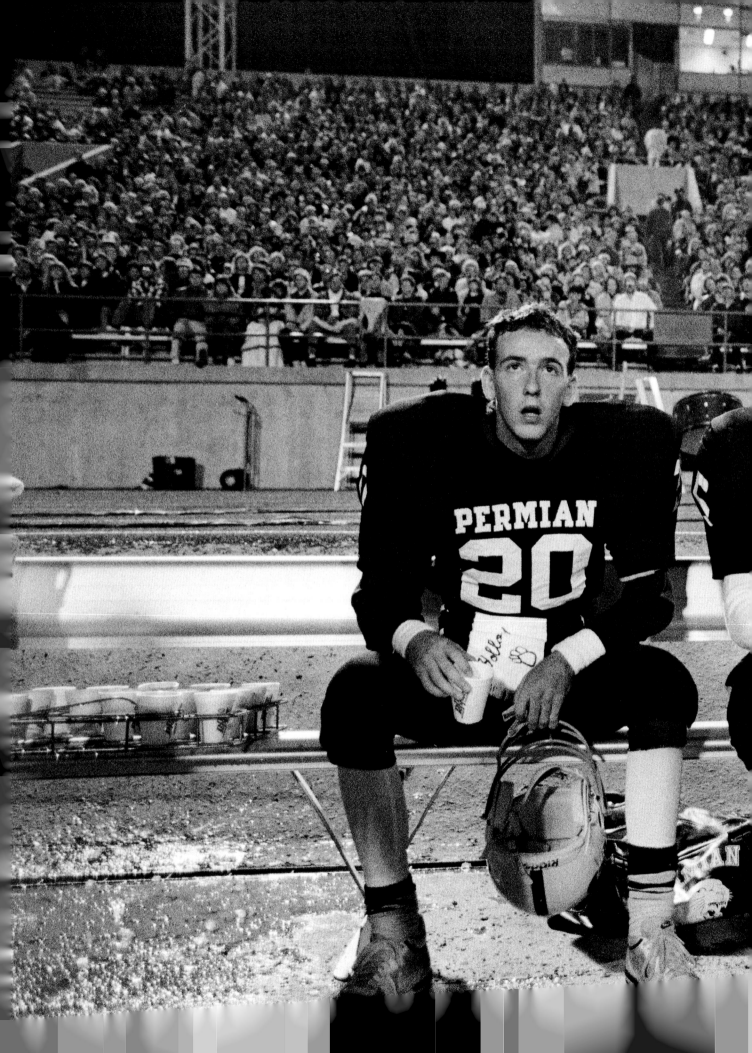

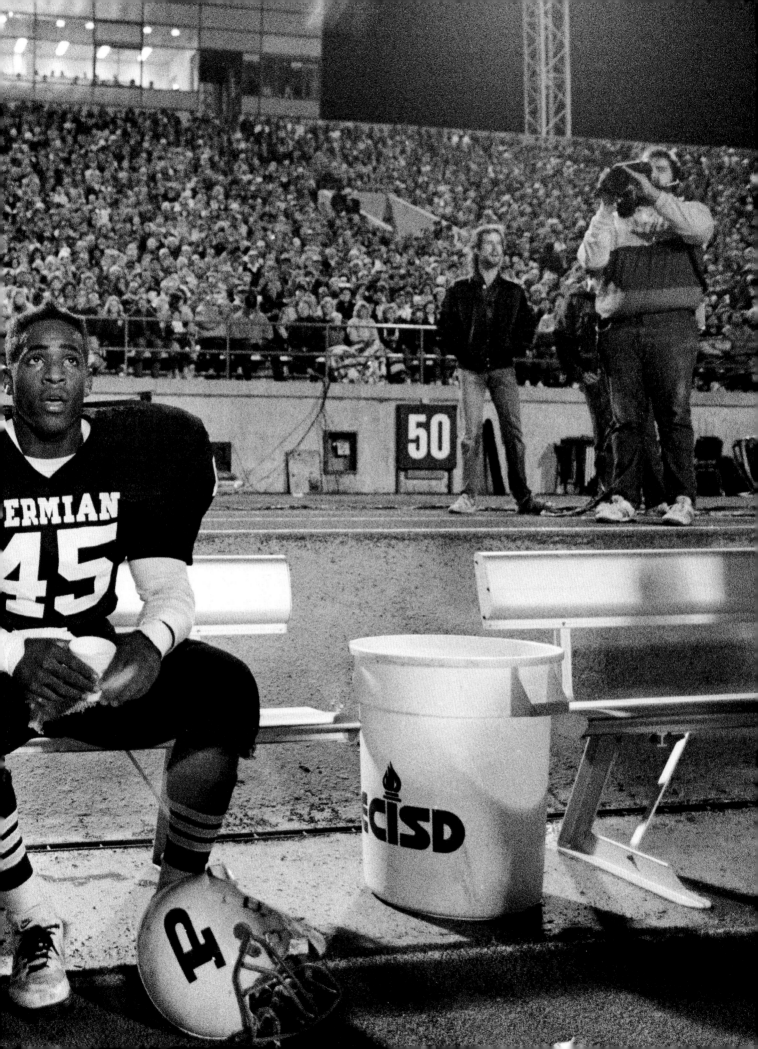

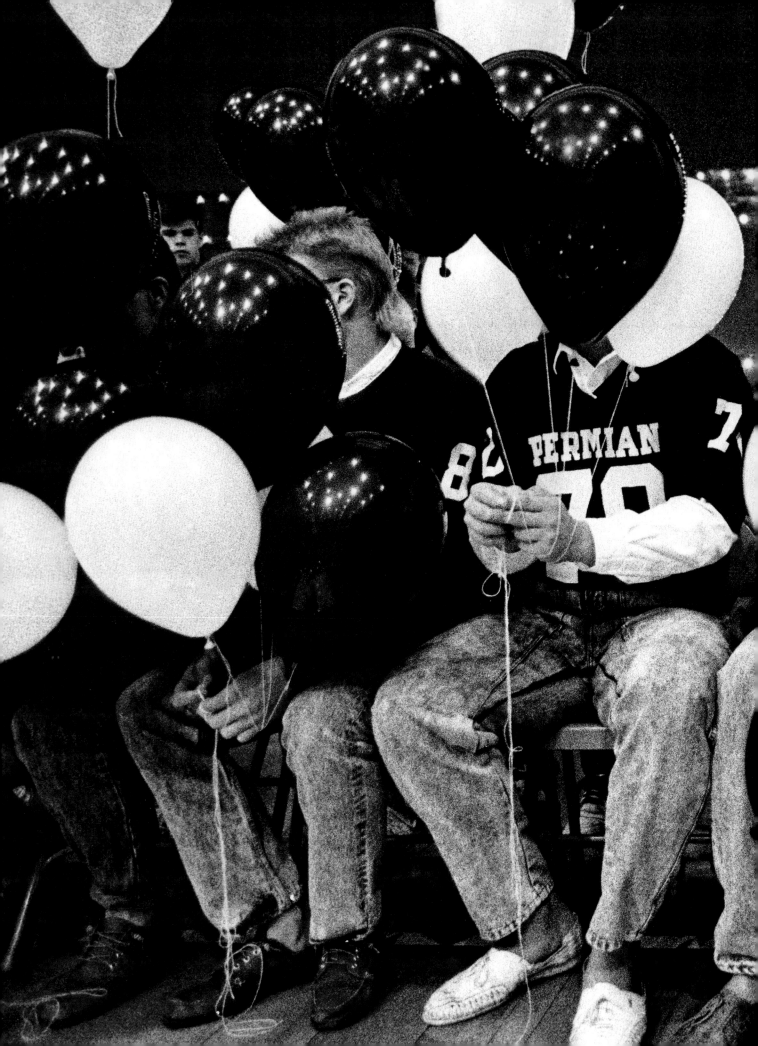

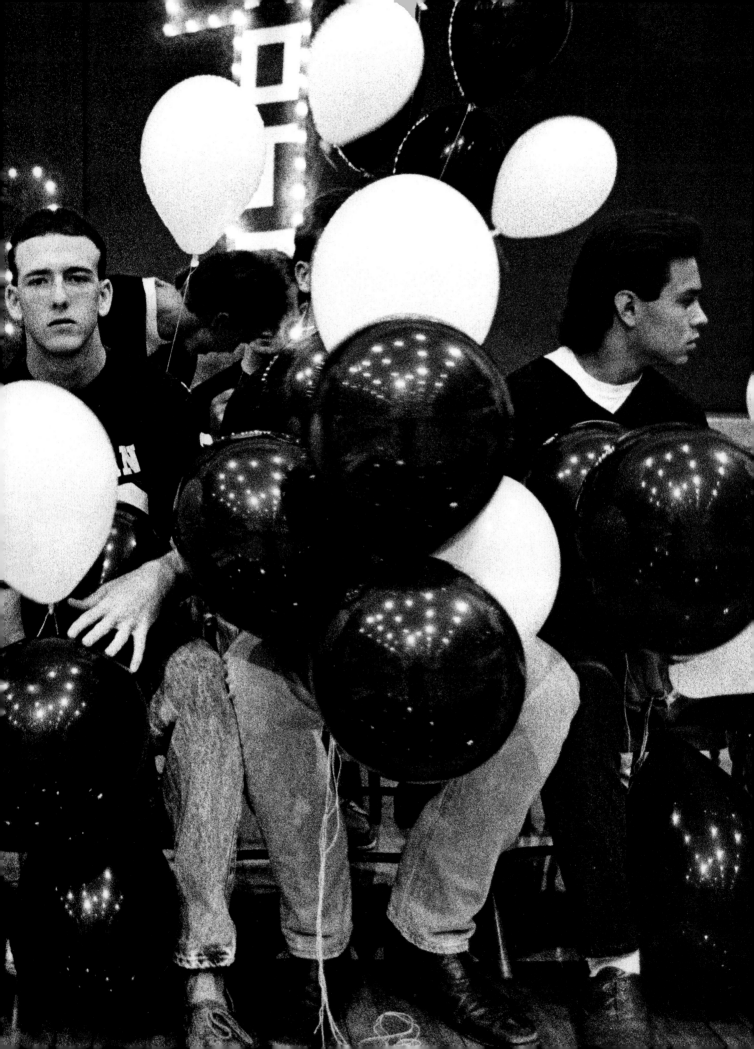

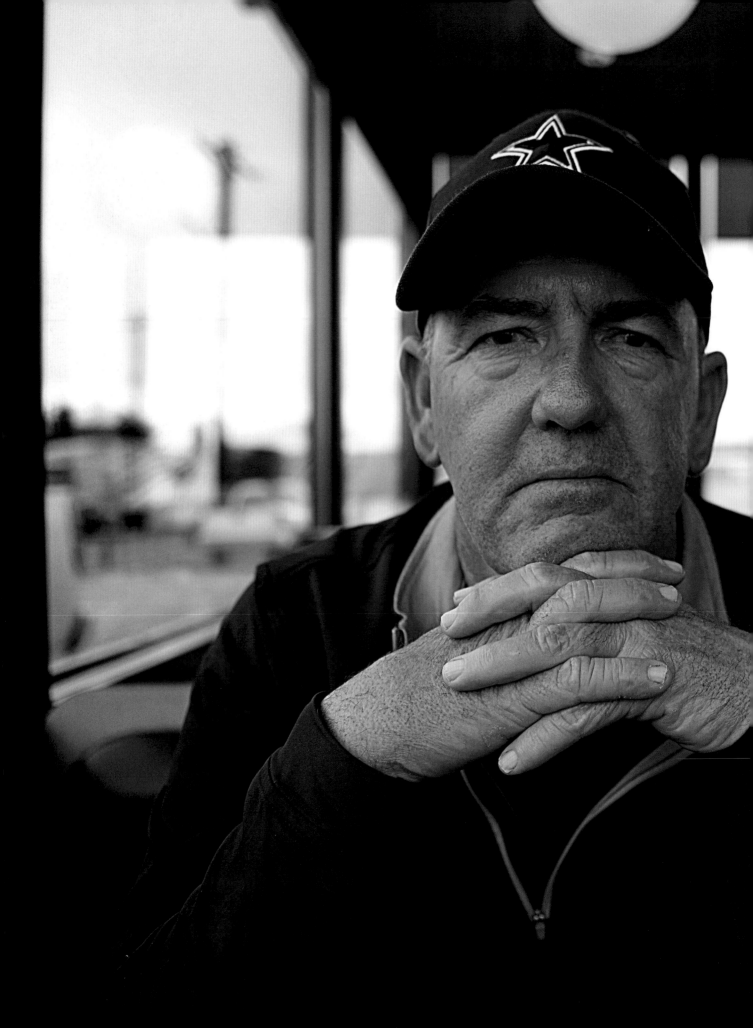

JULY 8, 2019
Denton, Texas

BOOBIE MILES

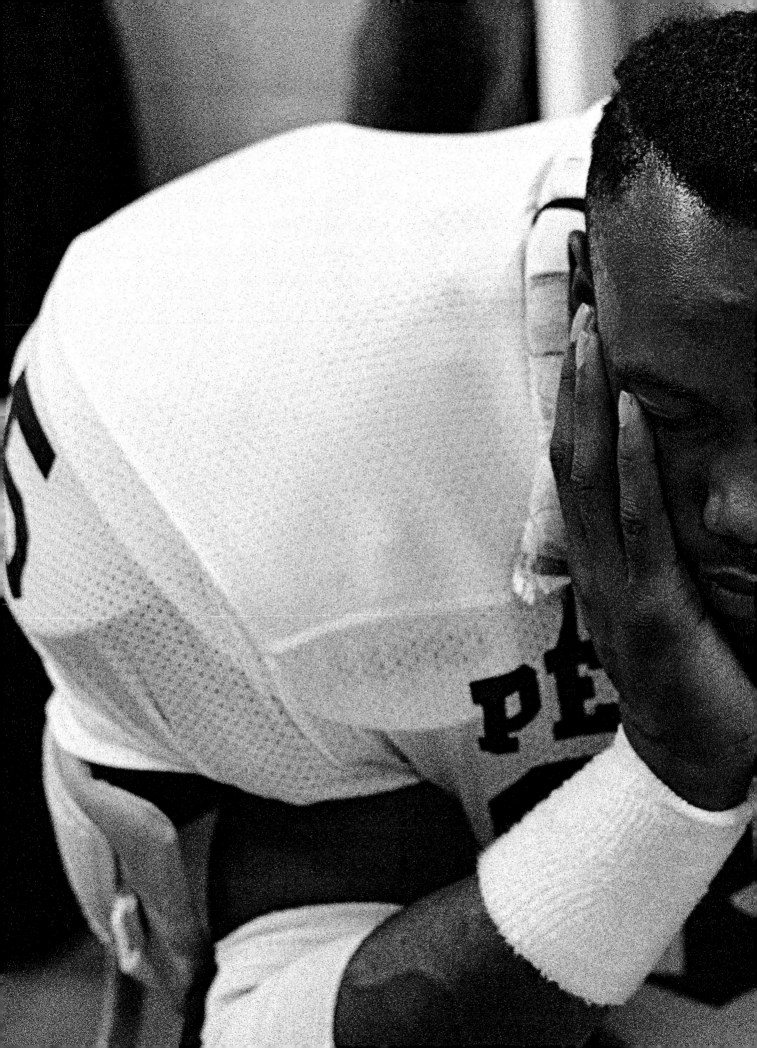

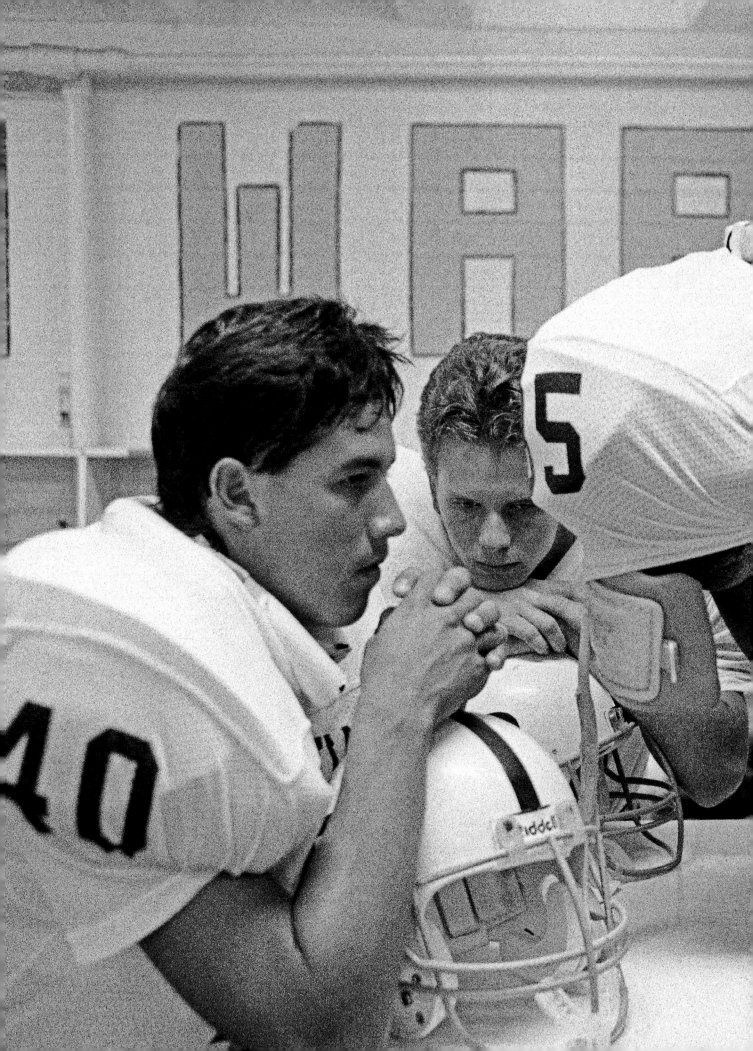

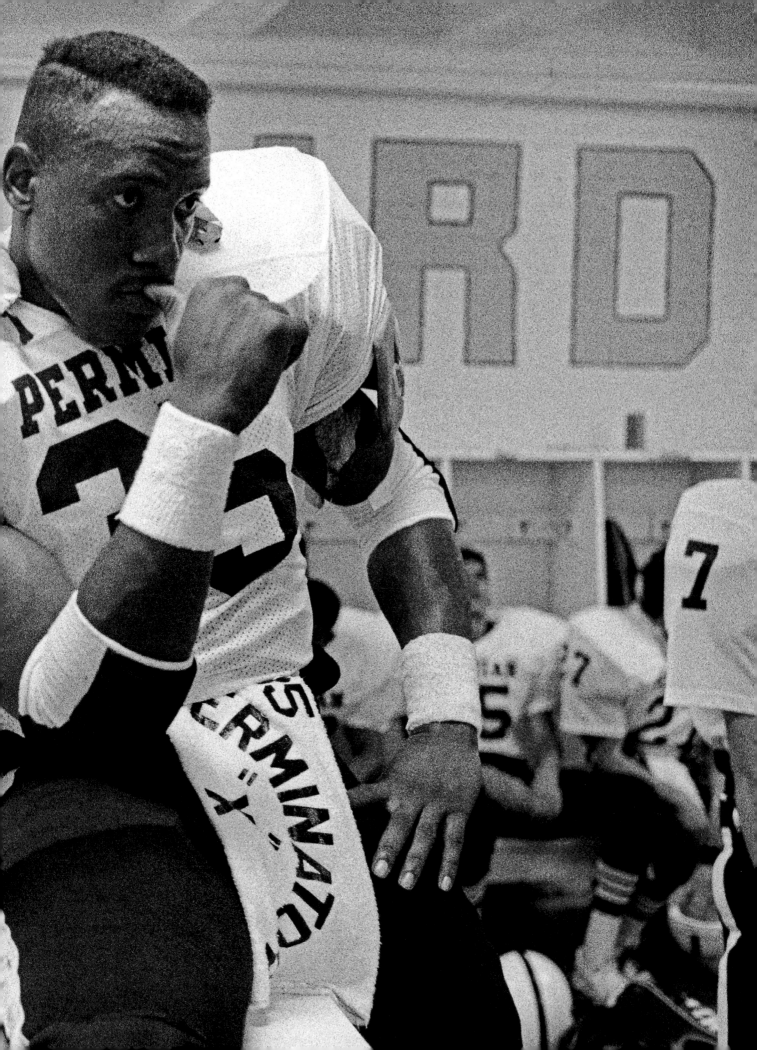

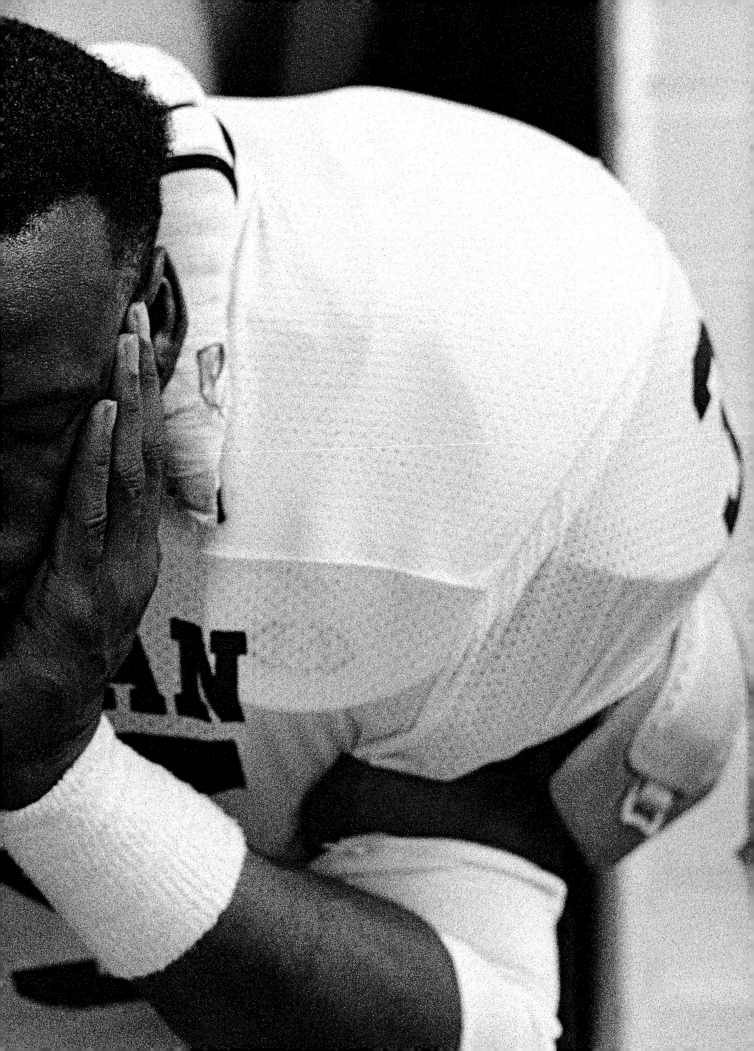

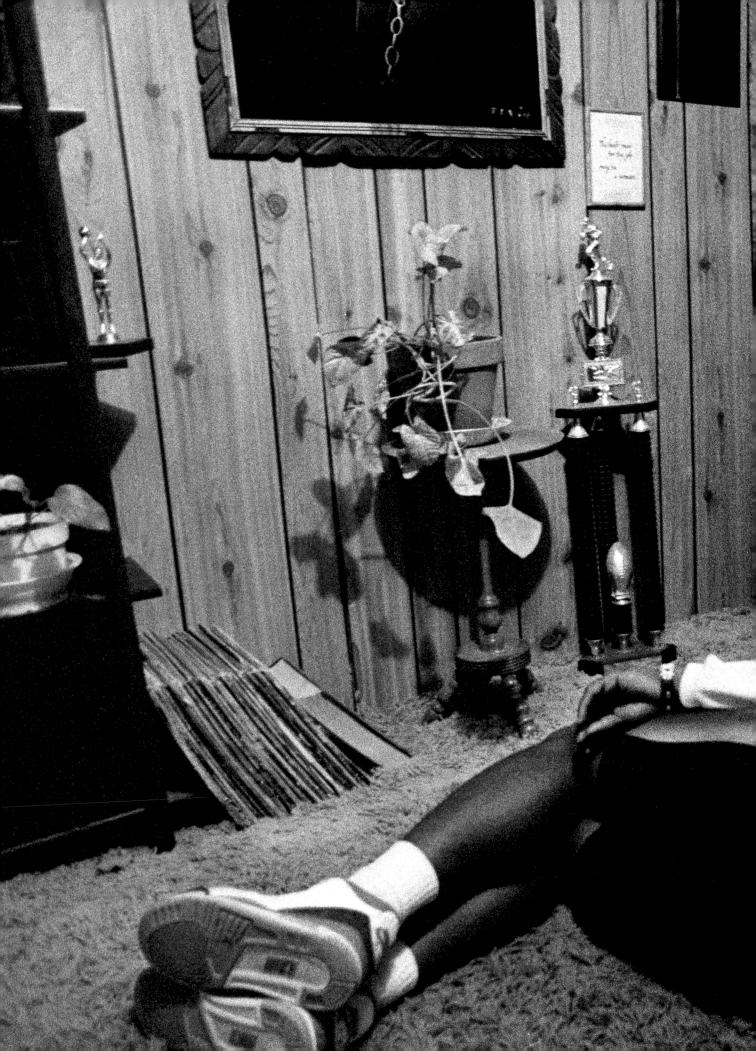

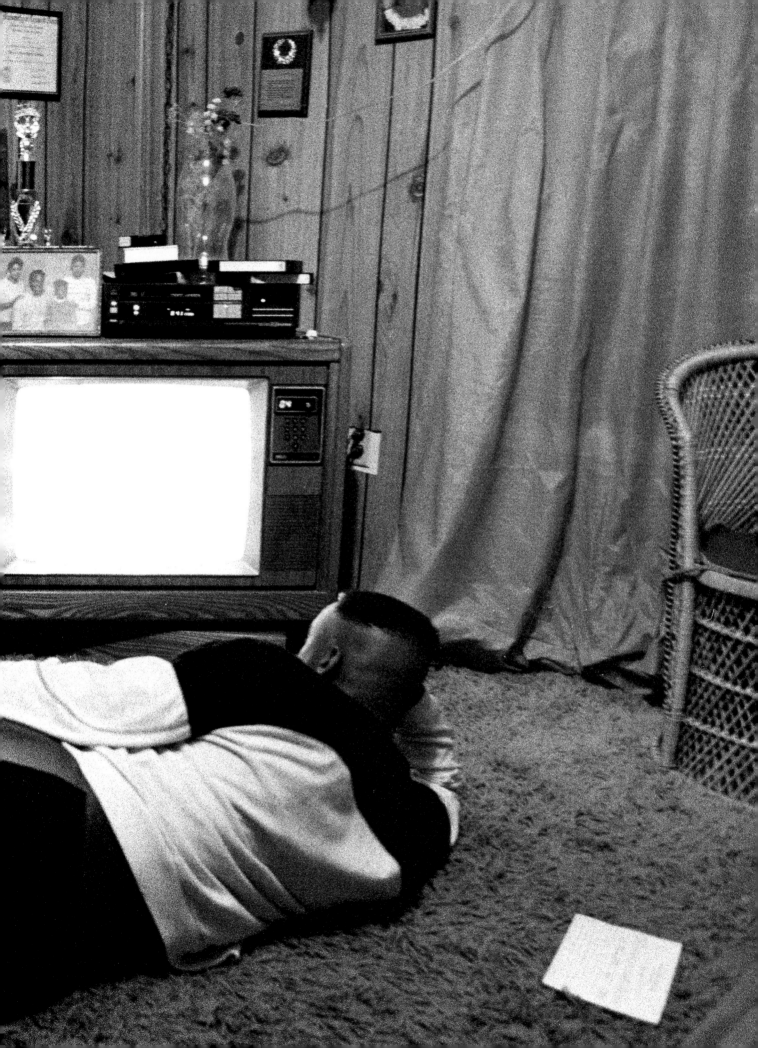

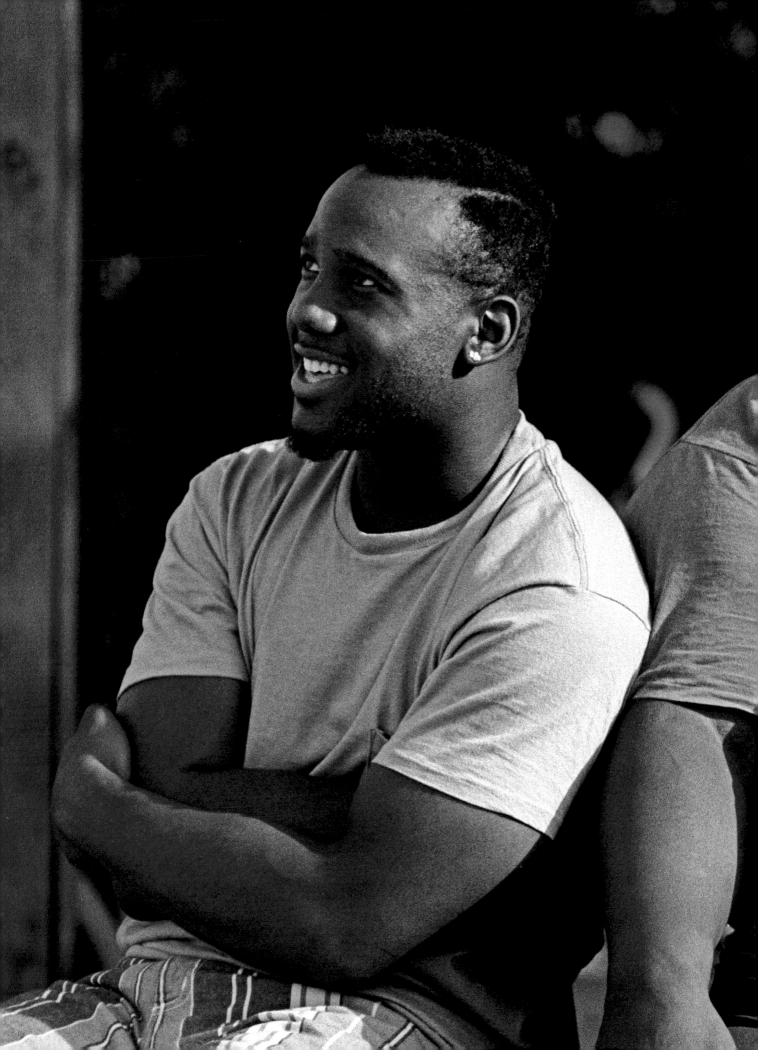

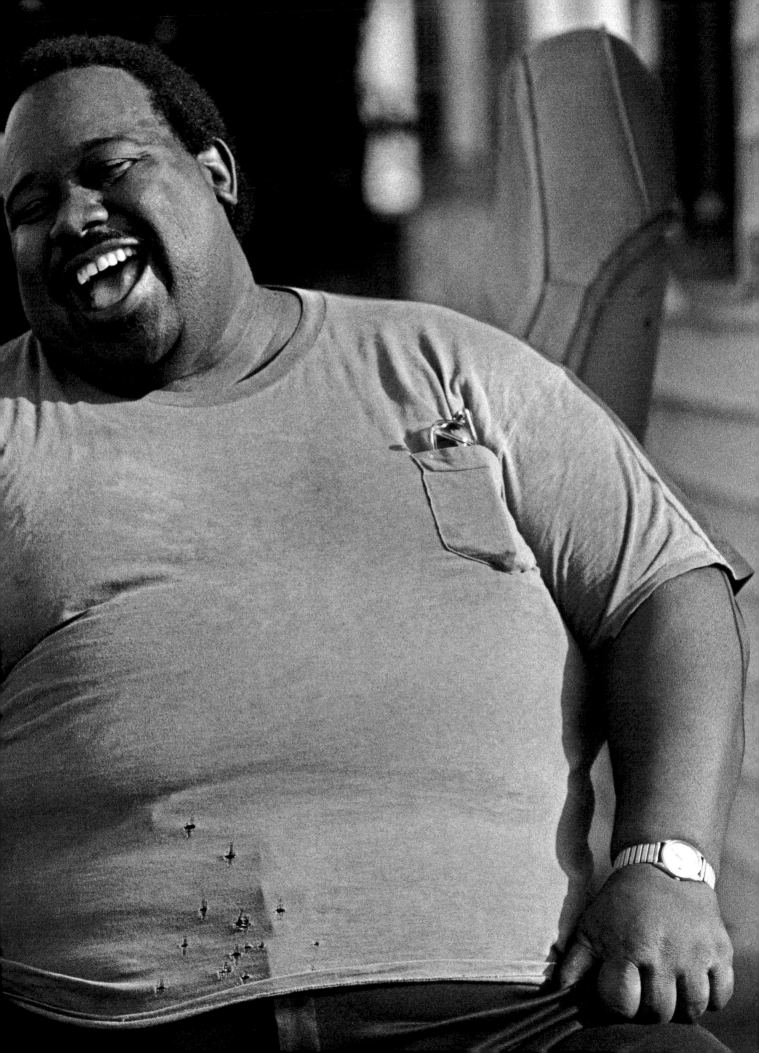

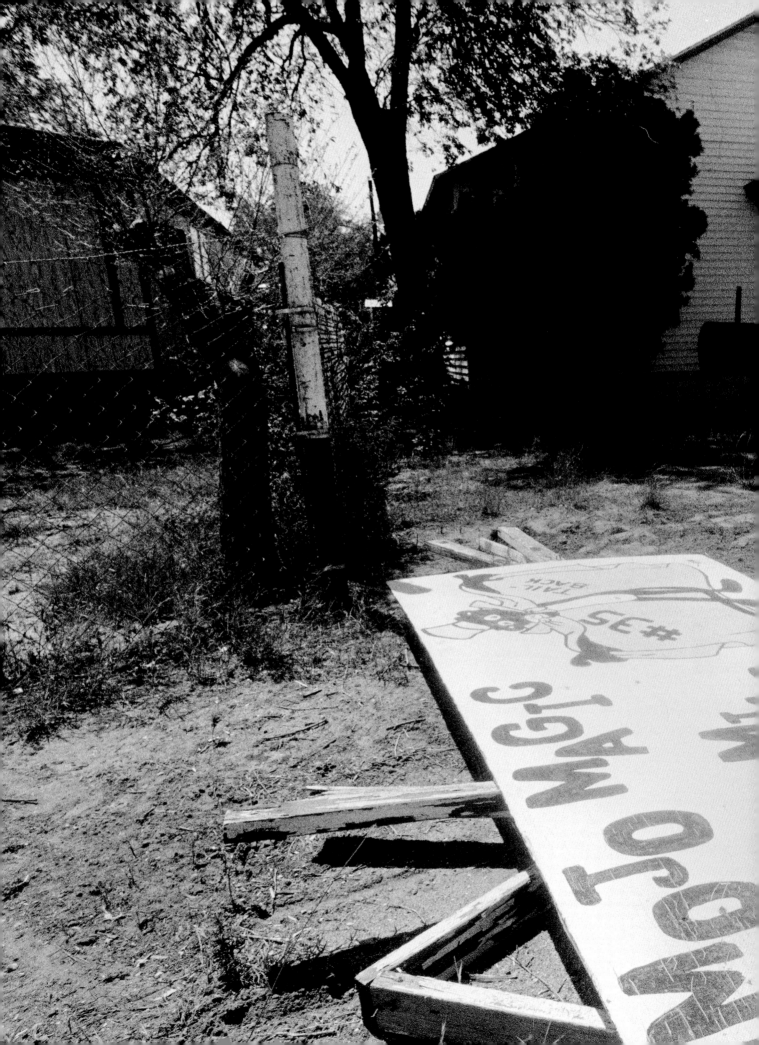

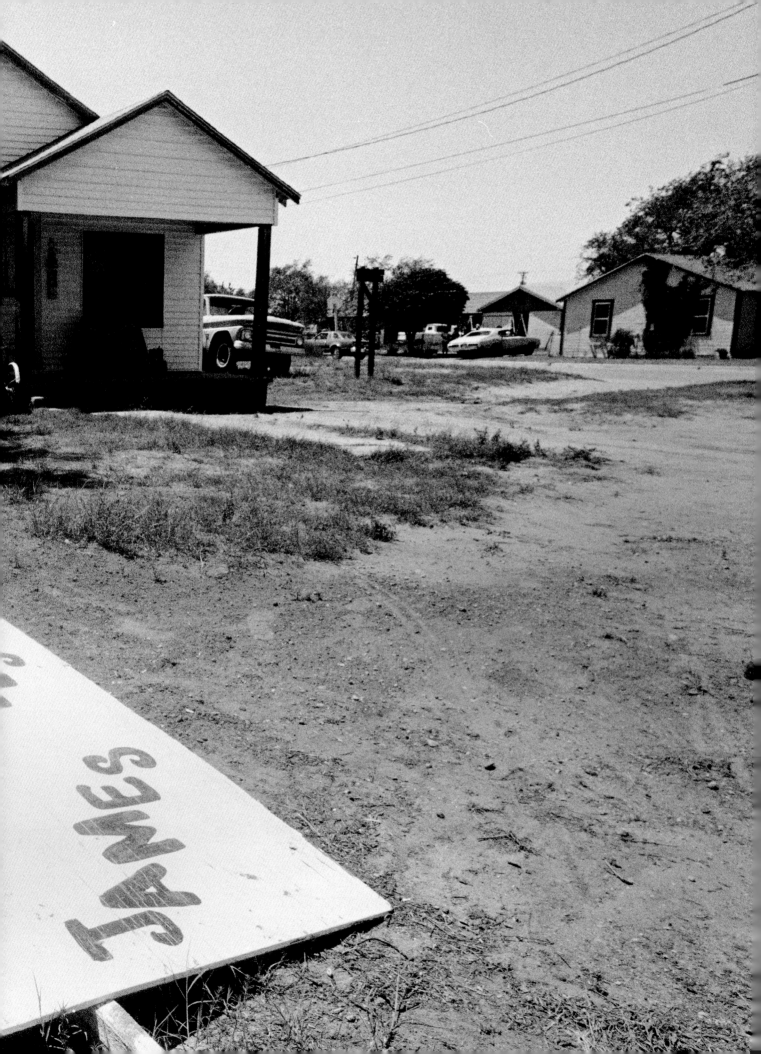

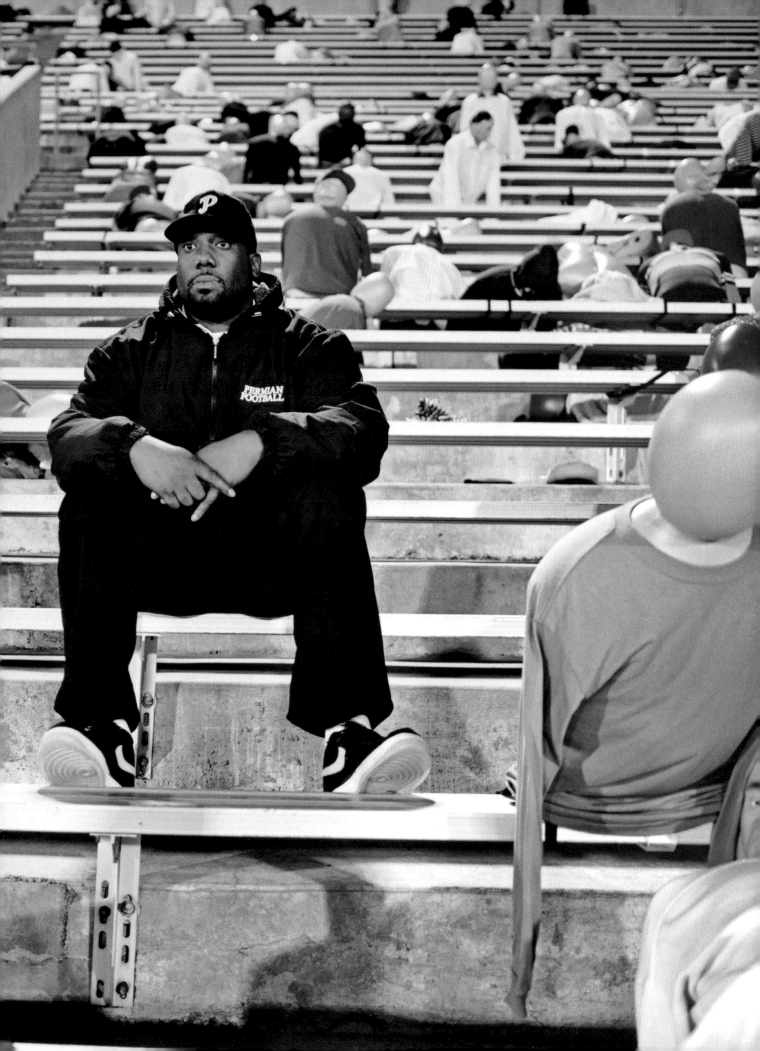

BRIAN CHAVEZ

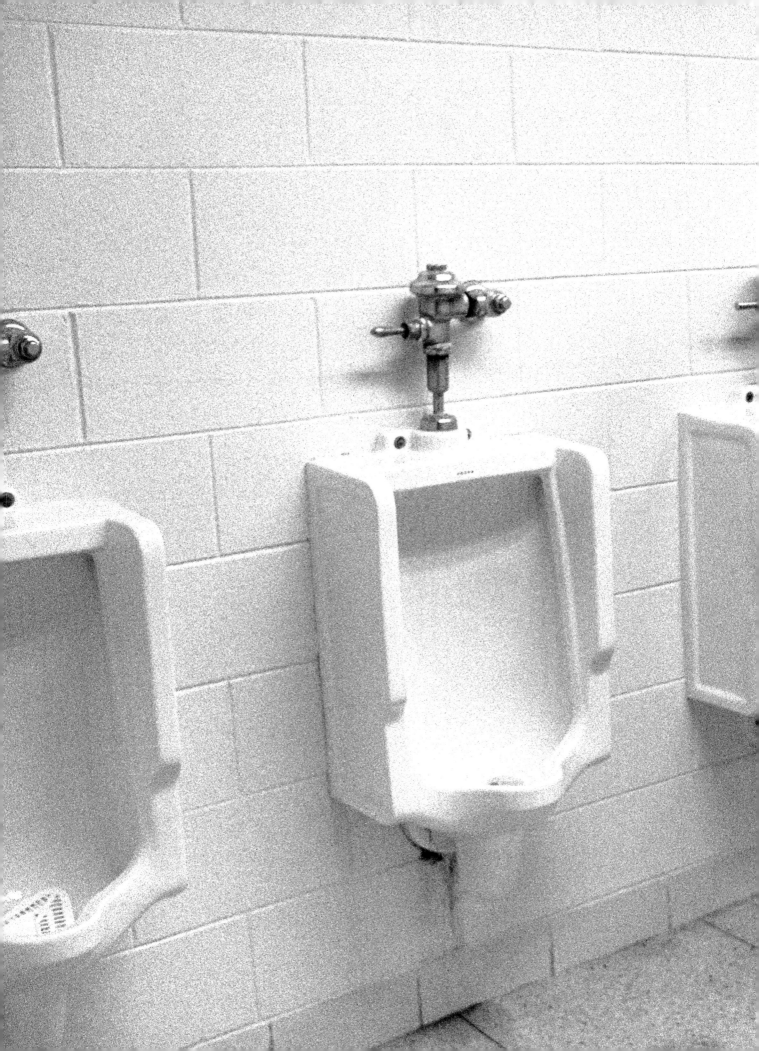

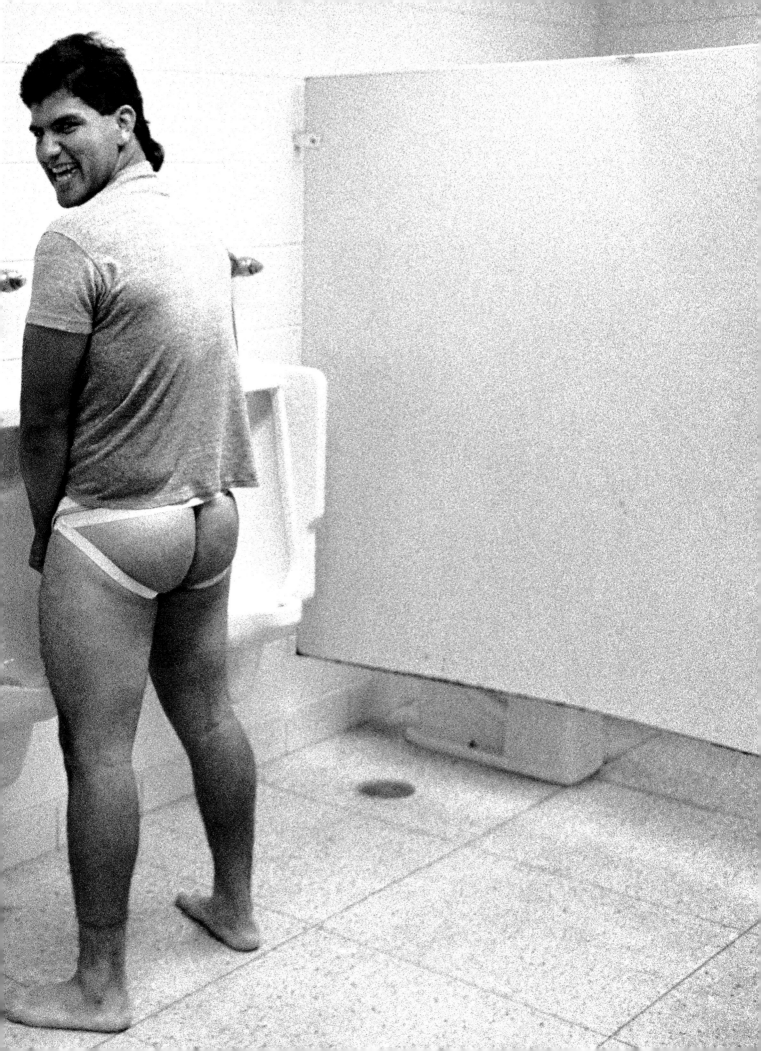

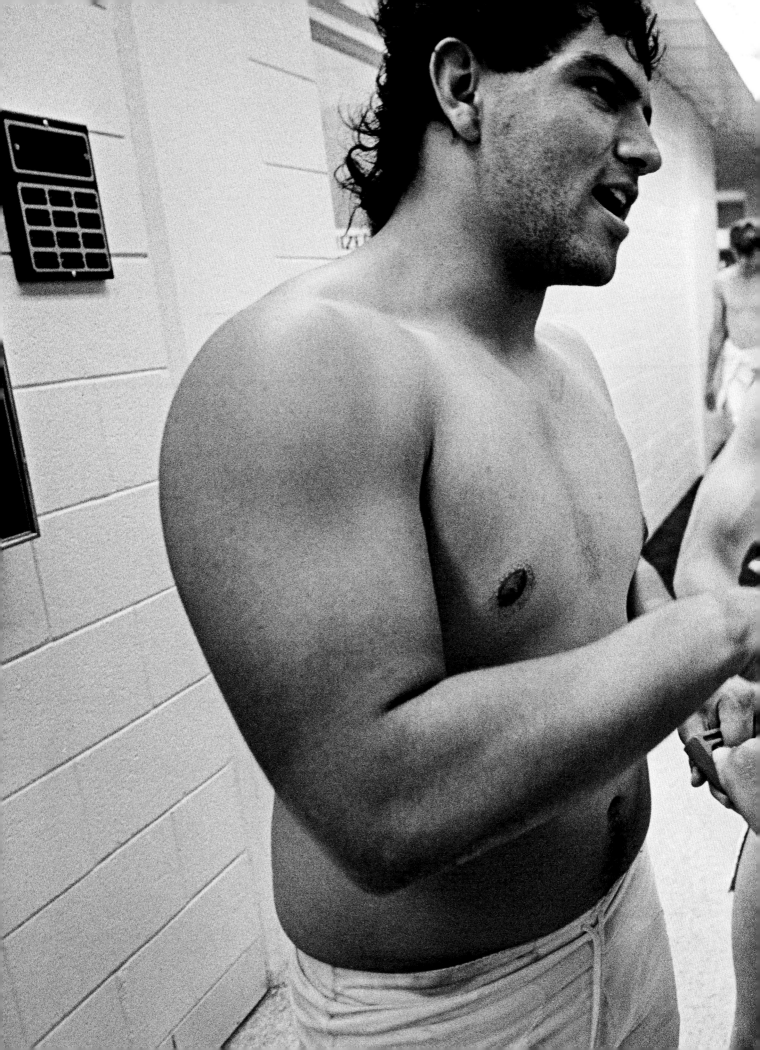

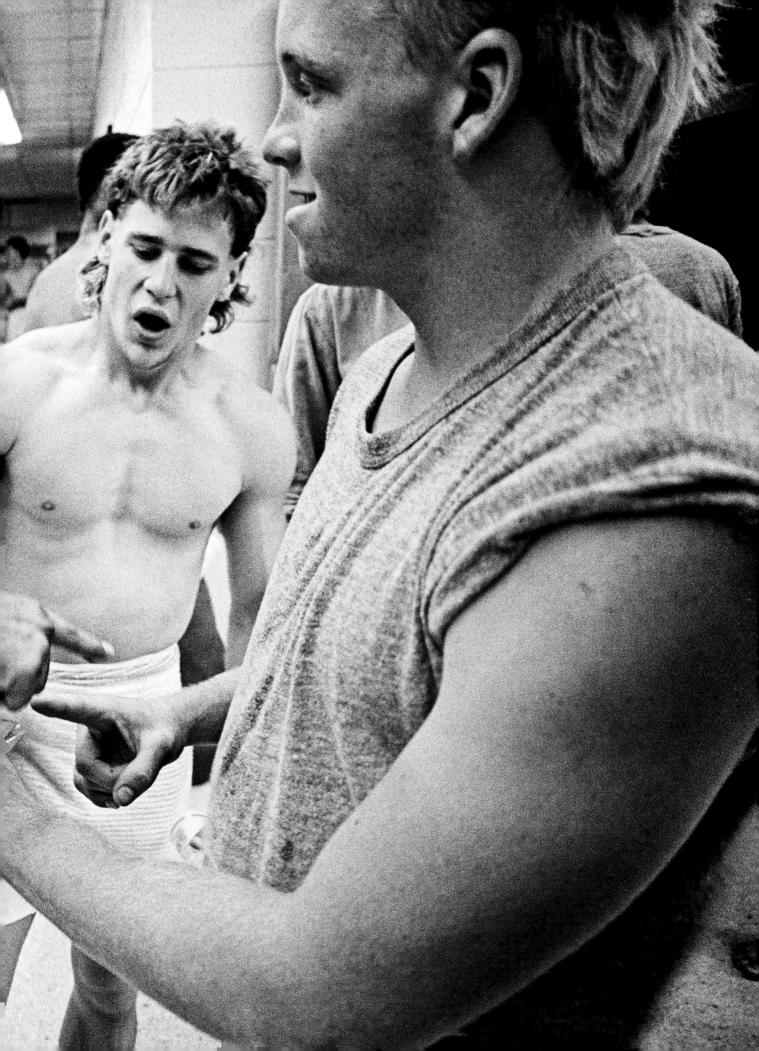

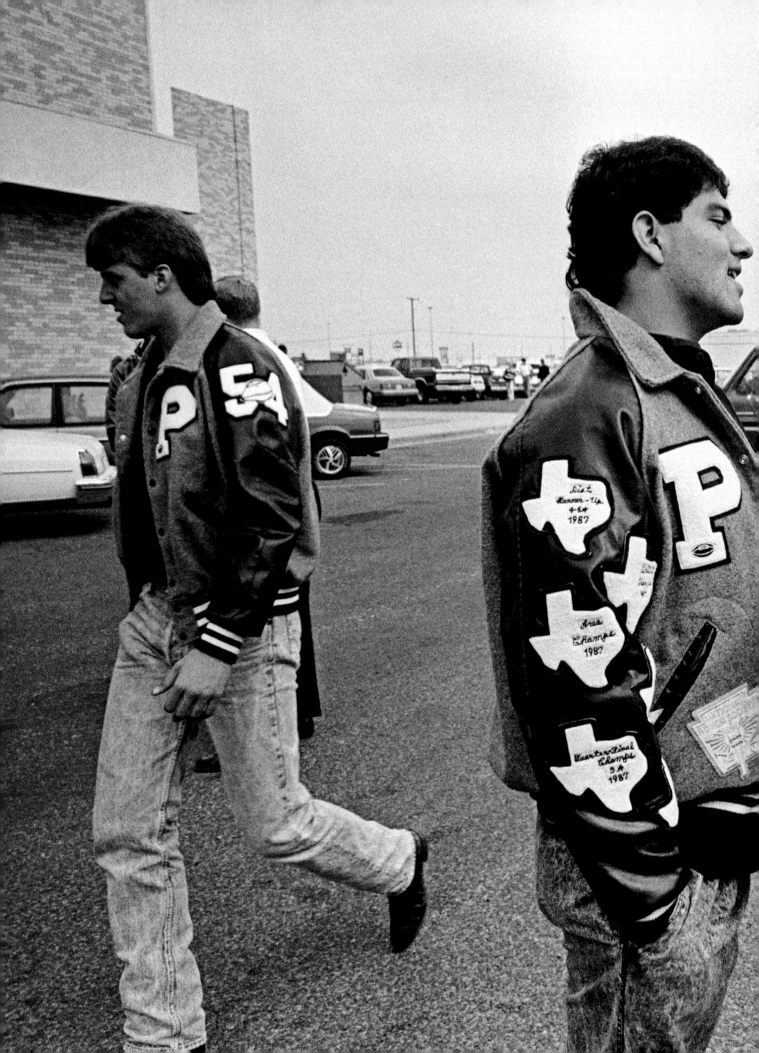

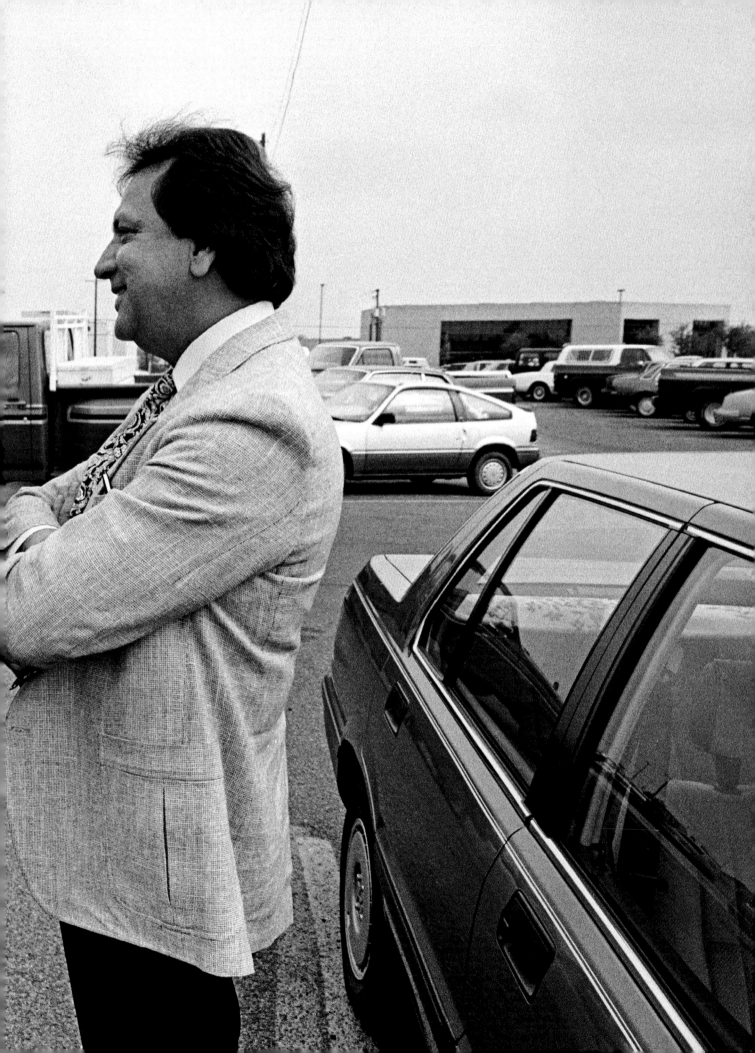

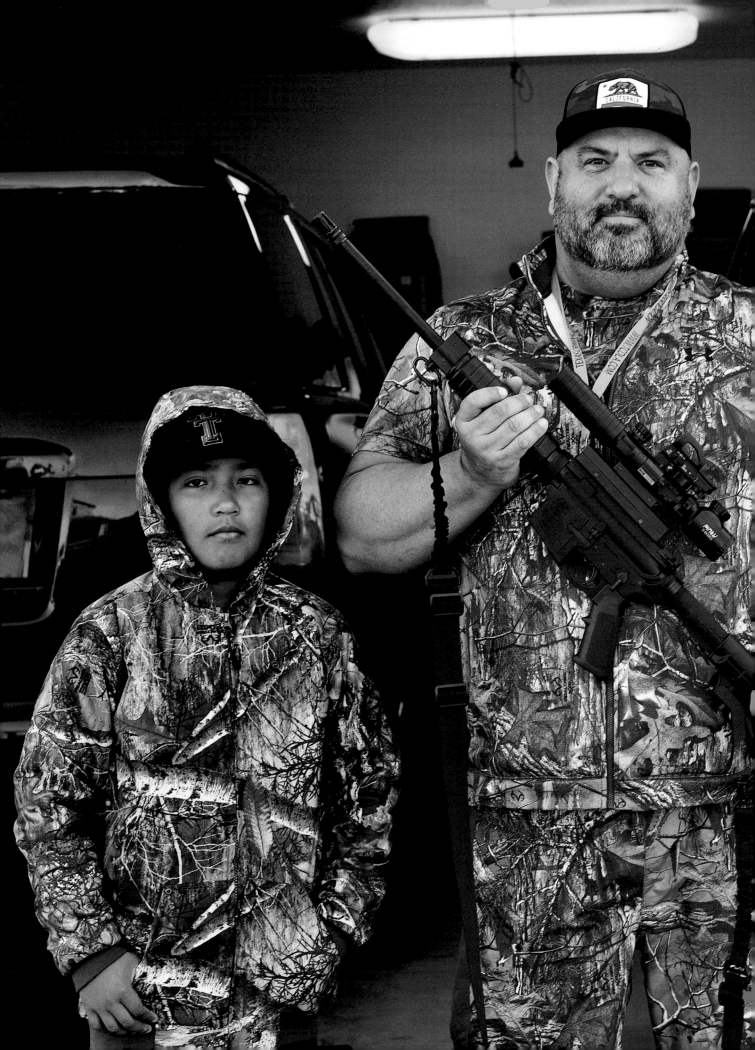

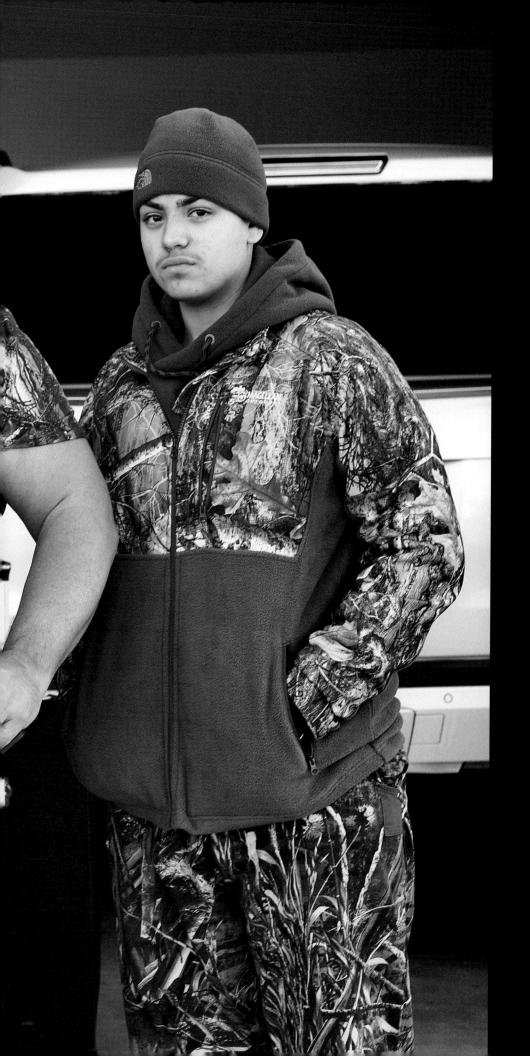

JULY 12, 2019
Odessa, Texas

IVORY CHRISTIAN

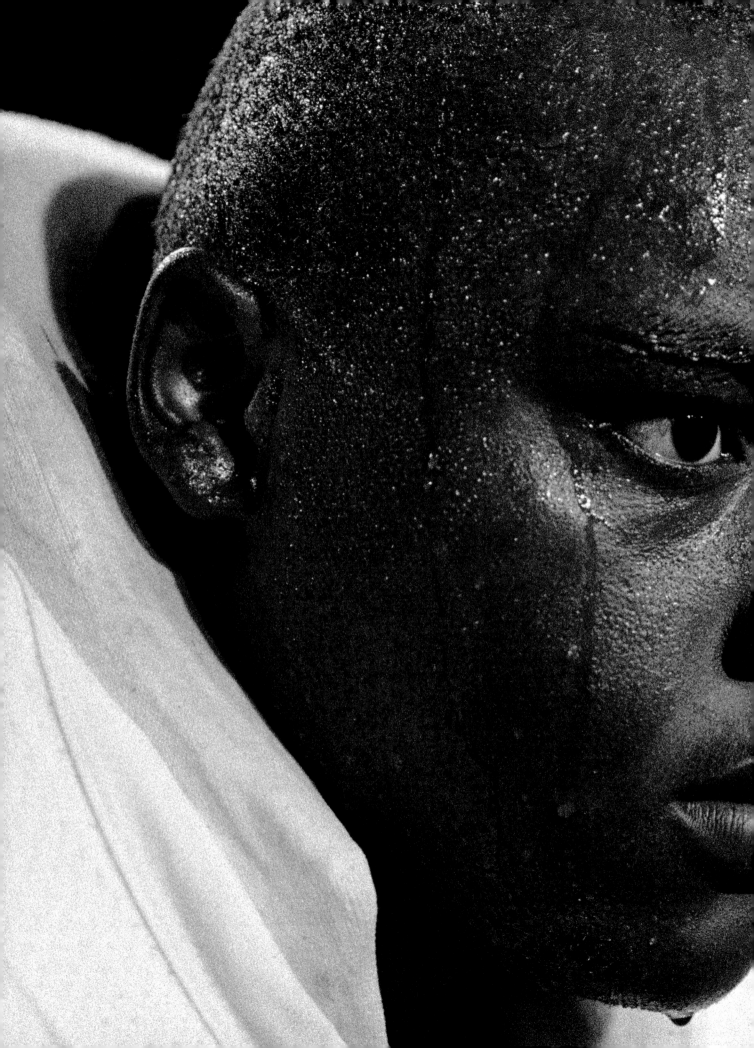

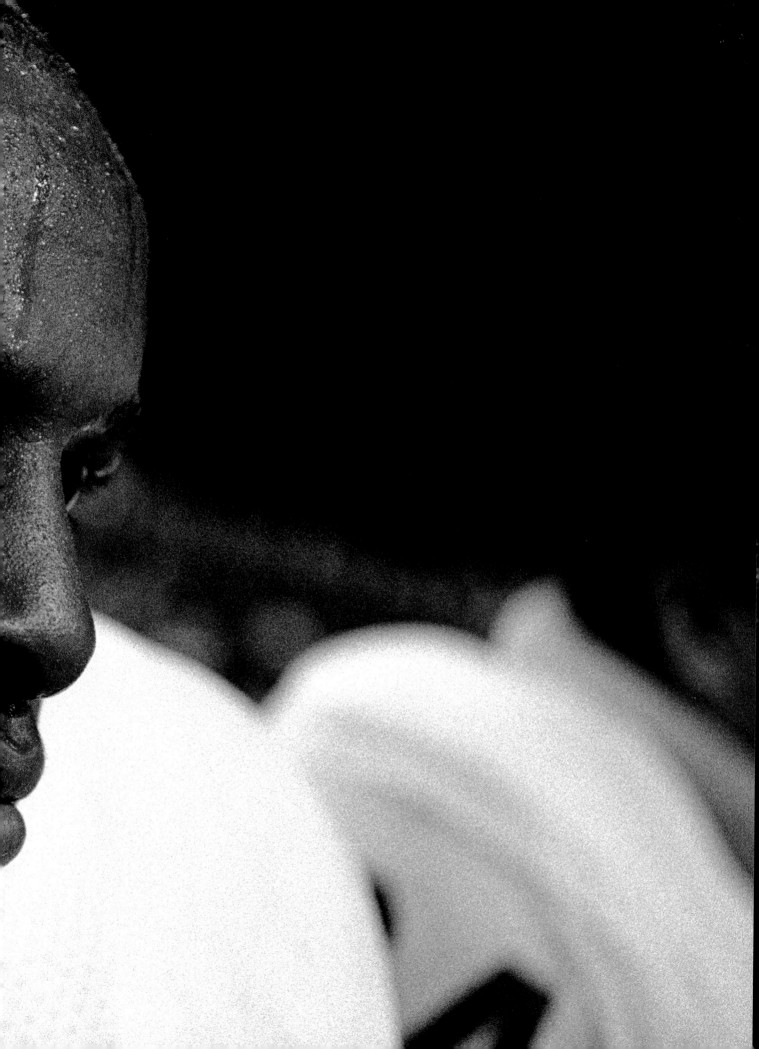

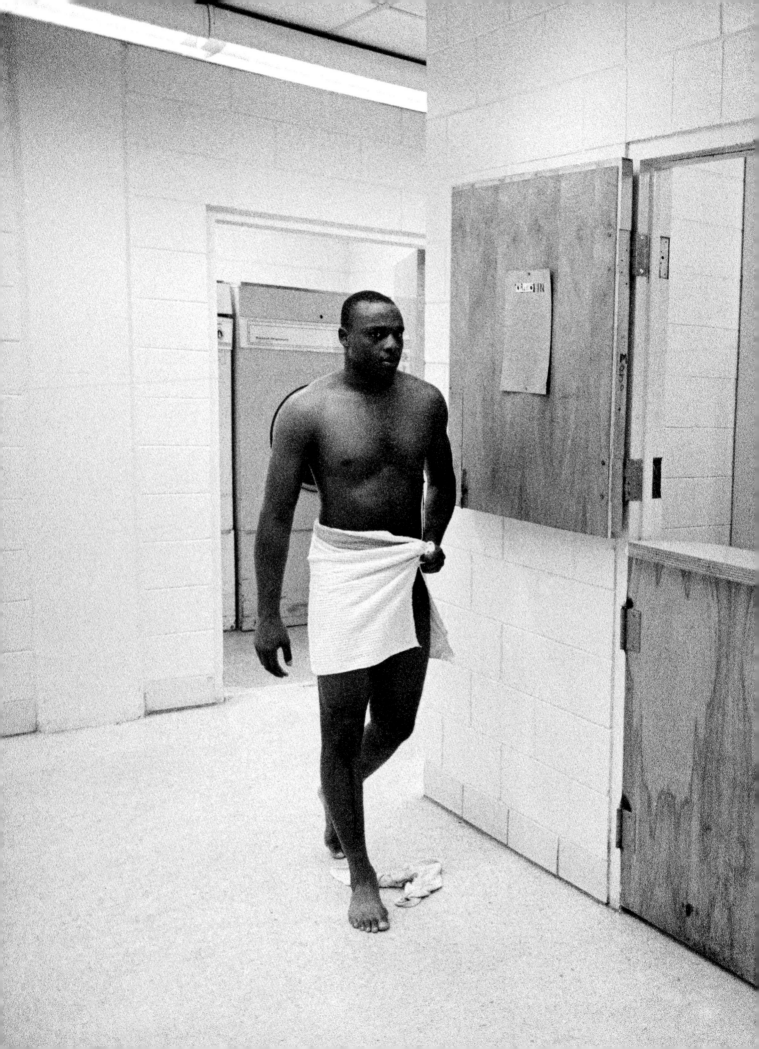

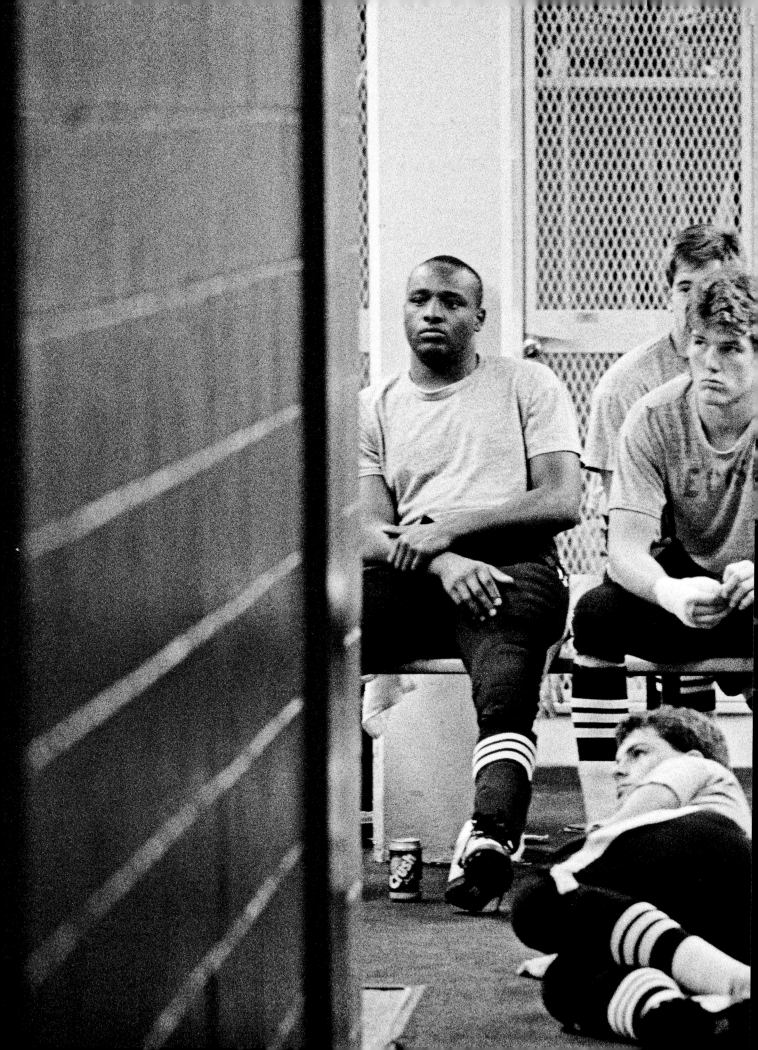

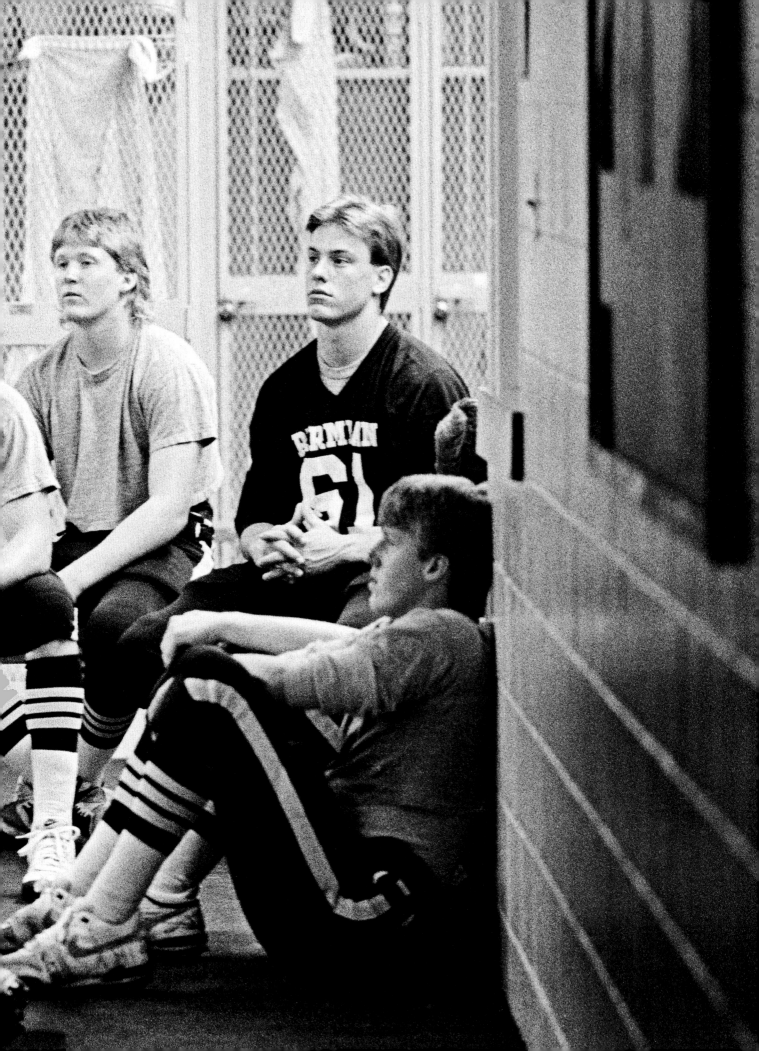

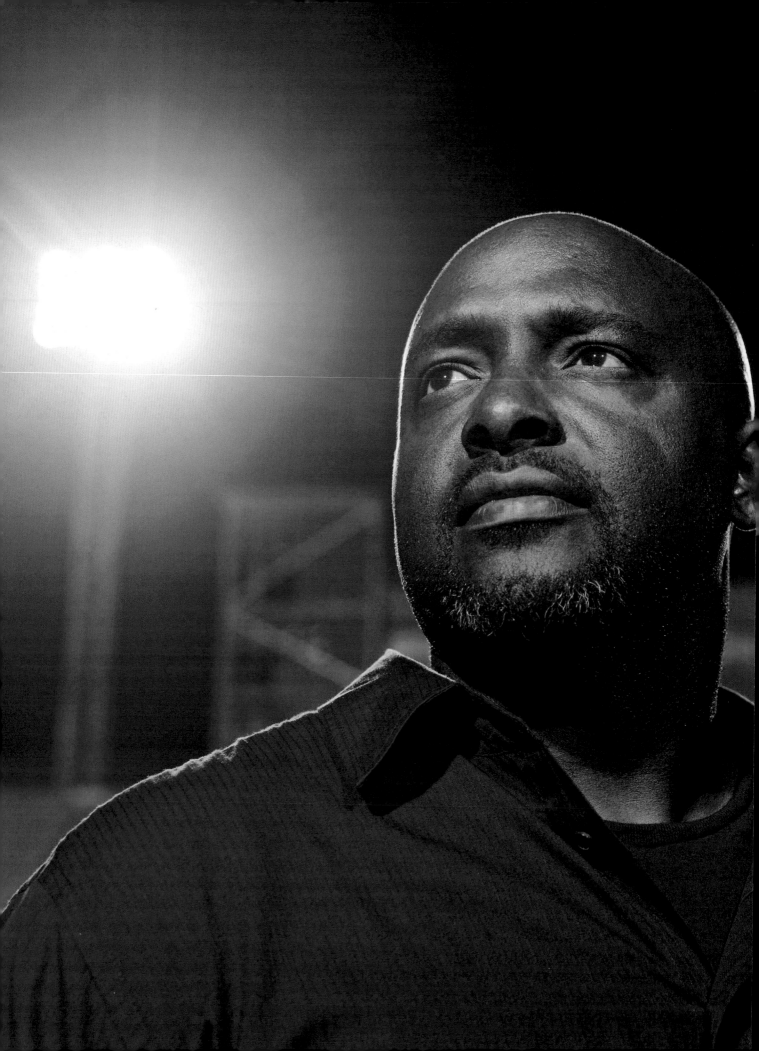

JERROD McDOUGAL

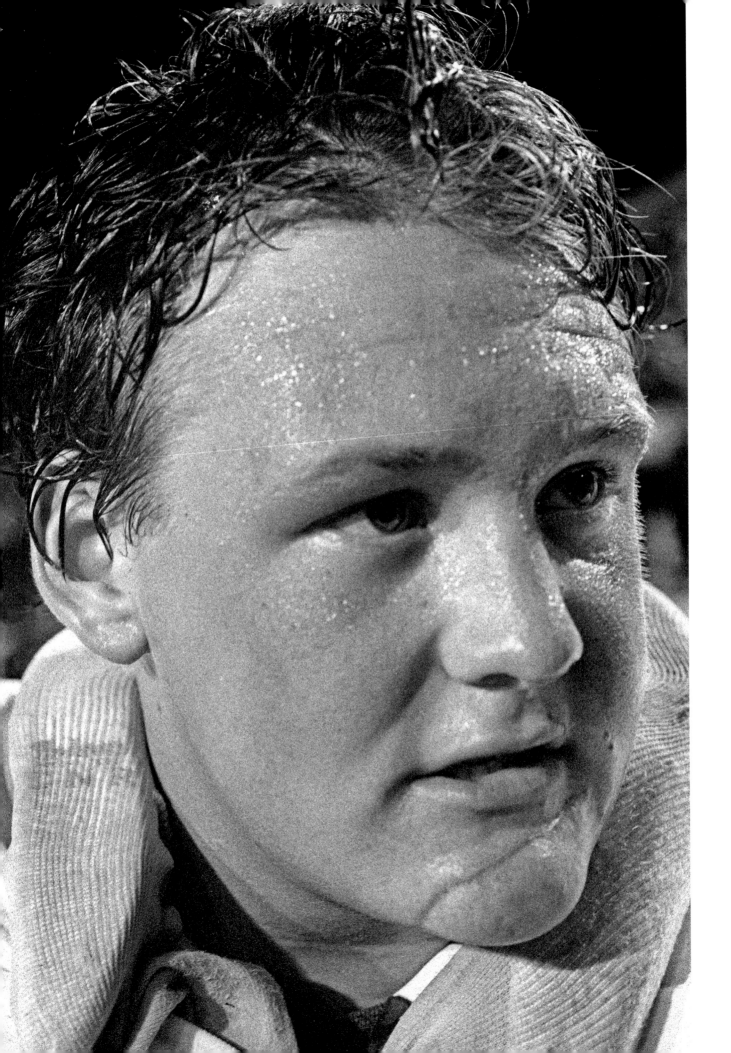

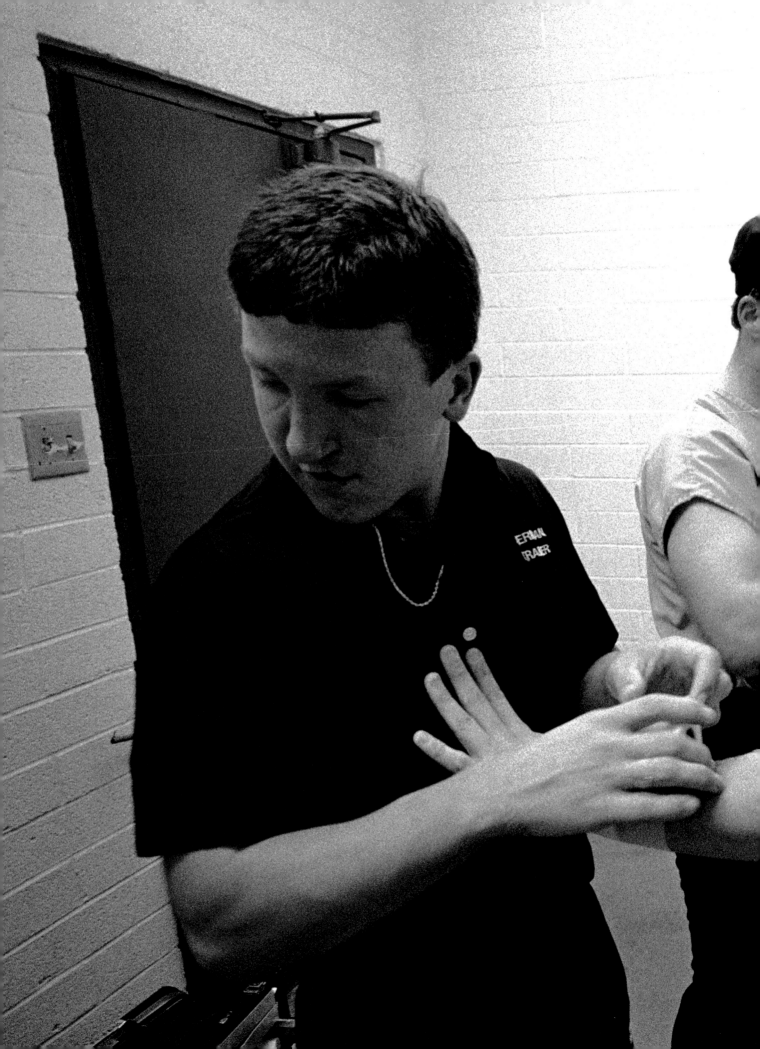

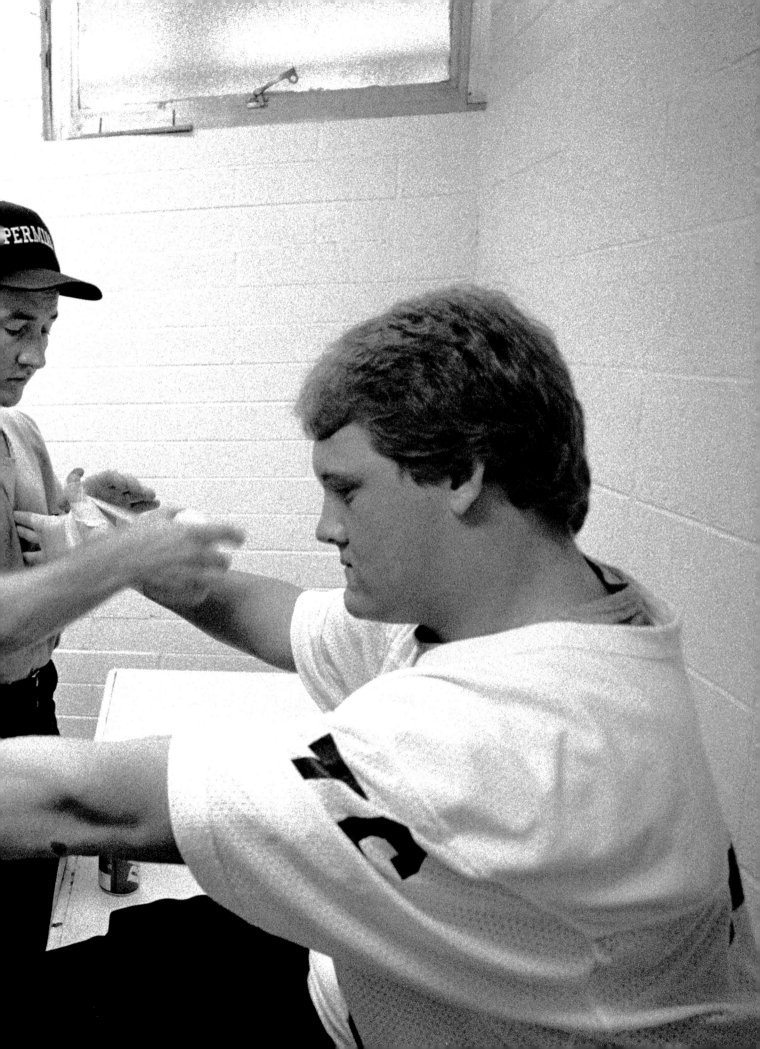

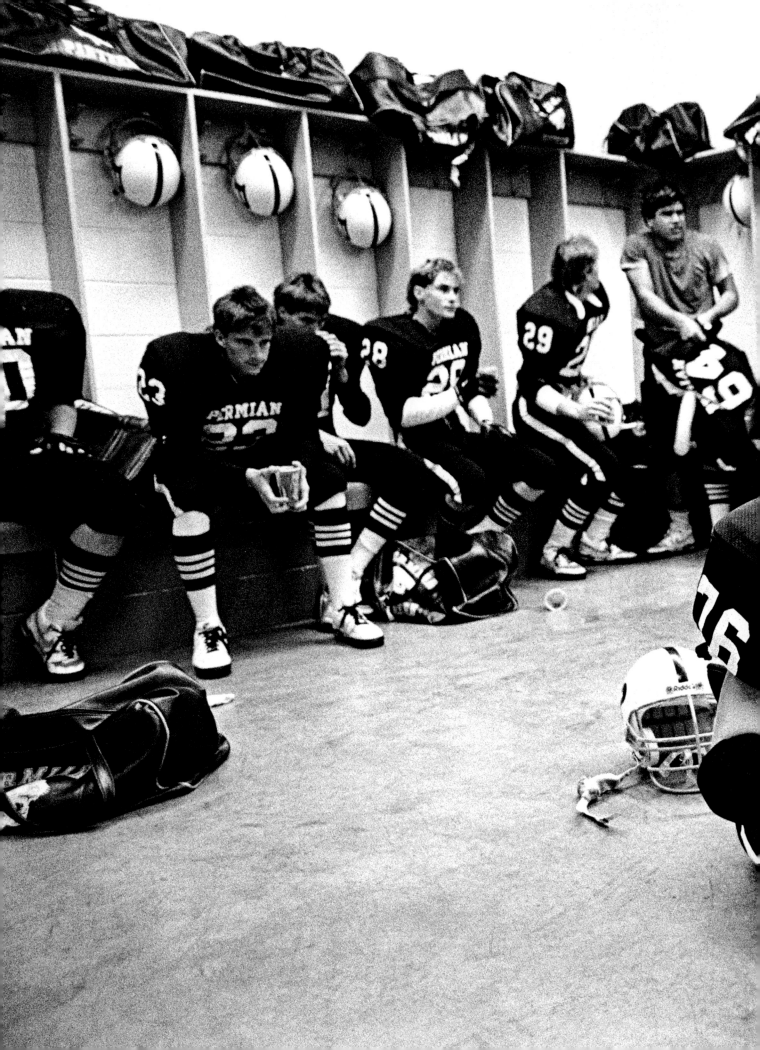

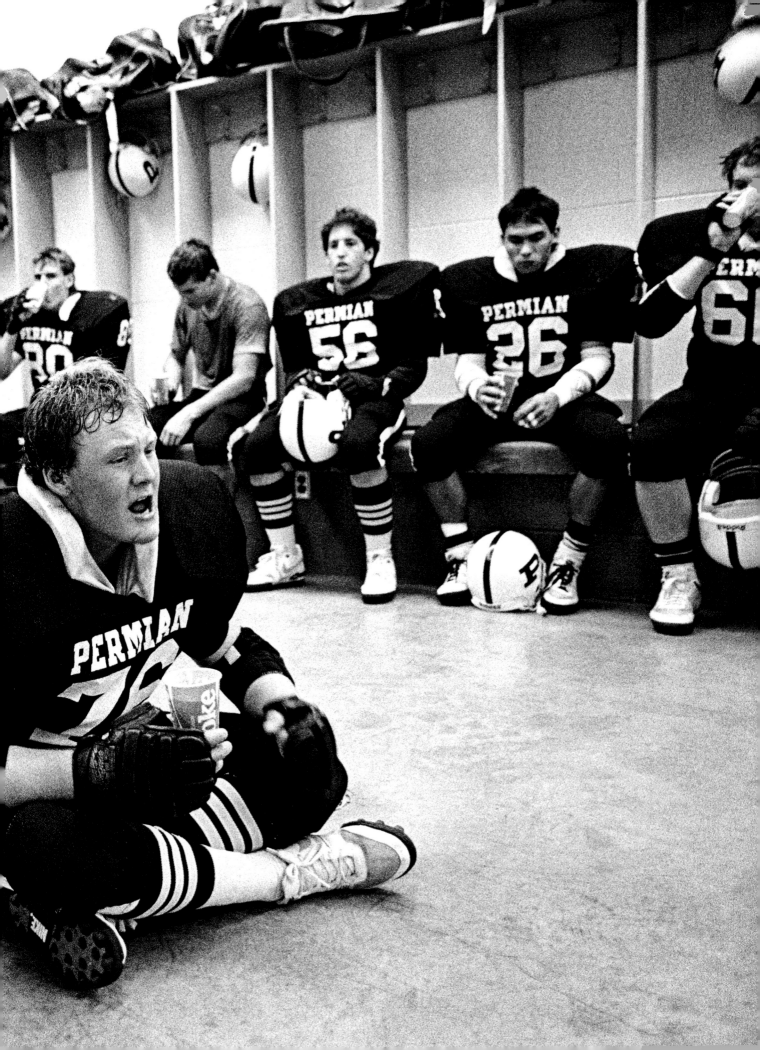

OCTOBER 15, 2015
Crane, Texas

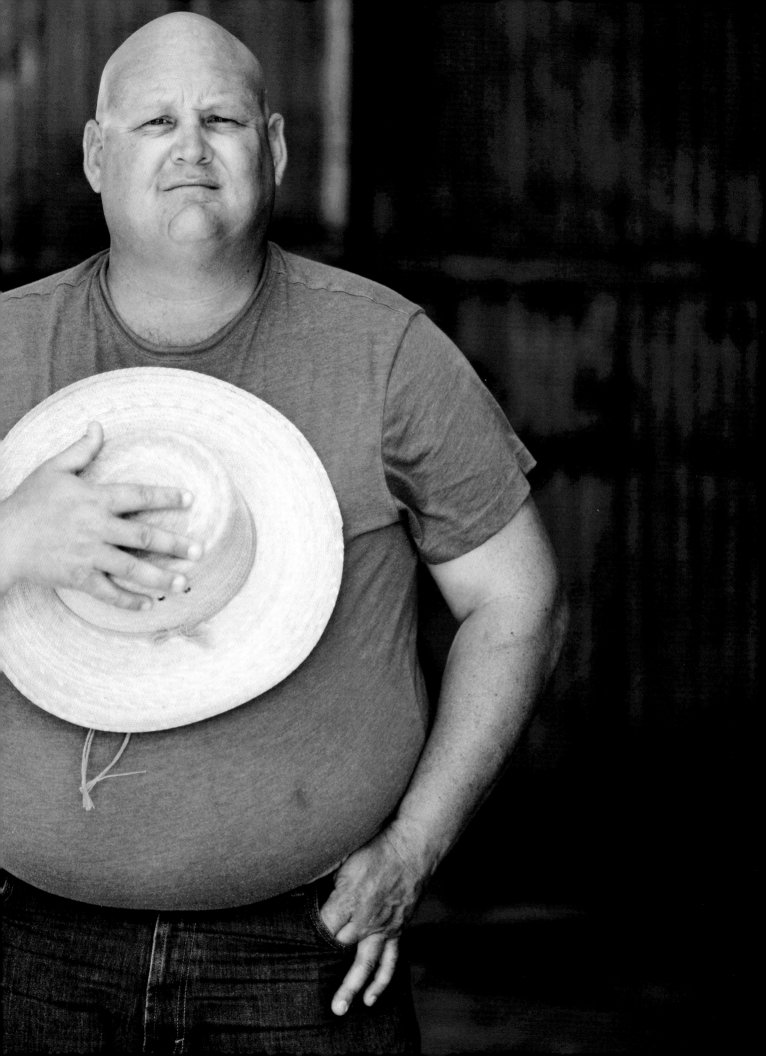

DON BILLINGSLEY

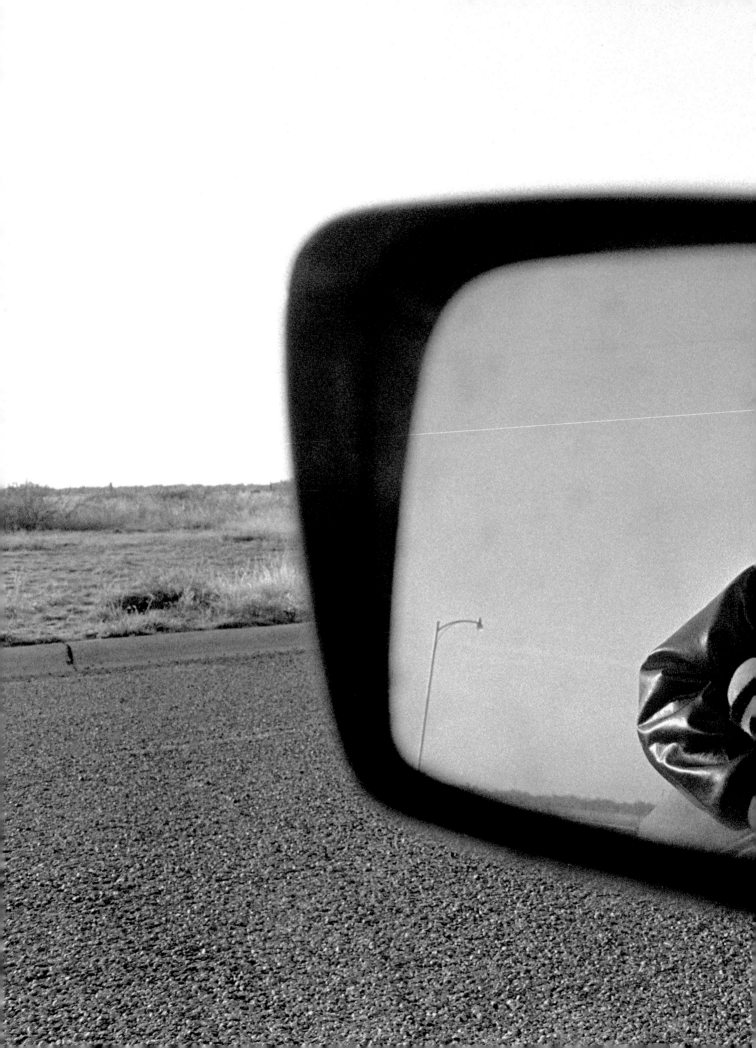

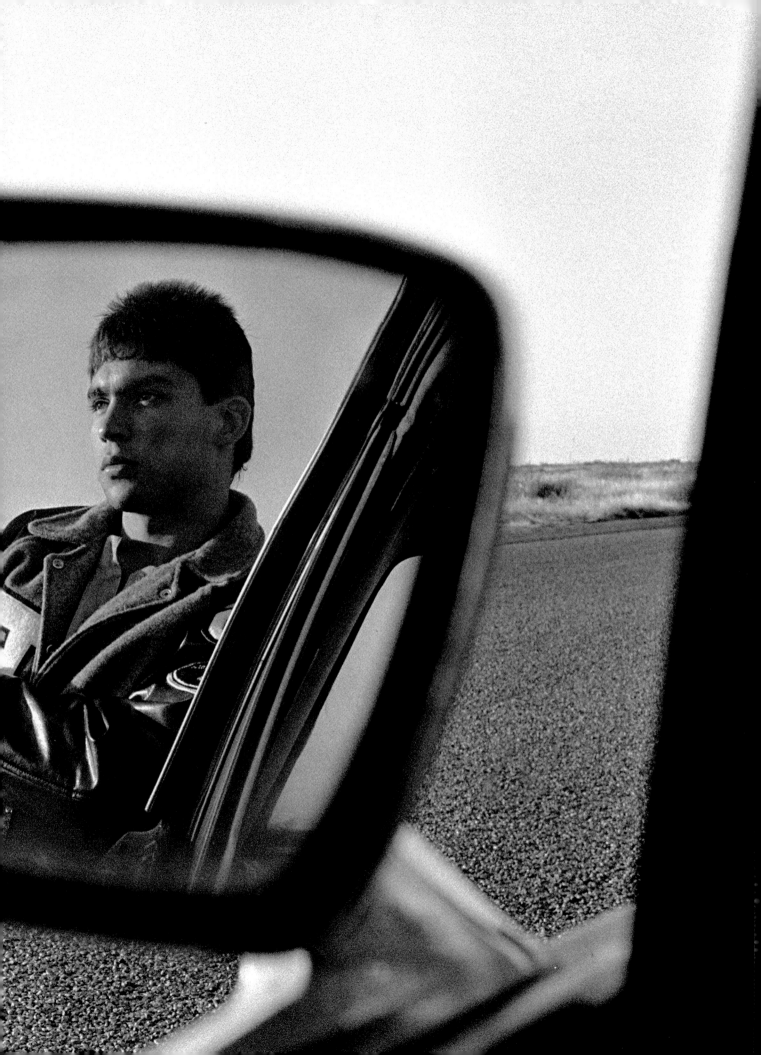

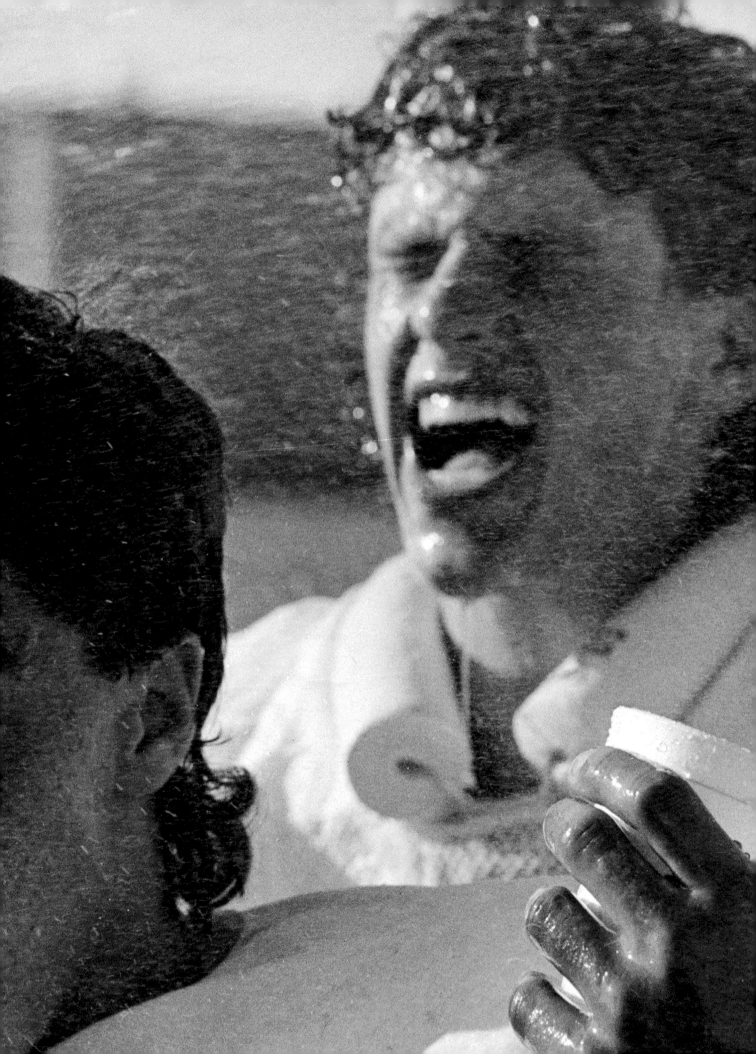

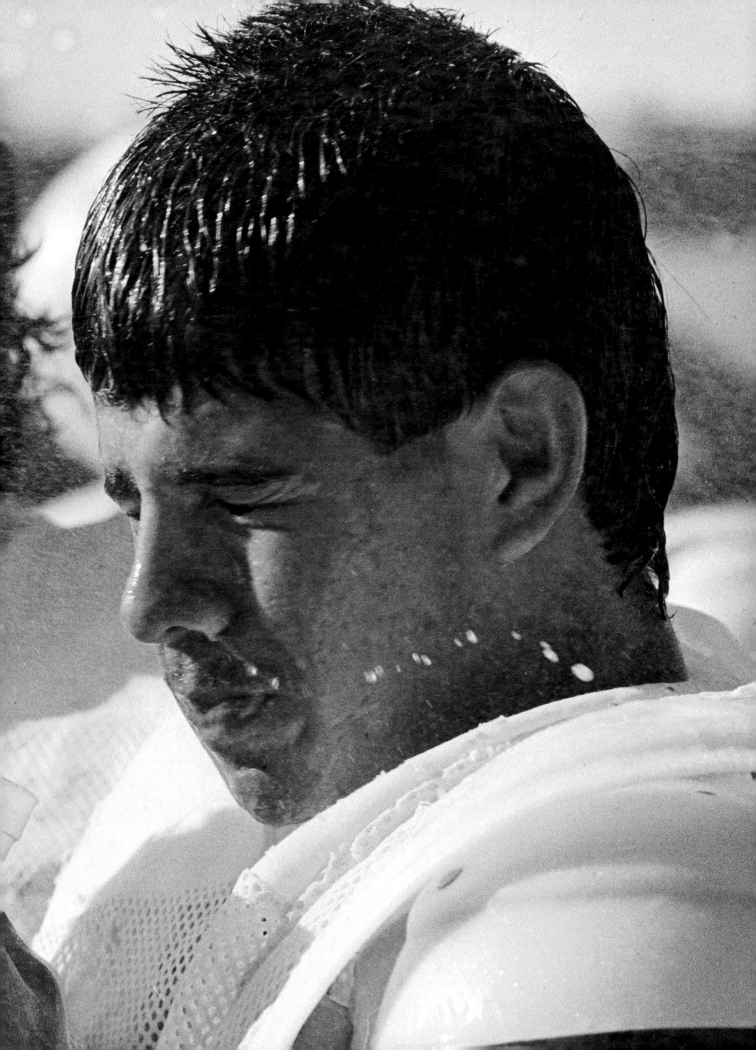

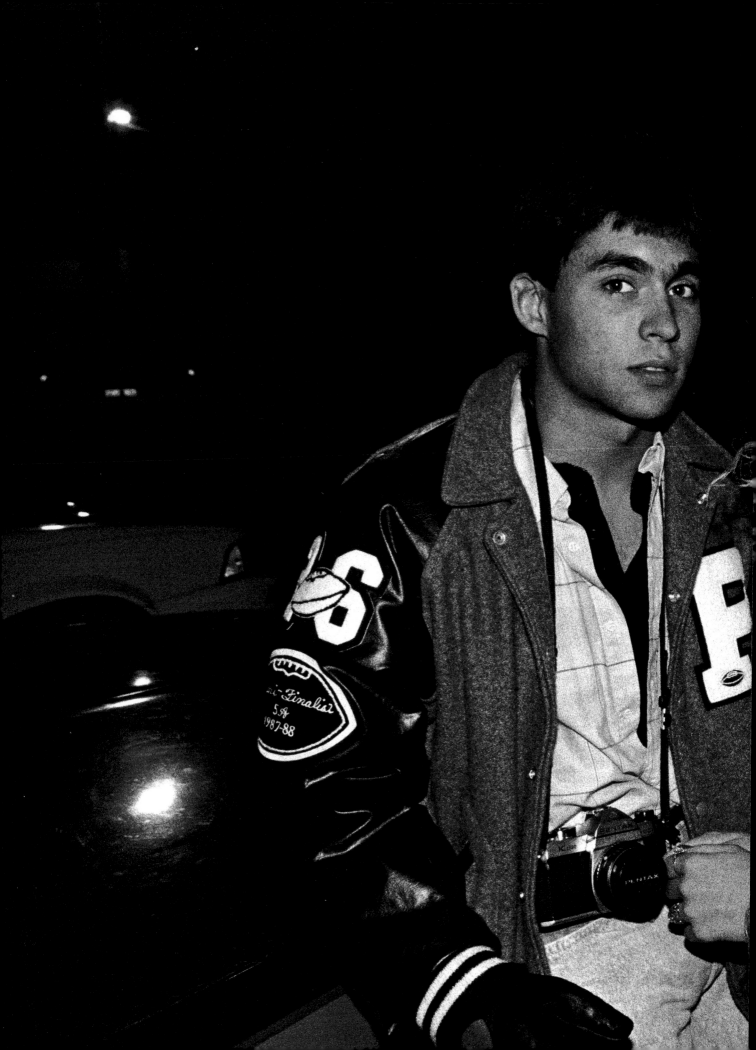

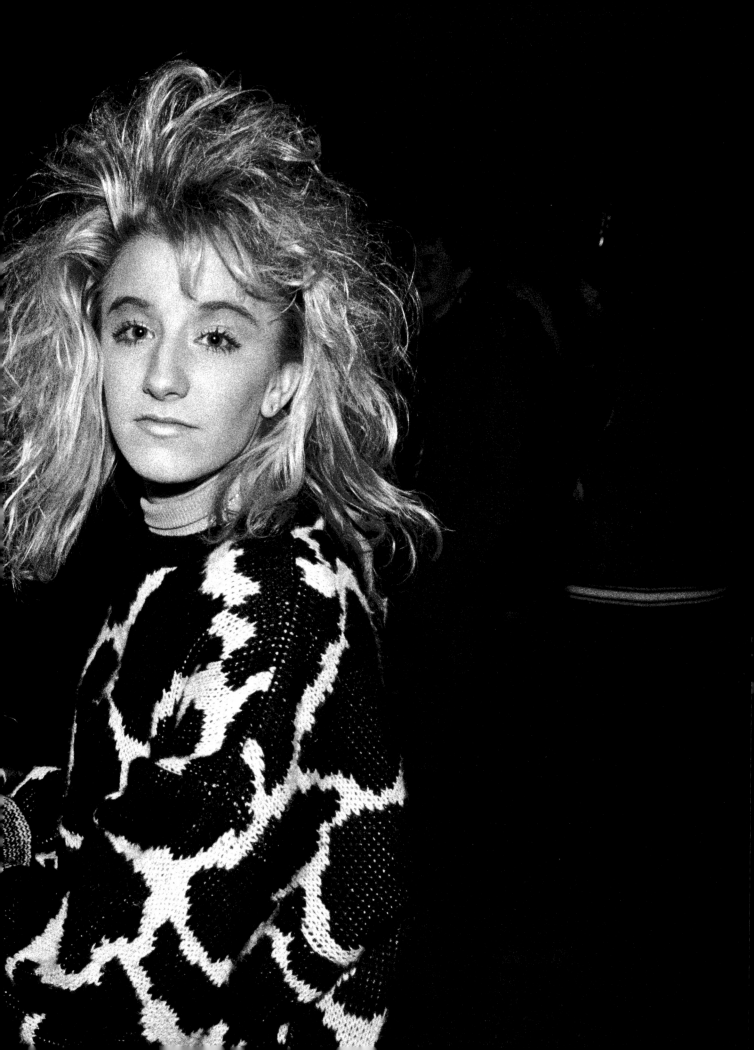

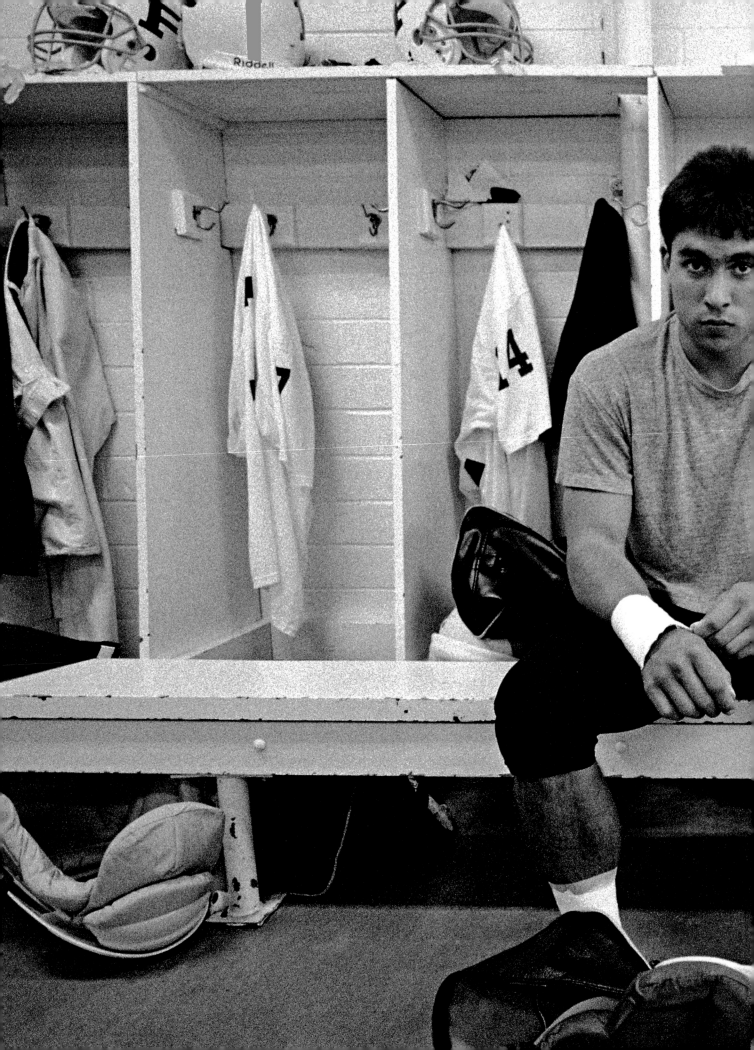

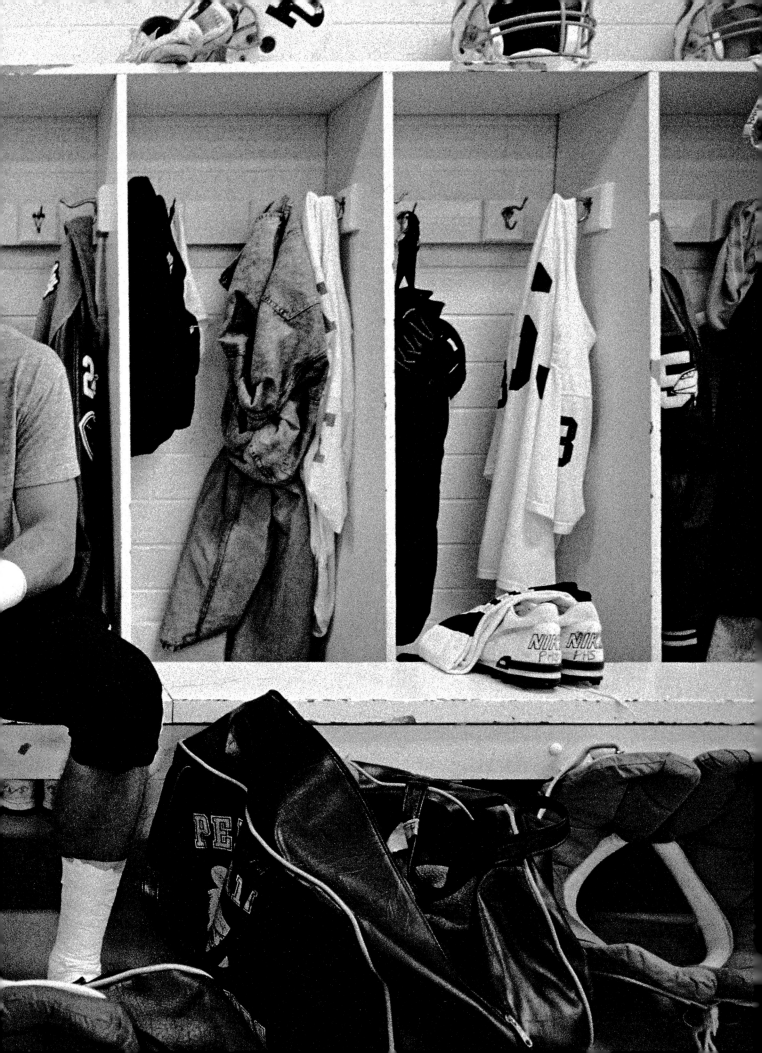

FEBRUARY 20, 2020
Lewisville, Texas

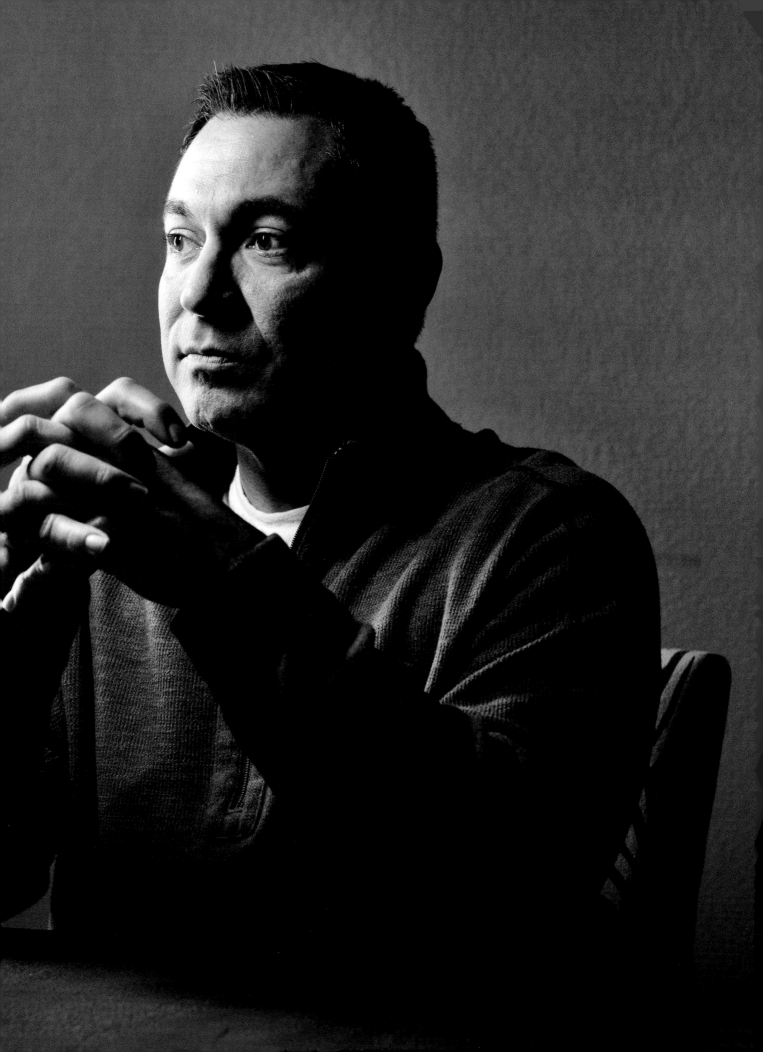

COACH GAINES

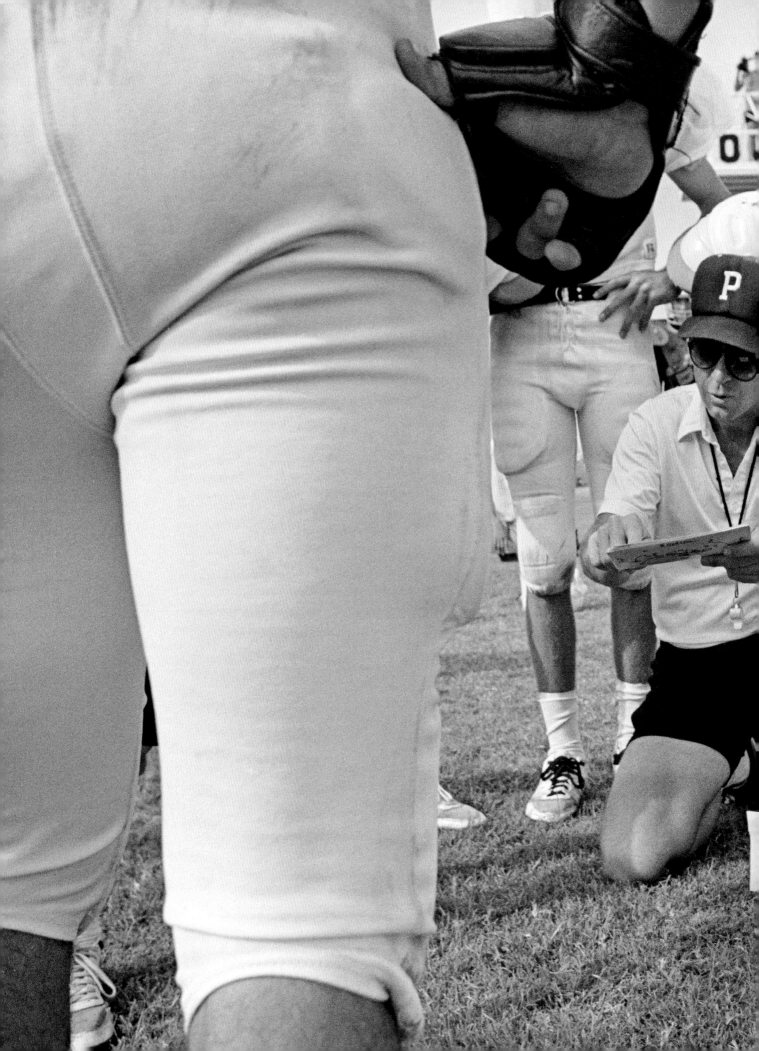

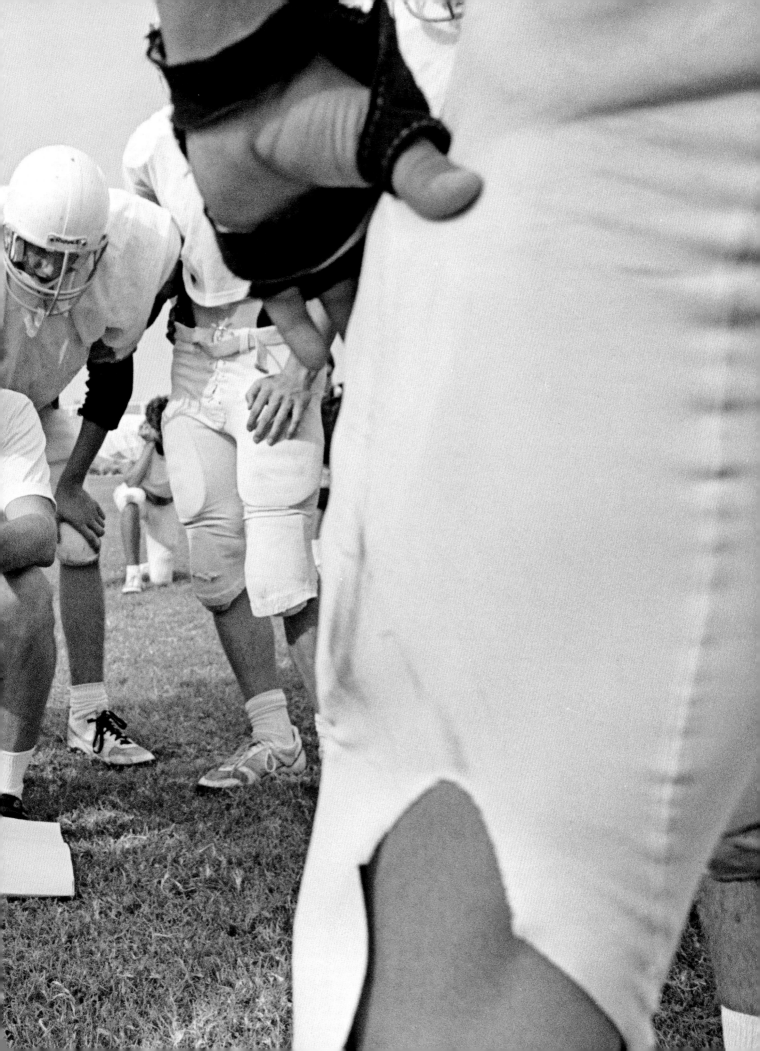

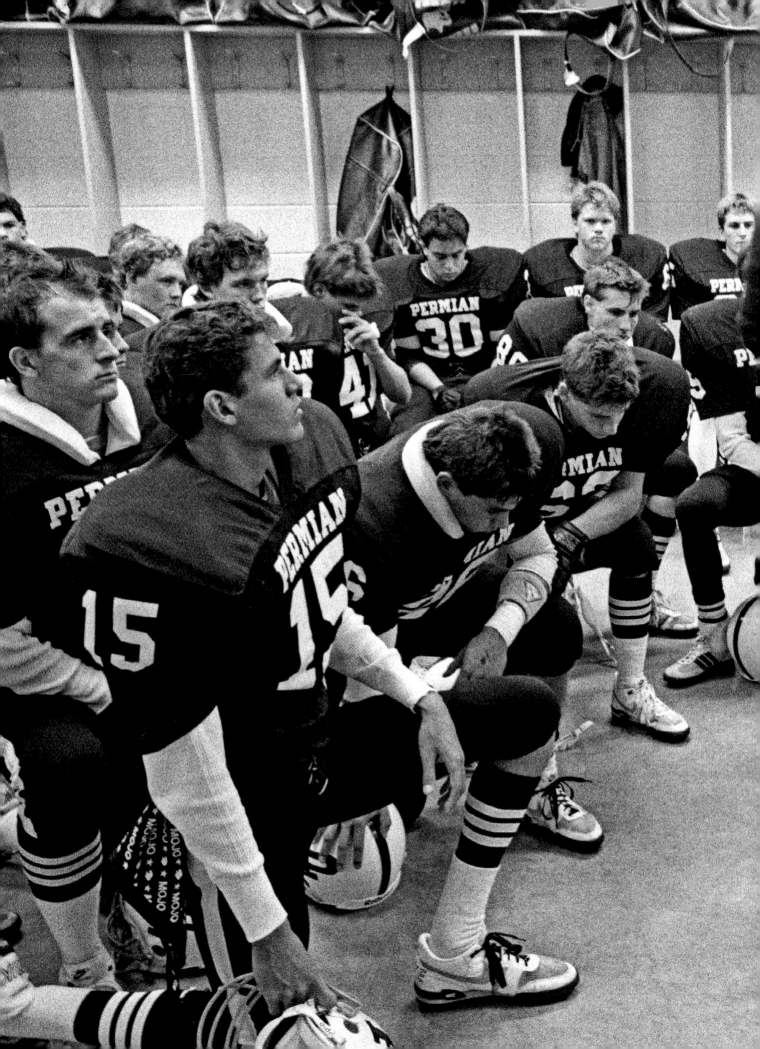

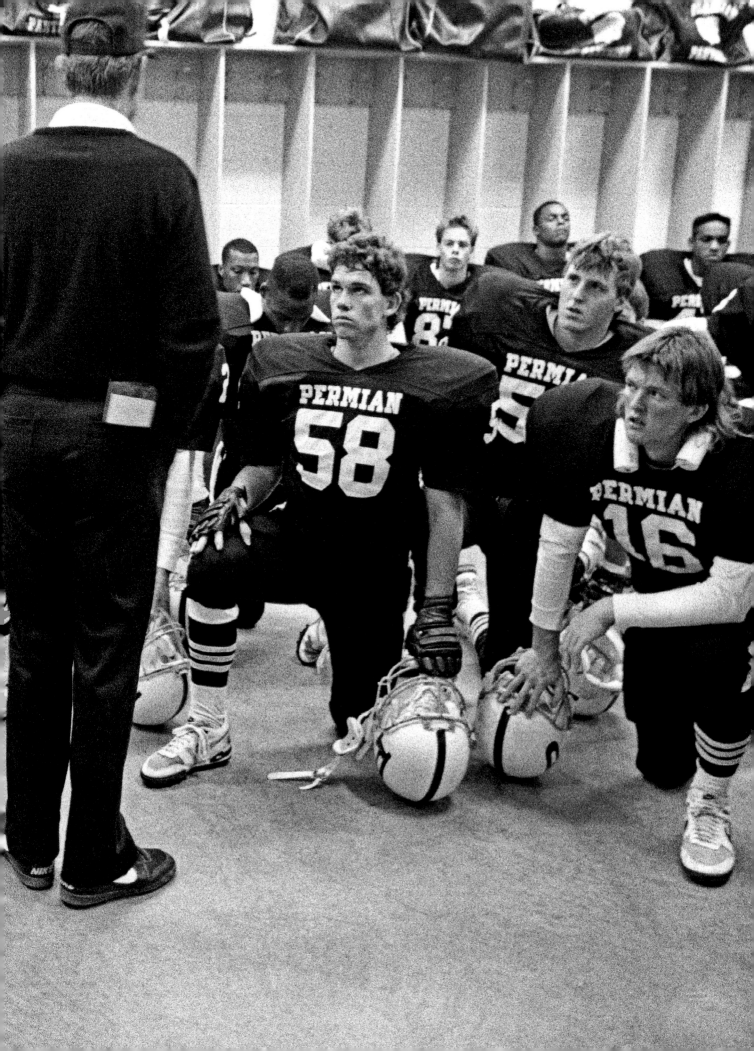

JULY 13, 2019
College Station, Texas

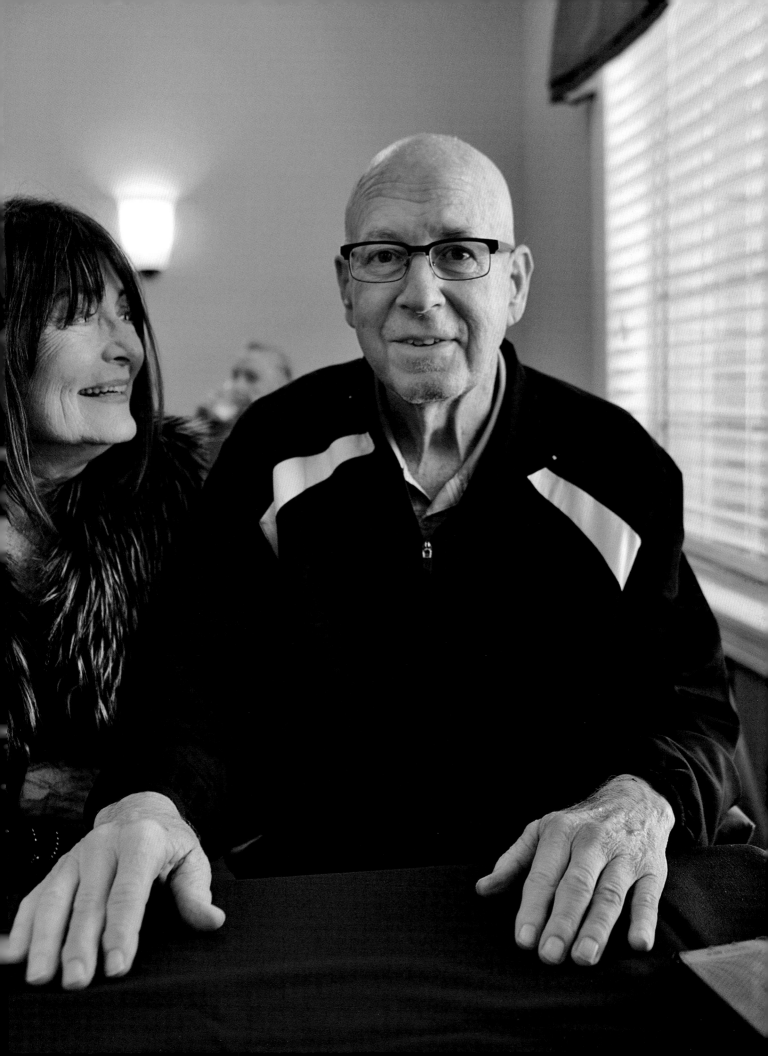

AFTERWORD
30 YEARS AND COUNTING

ROBERT CLARK

I FIRST MET BUZZ Bissinger at the Pen & Pencil Club in Philadelphia. It was the day he won a Pulitzer Prize for his investigative work on corrupt city judges for the *Philadelphia Inquirer*, and a celebration was underway.

What I tell people who ask about my time in Philadelphia is that the *Inquirer* was then the best newspaper in America. Editor in chief Gene Roberts, himself a Pulitzer Prize winner, had amassed a group of journalists that rivaled the greatest staffs of all time.

I was a contract photographer for the *Inquirer*, three years out of Kansas State University. I was hungry, with a bit of a chip on my shoulder and fighting every day for the chance to prove my worth on the staff of this great newspaper.

Sometimes it is the little conversations that change your life. I heard Buzz was leaving the *Inquirer* to write a book about high school football in West Texas.

"Permian?" I asked.

Buzz was surprised I knew about the Mojo of Odessa. I explained to Buzz that I had worked as an intern in Fort Worth for the *Star-Telegram* and covered a midnight practice of the Panthers. (The state prohibits practices until a certain date, so of course Permian started practicing at midnight on the designated date.)

He said, "That's really interesting."

I said, "You should hire me to shoot pictures for your book."

I didn't see him again for several months, until I touched down in Odessa to start my work for his book. Within minutes, I was shooting a parade in downtown Odessa, on a street that had seen better days.

The city of Odessa was on the downside of an oil boom and had seen hundreds of roughnecks leave town, as well as a good portion of its wealth. The boom-and-bust cycle has continued since the book was published.

Odessa was and still is, I imagine, a fistfighting town, similar to my hometown of Hays, Kansas. One night I pulled into the Circle K and was approached by a drunk oil-field worker. After some words, he took a swing at me and then fell to the curb and didn't move. Somehow that didn't seem strange to me at the time.

Besides, we were working hard; there was a lot to shoot and no time for distractions. Buzz had inserted himself into the world of Mojo football. For a year he attended every practice, every booster club meeting, and every coach's meeting, and even the trip to a local strip club with some of the players' fathers. (I went along. It was awkward.)

I was eager to view the work I was producing. It was 1988, so I was shooting with film, and every click was filled with anticipation of what might be revealed—or not. Pre-digital, you just had to wait and see.

In the last year, I have scanned hundreds of images from 137 rolls of film, pictures that have sat virtually untouched for thirty years.

The players were frozen in my negatives and my mind as beautiful, strong athletes, but upon reexamination of the work, I see macho warriors, as well as kids on the verge of adulthood. I went dove hunting with some of the players. They spent most of the time trying to stomp horny toads. They were young men with guns—and they were boys playing in a stock tank.

All of them, though, were trying to accomplish something that they'd been told since childhood they wanted—no, *needed*—in order to be special: an undefeated state championship season. I could relate. I had been an

I COULD RELATE . . . I WAS TWENTY-EIGHT WHEN I SHOT THE PICTURES IN THIS BOOK, NOT THAT MUCH OLDER THAN THE PLAYERS.

athlete; I loved football. I was twenty-eight when I shot the pictures in this book, not that much older than the players. Jerrod McDougal is the player I think I'm most like—more heart than talent, not scared of hard work. I'm not sure how many times he tackled leading with his head, but if it was one time, it was a hundred. Jerrod said to me, "I don't give a shit about the book; I only had one chance to be a state champion and it didn't happen."

For that reason, one of the images that sticks with me is of Jerrod and Greg Sweatt embracing after the loss to Midland Lee (pages 92–93). Emotions were raw and intense in the locker room under Ratliff Stadium. I walked in and slid toward the edges as quickly as I could, so as not to become a part of the agony. I saw a picture that I wanted and raised my camera to find out that the lens was fogged up beyond use; I had entered a humid locker room after a crisp, fall evening. I pulled off the lens and wiped the mist, first from the back element and then from the front. I got it just clean enough to shoot two frames that recorded the scene.

In the second quarter of the Midland Lee game, Boobie Miles was replaced by Chris Comer. Sitting on the bench, Boobie knew it was over. His knee was never going to be the same, and his ticket to the big time was now indisputably canceled. He sat alone, estranged from the huddle of the offense that was discussing the next series of downs. He quit the team at halftime, and you can see the anguish in his face and posture. I understand the decision he made that night, how it was too painful for him to watch his dream die. That is the last time Boobie was on the field in Odessa.

The picture that speaks to me the most, though, is of Mike Winchell (pages 106–107), taken during the pre–Midland Lee pep rally. The gym was so loud, it was deafening—way too much to process. The players were sitting in a line of chairs on the south end of the gymnasium, obscured by black-and-white balloons. Then

a few balloons parted and Winchell's face emerged, alone in a sea of activity, pressure on all sides . . . a fitting metaphor for the enormous weight this quarterback carried on the field.

Mike and I connected for a moment; I had yet to have that happen with him during my time in Odessa. I captured one frame, and it is one of my favorite pictures that I have ever taken. I have traveled to dozens of locations around the country and the world for *National Geographic*, and I have seen stadiums from above, lights glowing, countless times; when I do, I'm transported back to the field in Odessa, and it always makes me smile.

THIS AFTERWORD IS BEING WRITTEN ON THE heels of my fortieth high school reunion. We have lost seventeen people in my class, from car accidents, alcoholism, suicide, cancer, and the opioid epidemic.

Sadly, the Panthers recently lost Chris Comer, which brought some of them back together to mourn their teammate.

Looking at black-and-white negatives from thirty years ago made me feel like I was again at my first newspaper, working to make sure the pictures that I was shooting were good enough—worthy of what I had witnessed.

One day, when Buzz and I were looking at the pictures for the book, he asked me, "What if this is the best thing we ever do?"

I thought to myself, That would still be pretty good.

I have continued to photograph the players over the years, ten years after the book was published for *Texas Monthly* and again on the twenty-fifth anniversary for *Sports Illustrated*. I have seen them become middle-aged men, with all that that entails. The more recent images helped me see how the goal of a championship has given way to the hope for a life beyond the lights of Ratliff Stadium. And I can relate to that, too.

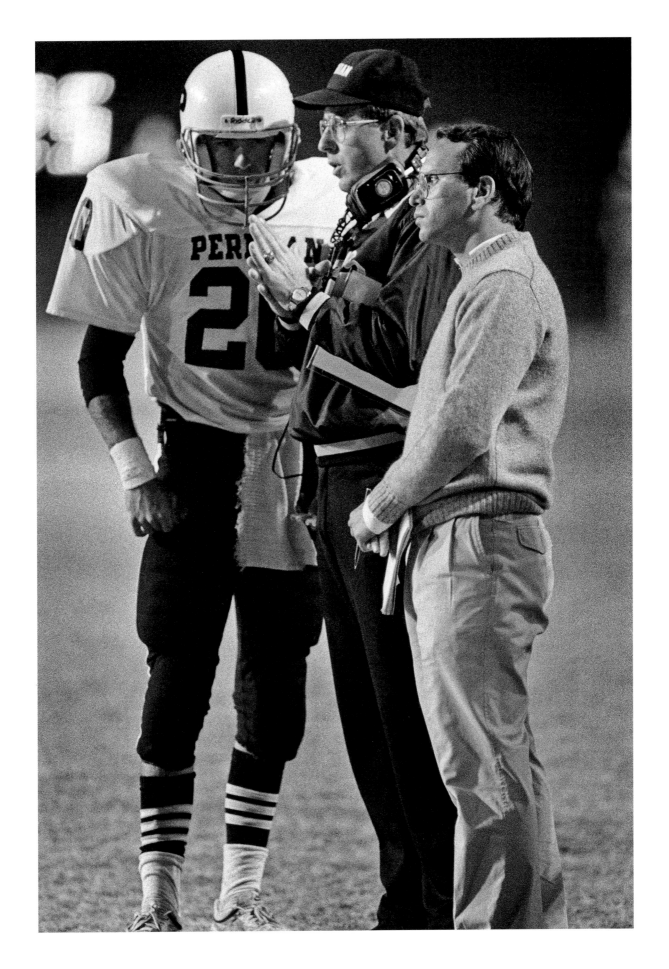

CAPTIONS

FIRST HALF

PAGES 2-3
They call it "sorry cotton." This field in the Permian Basin just northwest of Odessa, Texas, awaits harvesting.

PAGES 10-11
Coach Gary Gaines enjoys a moment of solitude as he walks the field before a road game against Abilene Cooper High School at Shotwell Stadium in Abilene, Texas.

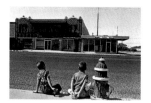

PAGES 24-25
Zack and Gerry Bissinger take a seat on the main road in Wink, Texas, at the intersection of State Highway 115 and North Roy Orbison Blvd. The city, which is home to the legendary singer and features a museum in his honor, reportedly hired college players from Texas Tech University to play in Friday night games in the 1930s. The Wildcats won the Texas State 1A Championship in 1952. Orbison has been credited with describing Wink as a combination of "football, oil fields, oil, grease and sand." It has been said, "If you blink you miss Wink."

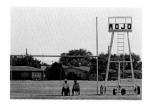

PAGES 4-5
Local boosters come out to watch the 1988 Permian Panthers practice.

PAGES 12-13
The Panthers locker room is always prepared with exacting precision before home games.

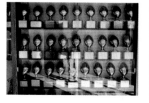

PAGES 6-7
One of the first things you see when you enter Permian High School is the massive trophy case dedicated to the Panthers football team.

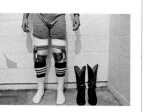

PAGES 14-15
Jonathan Golden wears knee braces for all the practices and games.

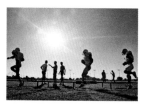

PAGES 26-27
An afternoon practice under the West Texas sun.

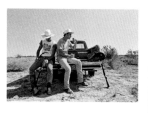

PAGES 8-9
Players Jonathan Golden and Ree Lucas take a break while dove hunting west of Odessa.

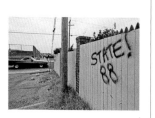

PAGES 22-23
Graffiti near Permian High School reminds the players what is expected of them.

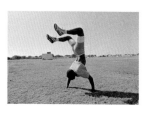

PAGES 28-29
Brian Johnson does a handstand on a Saturday morning the day after a victory over Abilene Cooper High School.

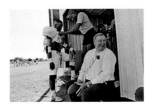

PAGES 30–31

James "Boobie" Miles has his shoulder pads tightened by Corey Williams, student manager, during an afternoon practice. Sitting nearby is Marion "Kiwi" Kwiatkowski, watching the proceedings. He had three sons who played for the Panthers during the 1980s.

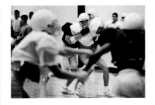

PAGES 36–37

A defensive player wraps up Mike Winchell during an early morning indoor practice.

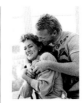

PAGE 44

Boobie Miles and his uncle, L. V.

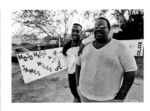

PAGE 51

High school sweethearts Chad Payne and Tracy Rickerson play in the hallway as they skip class on the way to his truck.

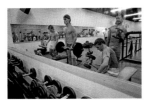

PAGES 38–39

Varsity players lift weights following an afternoon practice in the Panthers weight room.

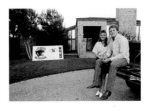

PAGE 45

Jerrod McDougal and his mother outside their home.

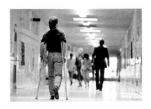

PAGES 52–53

Following surgery on his knee, Stacy Martin makes his way down a hallway at Permian High School.

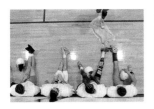

PAGES 32–33

Players rest and recover during an early morning practice. The 6 a.m. workouts take place four days a week during the season.

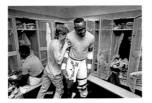

PAGES 40–41

Stacy Martin horses around with Boobie Miles in the Panthers locker room.

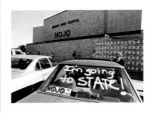

PAGES 46–47

Shoe polish was often used to write messages of encouragement on car windows.

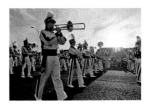

PAGE 54–55

The Permian marching band parades down North Grant Avenue in Odessa prior to a pep rally.

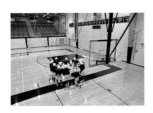

PAGES 34–35

Quarterback Mike Winchell takes a knee as he calls a play during a morning practice in the Permian High School gym.

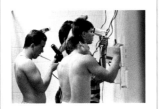

PAGES 42–43

Players crowd around the mirror to get ready for school after an early morning practice.

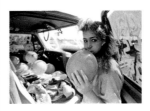

PAGES 48–49

Tracy Rickerson blows up balloons and fills up her boyfriend's pickup cab in a game day prank before the Panthers play rival Midland Lee High School.

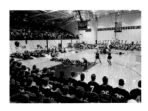

PAGE 56

Pepettes perform at a morning pep rally before the Midland Lee game.

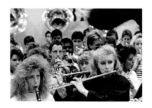

PAGE 57
At some point, the Permian band would play the theme from the television show *Hawaii Five-O*.

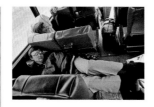

PAGE 63
Defensive end coach Kade King takes a nap on a road trip for a game.

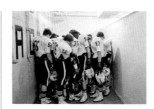

PAGE 67
The Panthers prepare to take the field against Abilene Cooper.

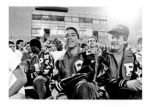

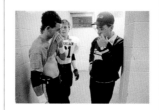

PAGE 71
Top: Steve Stowers (left) and Jonathan Golden (right) at a Permian junior varsity game. Bottom: Pepettes at a Permian junior varsity game.

PAGES 58–59
Coach Gary Gaines and his wife, Sharon, at the Midland Lee pep rally.

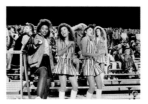

PAGES 64–65
Ivory Christian and Chad Payne read a Bible verse in the locker room before a game. "Be strong and courageous. Do not be afraid or terrified because of them, for the Lord your God goes with you: he will never leave you nor forsake you" (Deuteronomy 31:6).

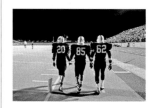

PAGES 68–69
Left to right: Quarterback Mike Winchell, Todd Crump, and Coach Gaines talk strategy during halftime of a game.

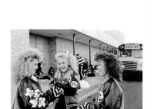

PAGES 60–61
Permian supporters (left to right) Bridgette Vandeventer, Kerri Edwards, and Jennifer Connelly talk before hopping on the bus for the trip to Abilene and the game against Cooper High School.

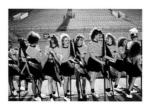

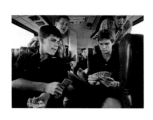

PAGE 70
Top: Pepettes at a Permian junior varsity game. Bottom: Girls of the Permian High flag team at practice.

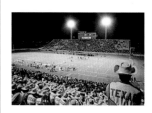

PAGES 72–73
Left to right: Team captains Mike Winchell, Ivory Christian, and Brian Chavez walk onto the field for the pregame coin toss vs. Midland Lee. This now-iconic image was the cover of the original *Friday Night Lights*.

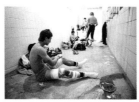

PAGE 62
Left to right: An unidentified JV football player, student trainer Steve Ward, student trainer Jeff Gasaway, and student trainer Brian Heathman play cards on the way to Abilene for the Cooper game.

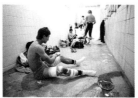

PAGE 66
Jonathan Golden adjusts his knee braces.

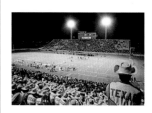

PAGES 74–75
Permian football was a big enough draw that the University of Texas band made an appearance at Ratliff Stadium.

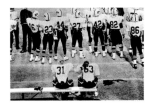

PAGES 76–77
Chad Payne (31) and Billy Steen (63) take a break during the Cooper High game.

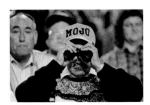

PAGES 78–79
An unidentified fan exemplifies the spirit of Mojo. The origin of "Mojo" supposedly dates to 1967 when a group of Permian alumni met in Abilene for the Panther game against Cooper. Legend has it that the Permian fans began chanting "Go, Joe" in support of a Panther player. Other fans thought they heard "Mojo," and the rest is history.

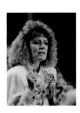

PAGE 80
Sharon Gaines, the wife of Coach Gary Gaines, cheers for the Panthers.

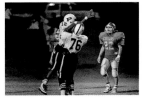

PAGE 81
After scoring a touchdown against Abilene Cooper, Robert Brown is lifted into the air by teammate Jerrod McDougal (76).

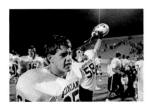

PAGES 82–83
Monty Masters (65) and Robbie Bentley (58) celebrate immediately after a win over Abilene Cooper.

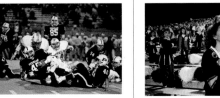

PAGES 84–85
Running back Chris Comer rushes for a first down against archrivals the Midland Lee Rebels.

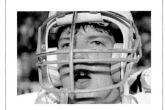

PAGES 86–87
Greg Kwiatkowski, a junior tight end, concentrates on the action on the field.

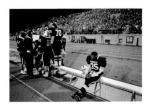

PAGES 88–89
Boobie Miles was pulled during the first half of the Midland Lee game. He later quit the team, for the first time, at halftime in the loss to the Rebels. In 1987, he rushed for more than 1,300 yards and was being recruited by more than half of the college teams ranked in the Top 20. Football was his ticket out of poverty, but it vanished when he injured his knee in the spring of 1988 during a meaningless scrimmage. He never recovered physically or emotionally.

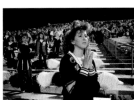

PAGES 90–91
Pepettes Robbie Freeman (left) and March Bryant (right) pray for a touchdown in the final seconds during the loss to Midland Lee.

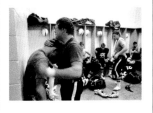

PAGES 92–93
Jerrod McDougal embraces Greg Sweatt and punches the wall in the locker room following the loss to Midland Lee.

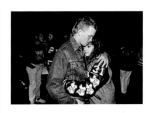

PAGES 94–95
Chad Payne and Tracy Rickerson (wearing his letter jacket) following the Permian loss to Midland Lee. They eventually married and had two daughters and one granddaughter. They divorced after twenty years of marriage.

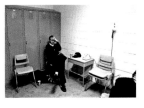

PAGES 96–97
Coach Gary Gaines sits alone in silence following the unexpected loss to Midland Lee.

MIKE WINCHELL

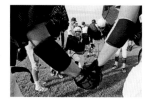

PAGES 100–101
Mike Winchell calls a play during afternoon practice.

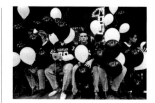

PAGES 106–107
Mike Winchell looking alone amid a crowd of balloons at a pep rally.

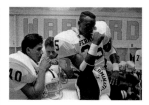

PAGES 114–115
Boobie and teammates listen to final instructions from the coaches before taking the field.

SECOND HALF

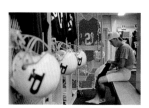

PAGES 102–103
Mike Winchell concentrates in front of his locker before the Midland Lee game.

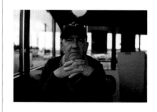

PAGES 108–109
Mike Winchell now works for an oil field services company near Denton, Texas. He spoke about the book and its impact: "People are interested in it when they find out I was in the book," he said. "I rarely think about it, but when I do, with some distance, [I think] it is a great document of the season we had."

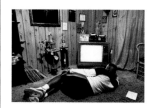

PAGES 116–117
At home, Boobie watches a VHS highlight reel that his Uncle L. V. put together to send to an assortment of colleges.

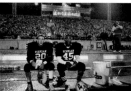
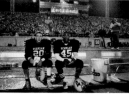

PAGES 104–105
Mike Winchell (20) and Chris Comer (45) sit in stunned silence as they realize the game against Midland Lee is lost and there will be no heroic comeback. Permian entered the night as a 21-point favorite and the math was simple: Win and advance to the district playoffs. Lose and fall into a three-way tie for two playoff spots.

BOOBIE MILES

PAGES 112–113
Boobie Miles meditates in the locker room before the Abilene Cooper game.

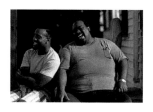

PAGES 118–119
Boobie Miles and his uncle, L.V. Boobie attempted a comeback at Ranger Junior College in Ranger, Texas, and even had a fling in semi-pro football, but his knee was never the same. L. V. was effectively Boobie's life support system. He adopted Boobie from his brother and was the stabilizing force in his world. L. V. passed away in 1998.

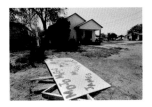

PAGES 120–121
Every player at Permian High had a sign in front of his house made by the Pepettes. Two years after Boobie's last game as a Panther, his sign lay broken in the yard, a reminder of the past.

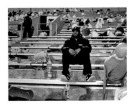

PAGES 122–123
Boobie Miles sits in the stands during the filming of the movie *Friday Night Lights*. In retrospect, Boobie said he feels his future was taken away from him by a system that rewarded him for his football talent and gave him As and Bs in his high school classes, only to abandon him when he was injured. He has spent time in prison and struggled with drug and alcohol abuse.

BRIAN CHAVEZ

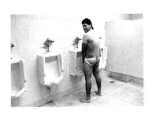

PAGES 126–127
Brian Chavez, the heart and soul of the team, takes a pregame leak.

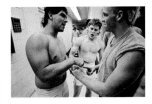

PAGES 128–129
Left to right: Brian Chavez, Coodie Dean, and Chad Payne during a pregame pep talk. "Suns out Guns out" is what Chavez said when seeing this picture for the first time years later. "We were all in such great shape."

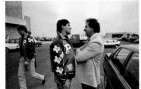

PAGES 130–131
Brian and his father, Tony Chavez, seemed to me to be very close. Brian was among the best students in the school and graduated as class salutatorian. That he wound up at Harvard was in part thanks to the advice and guidance of Buzz Bissinger. Chavez earned his law degree nearby, at Texas Tech University in Lubbock, before joining his father's law firm in Odessa.

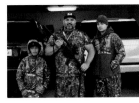

PAGES 132–133
Brian Chavez (center) with his M&P15, is flanked by his nine-year-old godson and nephew, Fernando Chavez (left), and his fifteen-year-old stepson, Kade Ramos (right). "I always say our fifteen minutes of fame have lasted thirty years," Chavez explained. "It's like having your senior yearbook memorialized as a *New York Times* best-selling book, a celebrated movie, and an award-winning TV show."

IVORY
CHRISTIAN

PAGES 136–137
Ivory Christian was a linebacker for the Panthers. He was the most physical player on the team, quick, fast, and strong. Devoutly religious, he enjoyed playing football, but even in high school, the game wasn't the be-all and end-all that it was for his teammates, the coaches, and the fans. Christian was the only senior from the 1988 season to make a major college football team. He played at Texas Christian University in Fort Worth, Texas.

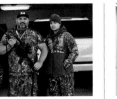

PAGES 138–139
Ivory Christian after practice in the locker room.

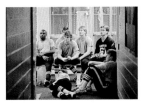

PAGES 140–141
Almost always quiet and reserved, Ivory Christian was his own person even among a crowd, as seen during this team meeting.

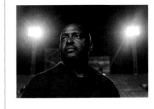

PAGE 142–143
Since graduating from TCU, Ivory Christian has worked at the same trucking firm in Odessa, Texas. He is married with one daughter, Ivy.

JERROD McDOUGAL

PAGE 146
Jerrod McDougal, senior offensive lineman for the Permian Panthers.

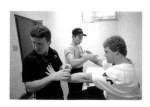

PAGES 148–149
Left to right: Student trainer Steve Ward and head trainer Trapper O'Connell tape Jerrod McDougal's hands and wrists before a game.

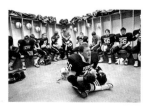

PAGES 150–151
Jerrod McDougal chants a motivational growl before the Midland Lee Game.

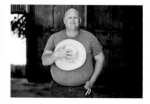

PAGES 152–153
Jerrod McDougal has had his ups and downs since high school ended. The loss of his younger brother, Jaxon, in a car accident hit the family hard, as it would any family. "Not a day goes by that I don't think about him," he said. The last time I spoke to him, he wanted me to check my contact sheets one more time to see if I had any pictures of his brother.

In terms of the book, he said, "I didn't really give a shit about it. I had one chance to be a state champion and I didn't want the distraction. I really love Buzz and, looking back, it is amazing to see what that book has done. It never goes away."

Jerrod is engaged to be married in 2020.

DON BILLINGSLEY

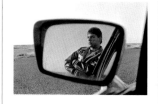

PAGES 156–157
Don Billingsley, the ladies' man of the team, in the rearview mirror of his 1967 Ford Mustang.

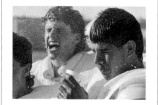

PAGES 158–159
Don Billingsley grabbing some water during an afternoon practice.

PAGES 160–161
Following the Midland Lee loss, with Christy Hefner. After hugs from several girls, Don winked at me and said, "Hell, losing this may be better than winning."

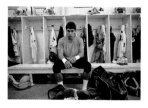

PAGES 162–163
Billingsley prepares for a game. When Boobie was injured, Don thought that he was going to get more carries. "But with the rise of Chris Comer to be this amazing back, it just had me blocking more than I had for Boobie," he recalled.

"I played at East Central (University) in Ada, Oklahoma. The facilities were such a joke and I said something about it in an article. They ended up getting a new locker room."

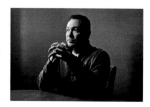

PAGES 164–165
After high school, Don became born again, "I realized I had so much more to be thankful for and welcomed the Lord into my life," he said. "My dad, Charlie, and I are closer than before." Charlie was an all-everything running back at Permian in the 1960s and was hard on Don, to say the least.

Charlie owned an Odessa bar, Dos Amigos, near the Ector County Fairgrounds. "The rule for me was to get home before he did," said Don. "I would have lived in Oklahoma with my mom if it had not been for the team, football, and that legacy. It was the sole focus of high school for me."

COACH
GARY GAINES

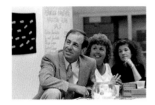 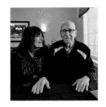 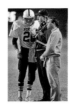

PAGES 168–169
Coach Gaines at a PTA meeting. He had a record of 46–7–1 while at Permian from 1986 to 1989. He coached the 1989 team to the Texas Class 5A state championship with a perfect record of 16–0. He left Odessa after the season and made numerous coaching stops, including four seasons as a linebacker coach at Texas Tech University, before returning to Permian. His record from 2009–2012 was 23–21.

PAGE 174–175
In 2012, during his final season at Permian, Coach Gaines started to exhibit troubling behavior. He would tell a story. Then he would start to repeat it. "We knew something was wrong," said his wife, Sharon. The diagnosis was early onset Alzheimer's.

Gary sometimes recognizes Sharon and their son, Bradley. He does know that she cares for him, and one time grabbed her purse and didn't want to give it back as she was getting ready to leave. "It is so hard; after fifty years of marriage, he is in his own world," said Sharon.

PAGE 179
On the sidelines (left to right): quarterback Mike Winchell, Coach Gary Gaines, and Buzz Bissinger. Buzz lived the book as much as the players, coaches, and residents did. He moved to Odessa with his boys and his second wife, Sarah. Buzz attended every practice, pep rally, and game during the season.

PAGES 190–191
In May 2017, at age forty-six, Chris Comer passed away during surgery. He was an unexpected star during the 1988 season when he replaced Boobie Miles at running back. The following year he attained legendary status at Permian when he led the undefeated Panthers to the 1989 state championship. In the title game, he ran for 166 yards and two touchdowns as Permian defeated Aldine, 28–14, at Texas Stadium in Irving.

Through a Facebook page, the team and students of Permian High School raised money to help with Comer's funeral expenses.

In 2009 Comer was interviewed by the *Odessa American* newspaper. "When someone asks where I'm from, I say Odessa even though I live in Houston. You never forget where you come from," he explained. "There is life after Permian . . . but you just never forget that gridiron life. What we went through all season, it's kinda instilled in your heart. If you go through what we went through, you're a pretty tough cat."

PAGES 170–171
Coach Gaines during a practice.

PAGES 188–189
Ree Lucas takes a break from dove hunting to search for horny toads to stomp.

PAGES 172–173
Giving his pregame speech to the team before the crucial game against Midland Lee.

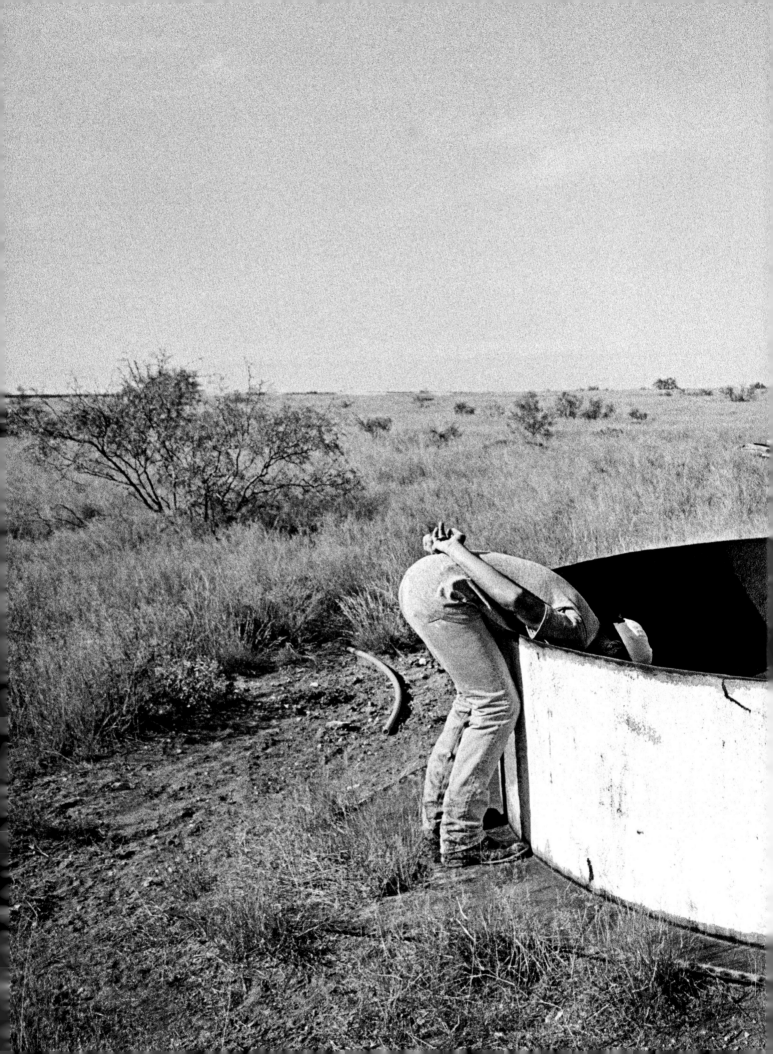

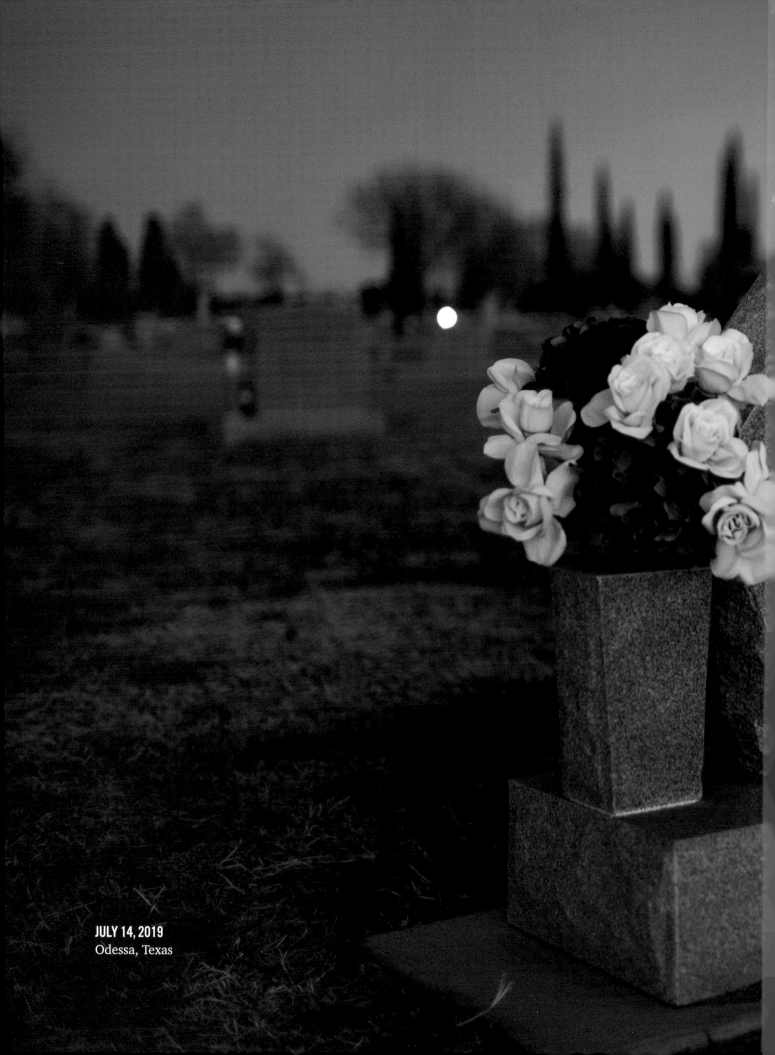

JULY 14, 2019
Odessa, Texas

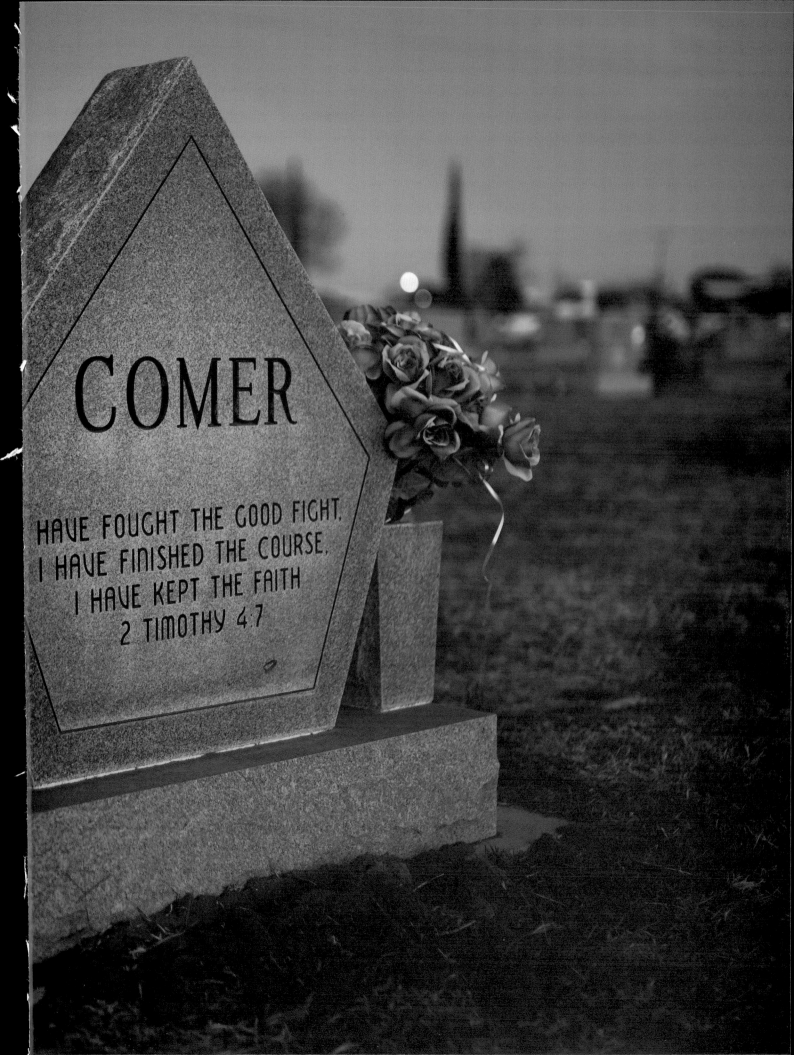